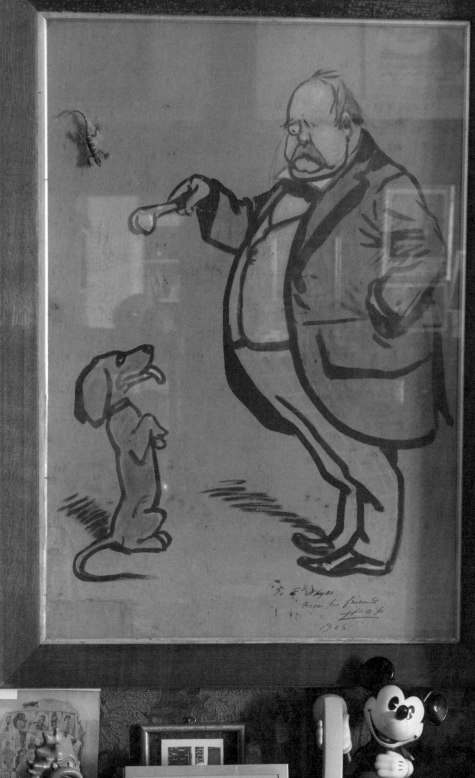

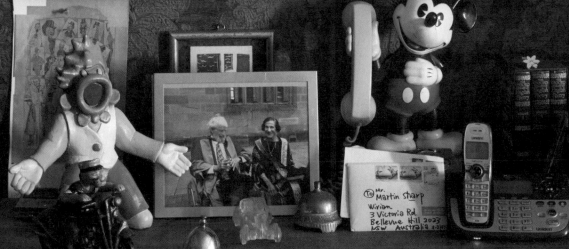

41 -

THE MAVERICK SOUL

*Inside the Lives & Homes of Eccentric,
Eclectic & Free-spirited Bohemians*

By Miv Watts

Photography by Hugh Stewart

Design by Tracy Lines

hardie grant books

CONTENTS

Ezy's Sale 6'6

THE RUBAIYAT OF OMAR KHAYYAM

FOREWORD

I FIRST MET MIV FORTY-TWO YEARS AGO AT MY FATHER, ALAN ALDRIDGE'S, MAGICAL rambling rectory in North Norfolk. She arrived in an old Renault with her two kids, Ben and Naomi, and it didn't take long before we were all climbing trees and laughing. It was to be a lasting friendship.

I was intrigued by this glamorous woman who dressed full of colour, slept naked (this was new to me) and sang made-up songs while driving, which we all loudly participated in. Her happy spirit was a breath of fresh air for me as my parents had just separated, and I was caught in the middle of misery.

What I learnt through my years of friendship with Miv is that she is full of layers – layers of life through her own sadness and joy; layers of style in her dress sense, piling on different patterns and colours, mixing things that don't go but somehow making it all work; and layers of taste. Her homes are full of things she has found on her travels and the rooms seem to say 'Come in and sit down, enjoy yourself and feel me.' It's a long way from the beige dullness that was thrown upon us as 'style' in the nineties and was lorded as the new chic – where less really was less, and banality was devoid of character.

Today we find ourselves in a time where celebrity is revered. It's a world of fake nails, fake breasts, fake news and fake lives being transmitted through social media. In *The Maverick Soul* Miv explores the polar alternative. She discovers the heartfelt side of people living far away from this shallow, transient trend. They live in their truth, the way they want to, surrounded by past stories and the history of their own journeys. This is about the confidence to be who you are and not worry about the judgement of others. It's not beige walls screaming out for interest but people actually living their interest.

–SAFFRON ALDRIDGE

INTRODUCTION

IN THE COURSE OF A LIFE, IF ONE IS LUCKY, ONE MEETS A FEW PEOPLE WHO LEAVE A mark, touch the heart, turn a switch, leave a print on the soul. Such mentors can have an impact on one's future and they can be the inevitable catalysts of change. In my case, often I didn't want to listen to their advice and, by the same token, I failed to recognise the inspiration they gave me until much later in my life; too often they were gone.

I had a grandfather who filled my holidays with huge adventure; who took me on walks in wild places, made secret camps for us all, collected everything from found pieces of shrapnel to broken Spode china cups; who woke us up at 4 am with 'scrams' (snacks) and stealthily steered us into the dawn and out onto the Welsh moors. Fashioning go-carts from old perambulators, he would tie to them anything that might cause a cacophony of sound. Aside from setting me alight with a misplaced smoking pipe in the bottom of my cot as a baby, we never came to much harm, but we did raise a few eyebrows. We were an unruly bunch!

I am grateful that I was able to spend a large part of my childhood on Anglesey with a man who made every one of his grandchildren feel special. With his teachings, I learnt to be true to myself, to recognise beauty, and to delight in the precious gift of an old man's imagination. This has had a profound effect on the course of my life, not only in memories of an adventurous childhood, but in the actual sensual pleasures I found in his quirky world.

His study was where he kept his rolltop desk, with its inky fountain pens and its drawer full of withered rubber bands, sealing wax and broken briar pipes. This drawer always contained a strong smell of sweet tobacco and rust, and to it he would turn in his creaky desk chair when a pipe needed filling. Then we knew another of his stories was about to begin. We, his grandchildren, would sit spellbound while we listened to his poems in his rolling Welsh vowels. At the end of the holidays, when it was time to leave, the lenses in his spectacles would turn foggy and, dressed in his fine Sunday suit, he would take out his big handkerchief and wave us away until he and his pennant receded into the immediate past and our focus switched instantly to the future.

When he finally reached the end of his days, he insisted on having his knees up in his bed. This, he imagined, would give him a last look at his beloved Snowdon and the mountain trail we so often hiked together.

As we age, we begin to see the influence the past has had on our lives and the people we remember most are those who have been truthful, maybe sometimes even punishing, but with integrity and for the sake of something bigger in ourselves that we were yet too young to meet. The strangest discovery is the day we realise that, unconsciously, these mentors have had a hand in mapping the paths of our lives. They are the free spirits. They are the ones who lived like kings while the soles of their shoes were letting in water.

These are the Maverick Souls.

The Maverick Soul seeks to learn from actual experience, to stand on the edge, to feel the wind around them, often to fall, but always to persevere with the understanding that on occasion life might deal one a bad hand and this is an opportune time for personal growth. These people make most decisions based on trusting intuition. The homes they have built around themselves are a reflection of a multitude of clear choices and

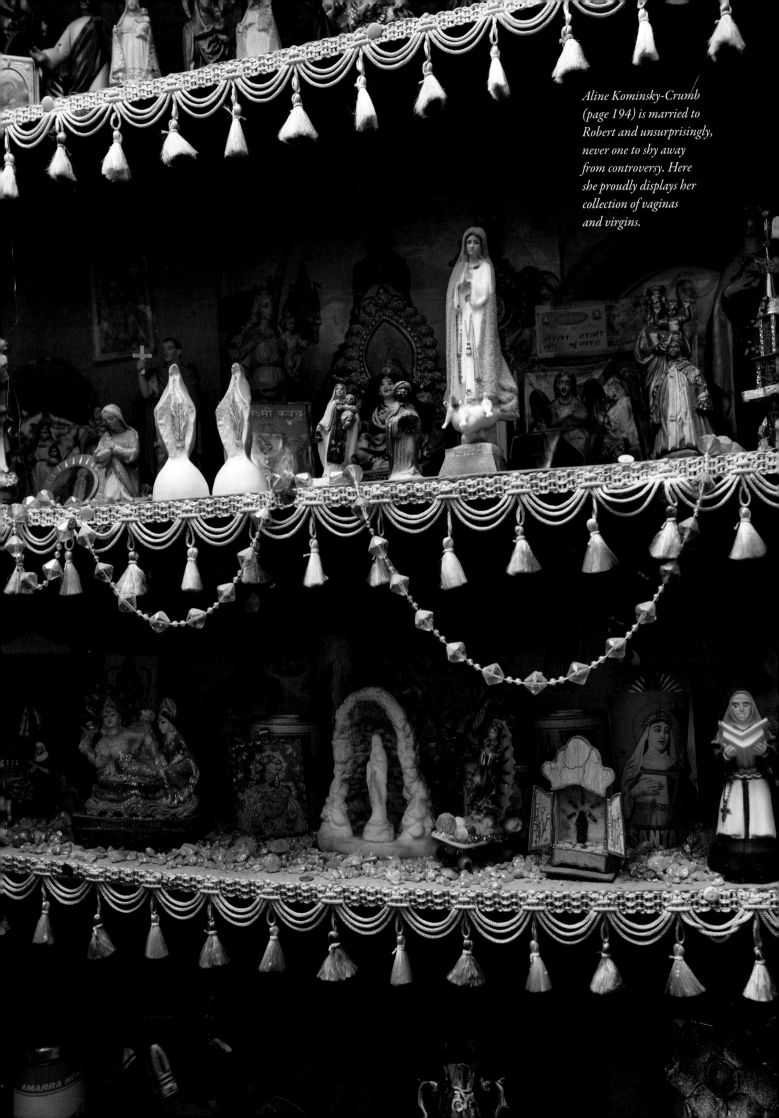

Aline Kominsky-Crumb (page 194) is married to Robert and unsurprisingly, never one to shy away from controversy. Here she proudly displays her collection of vaginas and virgins.

universities
are
places
where

pebbles are
polished and
diamonds are
dimmed

an avoidance of low-brow influences. These homes reflect free thought and free spirit. They are built from discerning choices, from items gathered from a variety of cultures; mementos from unforgettable events. There are stories in all these pieces because each one has had a personal resonance with its curator and with each story comes another layer of empathy and an understanding for humanity and one's own personal place within it. These homes can be cluttered and chaotic or cool and clean-lined, but they are never contrived – the emphasis being on passion, never on trend. The Maverick Soul is a patchwork of a life lived to the full in every aspect.

In addition, our subjects know that sometimes life leads one to solitary places. Melancholy can be a positive force. What artist has not produced some of his best work under the dark cloud of melancholia? Out of the darkness comes light. Contrary to the media battering we endure in our culture, happiness is not a permanent state to which one can aspire. Happiness comes in fleeting moments of passing joy – there one minute, gone the next – leaving the indelible stain of hope. These homes represent an archive to both the recognition of the occupant's hopes, joys and sadness and the courage required to live life on one's own terms, to seek the genuine, to demand the authentic, to keep integrity in all one's choices. This in turn provides a launch pad from which to enter the world with confidence, elegance, grace and vision.

The people I have chosen for this book are people who have inspired me for their courage to live outside what is perceived to be the empire of mass culture. These people are comfortable in their skin. They have an innate understanding of place and the connectedness to their immediate surroundings. Family history, memories, form, texture and integrity play an important part in their lives. In some cases, the world is their village and a passion for life means that travel is a large part of it. The narratives of other cultures influence decisions, and from this intimacy with the unfamiliar, comes the ability to see life's bigger picture. These Maverick Souls follow their instincts and chip away the assumptions and prejudices that keep the more fearful amongst us locked into the routine of a sometimes less fulfilling and often monochrome life.

It has always been a passion of mine to explore the reasons behind why people surround themselves with the things that they do. From a career in set design for film and television, it was an enjoyable challenge to build a history around the characters by placing them in a set that revealed as much as it could about the personality of the protagonist. This, of course, is relevant in life; so much of ourselves we give away in our choices. Our homes give us the opportunity to express who we truly are in the stories of the things we surround ourselves with, the memories they trigger, the comfort they provide, the beauty in their very existence, the inspiration that comes from our collections, the knowing that these walls over time will witness every moment in the theatre of our lives and remain our closest confidante and our safest harbour for as long as we choose.

This is a book about people and the layers to a life. No one person is a reproduction of another; each of us is unique, shaped by the diversities of our own individual layers. Carl Jung said: 'The least of things with a meaning is worth more in life than the greatest of things without it.' This book has been a labour of love. Together with Hugh Stewart's deeply evocative images and the hugely generous participation of all our subjects, I hope to encourage readers to live by their own instinctive choices, to create a home that both comforts and protects. To consider the integrity and spirit in well-crafted pieces that resonate deep within us. To enjoy the adventure in creating a home not driven by popular opinion, but which evolves with patience, curiosity and truthful self-expression. There is not enough time left in this world to be anything but authentic. Bon voyage.

MARIANNE FAITHFULL

Singer / Songwriter / Musician / Survivor

MY PATH WITH MARIANNE HAS BEEN A LONG ONE. DECADES HAVE SLIPPED BETWEEN us as our lives have woven curious patterns through the tough and twisted tangleweed of the music business, both of us sustaining the inevitable bruises from abusive relationships, troubled parenting and, in Marianne's case, a long and hard battle with addiction. Today her painful history is merely a faded memory encapsulated in a framed collection of defamatory English journalism based on the notorious Mars bar story. Collaged together – a gift from artist Richard Hamilton – it hangs in her bijou apartment overlooking the famously well-trodden stones of Montparnasse. Marianne emits her throaty chuckle. 'Everybody wants to talk about that piece. All of it was so stupid!' And from her tone, we can deduce that this lady has moved on and doesn't wish to waste her time dwelling on a brief era that left her helplessly damaged and hopelessly lost. It has been a long journey and she says, 'The English have found it hard to forget. I will never go back to London, NEVER!'.

Today, however, Marianne's life is an orderly round of morning walks through her beloved Paris, penning new songs and planning future concerts around Europe. She recently performed a triumphant gig at the Bataclan theatre, one year after the terrorist attack, for which she wrote the heartbreaking song 'They come at night'.

Her life, she says, is often lonely but recently she has formed a strong bond with her grandchildren. Her relationship with her ex-husband, artist John Dunbar, father of her son Nicholas, remains stoic and supportive

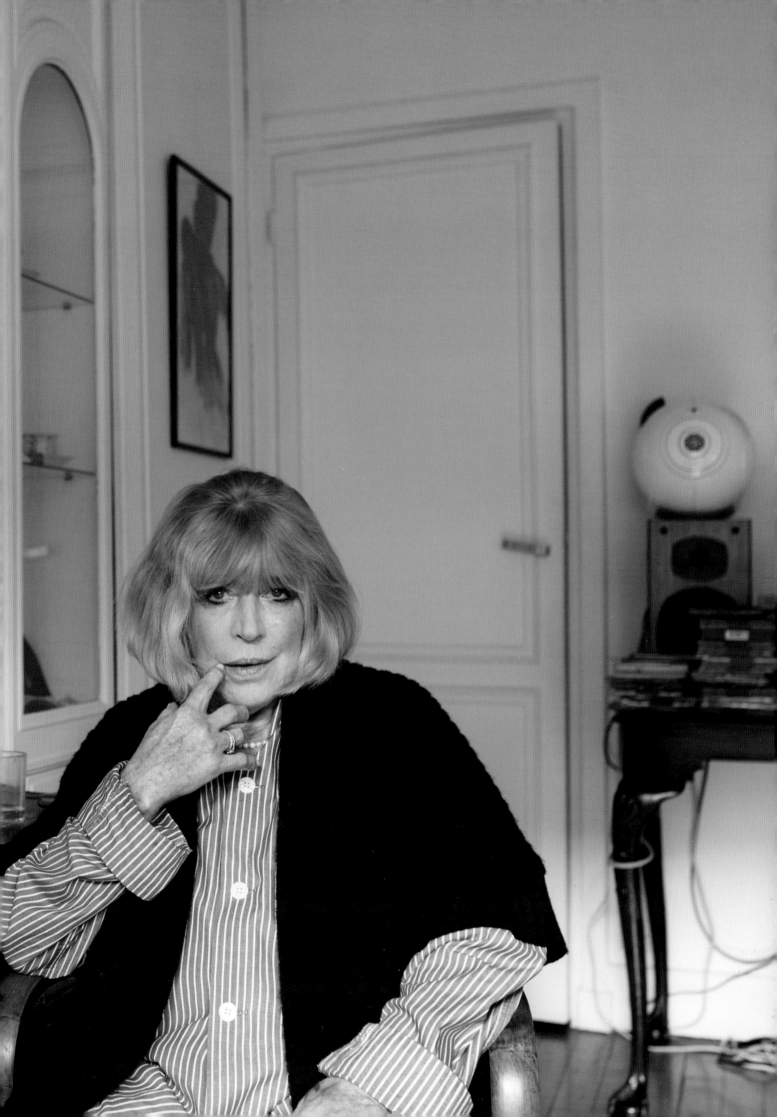

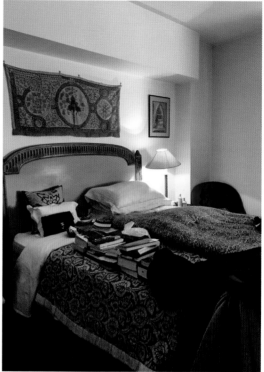

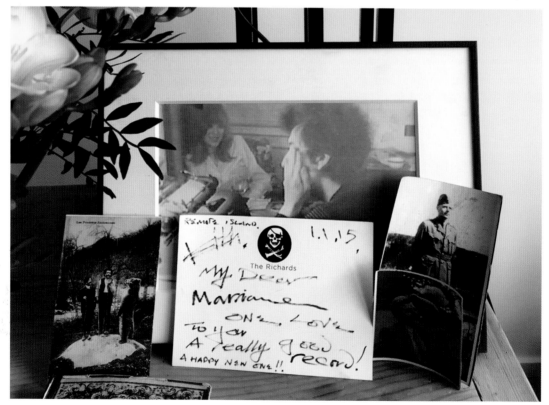

Top: *It is the evening of the day in Marianne's bijou apartment that looks past the deep red rose, out onto the streets of Montparnasse. Bottom: Old photographs of family and extended family sit beside a congratulatory note from Keith Richards. They say if you lived through the sixties and seventies you won't remember a thing – that's only partly true.*

as the years have rolled by. Their fondness for each other is evident in the way they lovingly tease over their respective contributions to this book. Marianne says John is an unsung hero in the Art world because he withholds so much of his work and stories, and is basically lazy. John says Marianne can be terribly grand, somewhat forgetful, but retains a ferociously sharp wit. His comments are verified by the revelation of a photograph of Marianne and Mick Jagger, dismissively placed in the recessive shadows of the lavatory. 'Best place for it,' shrugs Marianne. 'I have no nostalgia about that time.'

Do I think my lady doth protest too much? Not at all. It is clear that while she accepts her mistakes along with her achievements, she does not dwell on them. She can move on, and these days her focus is on a determination to be well. Recently she suffered a series of breakages to her delicate skeletal frame and since then has been suffering undue pain. But this has not deterred her from performing, and with the help of her walking stick (which she often uses to make a point) she makes a formidable impression strolling the boulevards of Paris. She will not indulge in sentimentality of any kind. Her work is paramount to her survival and she will work, writing songs, until she is carried away to the catacombs of Père Lachaise. Her songs are consistently poignant and truthful, sometimes angry and sad. They are all and everything she has left. They are important songs.

'I was going to write another book. But fuck it! I can't write. But I can write a song and that is who I am!'

Marianne is not rich by rock-star standards. Her tiny flat is quite humble and full of family heirlooms. There has been no attempt at design; it is simply a practical assemblage of inherited loveliness. Paintings and photos adorn every wall – by Martin Sharp and Francis Bacon; a wistful portrait by Marlene Dumas. Friends like William Burroughs, Nick Cave and Pink Floyd's Roger Waters have written songs for her.

Fragile porcelain tea sets, shells and figurines sit gingerly on glass shelves, a reminder of her genteel birth. An only child to Hungarian Baroness Eva von Sacher-Masoch, a ballerina for Berlin's Max Reinhardt Company, and Robert Glynn Faithfull, a British Army intelligence officer, who left to live on a commune when Marianne was a small child. A letter from her late father, now laying haphazardly on the dining table, announces a father's pride in his daughter's success as an artist and a good human being. As she reads it to me, I sense an unburdening relief from her parent, who must have suffered so much anxiety over his daughter's welfare. What trials we put our parents through during that decade of recklessly hedonistic years. Damaged by our parents' war experiences but oblivious to what really occurred, so rarely did they speak of it, we baby boomers set out to shake off the traces of congenital shrapnel by rejecting authoritarianism. To live free and unfettered, to avoid responsibility, to live without reserve – until ultimately our war turned inward against ourselves. Marianne has suffered her fair share of guilt and pain over her lost years but here she is, four decades on, elegant even in her PJs, which she chose for our portrait. She spends a lot of time in her bedroom reading voraciously – the reading matter on one side of the bed. 'It keeps people from sitting on the bed, let alone even thinking of getting in it!'

The books pile up beside her silver brushes and scent bottles, which her trusty maid rearranges on a weekly basis. I am allowed to sit on the bed, briefly, until the aroma of roasting chicken takes us to the kitchen. 'I am a very good cook,' she says as she squeezes the last of the juice from a lemon over the sizzling bird. Replete, I lean back in my chair. I see her stick leaning against the wall next to her Chanel handbag, two vital components of her life now. Every day she walks a little further, gets a little stronger, laughs a little longer and never, ever, loses that wickedly charming smile that curls at the edges and spreads an intriguing vulnerability and suspicious imperialism beneath her intensely blue eyes. 'Come back and see me soon, darling. I get very lonely and love our little chats, but now I must water my plants.'

Back on the pavement of Montparnasse, I consider the protection and esteem extended to the iconic women of Paris. Cherished as much for their indiscretions as they are for their beauty and their talent, the whole picture of what has been, is now, and is still to be. The songbird of Montparnasse has found her home here above 'The Boulevard of Broken Dreams'. Paris adores her, feeds her soul and feels her pain. *Vivre la Faithfull, l'oiseau de chanson de Montparnasse, et vivre la France* for being so entirely libertine.

RAFFAELLA BARKER

Novelist / Artist

IN A QUINTESSENTIAL ENGLISH HOUSE ON THE EAST ANGLIAN COAST LIVES A quintessential English novelist. The daughter of truly Bohemian parents, she has 14 siblings and a pressing urge to write about family life in all its glorious, frenetic detail. To date she has penned nine novels.

Raffaella Barker walks me through her garden, beginning with the giant imported rose bushes and ending in raptures over her first ripe damson. As we walk, I am subconsciously aware that I might accidentally have stumbled, like Alice, into a chapter of one her bucolic novels and I ought to keep my eye out for the little bottle that might bring me back to reality. But I have hopelessly fallen into the well of her story and am on a ride through her mellifluous delivery of the tale.

Raffaella is the daughter of the renowned, rebellious Bohemian poet George Barker, so it is hardly surprising that words fall from her mouth in captivating capsules, a combination of drama, precision and wit.

She is excited to talk about this Norfolk home that she acquired from the estate of the late Lady Bridget Rathcavan. According to rumour, the lady died of fury in her bathtub over a dispute with the neighbours about the improvements she was making to what was ostensibly a mere fisherman's cottage. Her ladyship had fancied she might replicate her Irish stately home here on the Norfolk coast. At eighty years old, she embarked upon raising the roof and adding an Italianate extension. Gathering mountains of recycled eighteenth-century

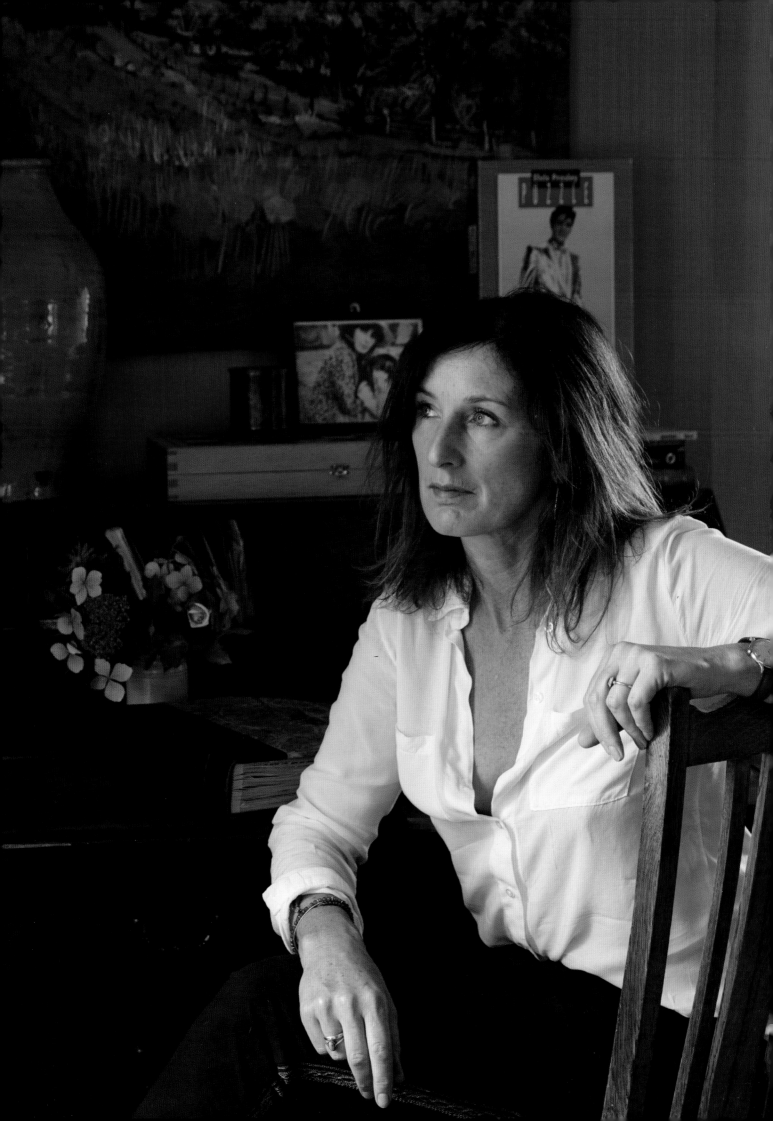

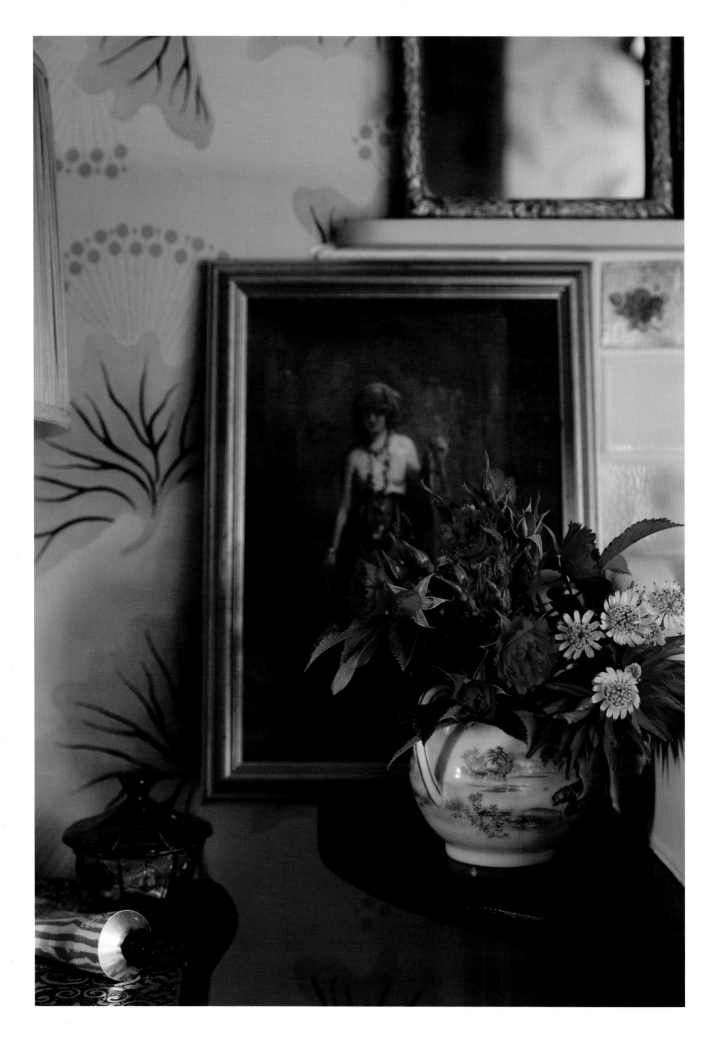

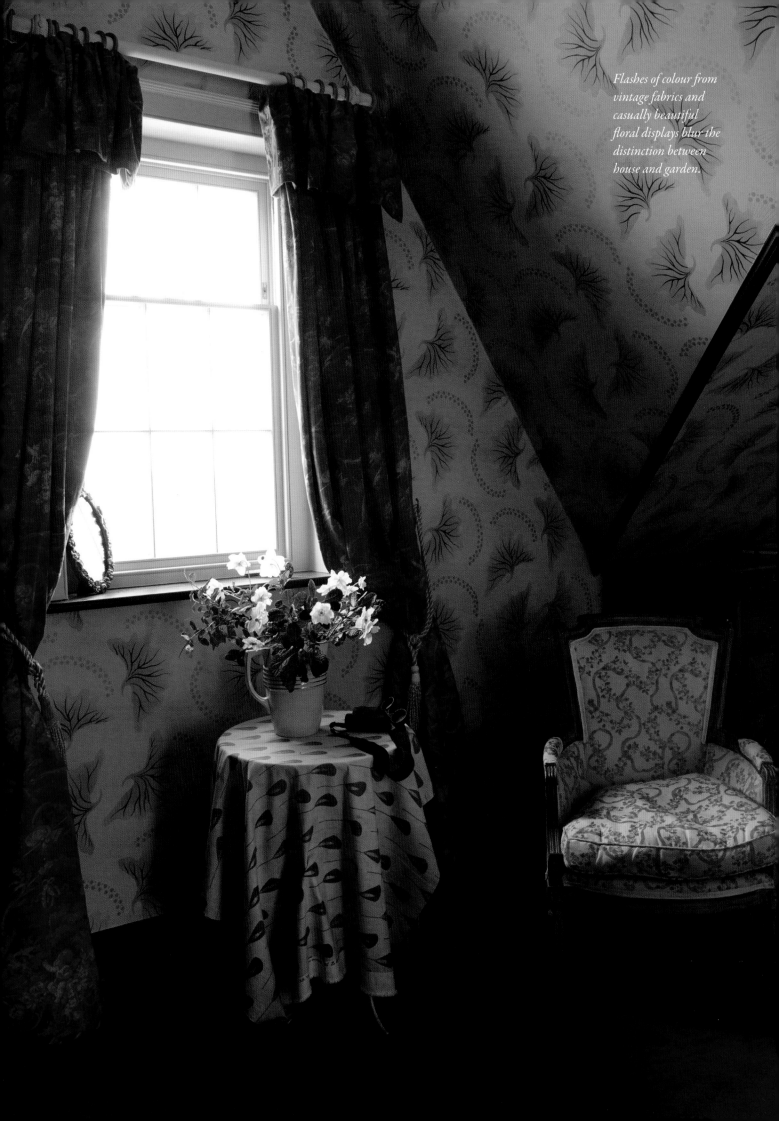

Flashes of colour from vintage fabrics and casually beautiful floral displays blur the distinction between house and garden.

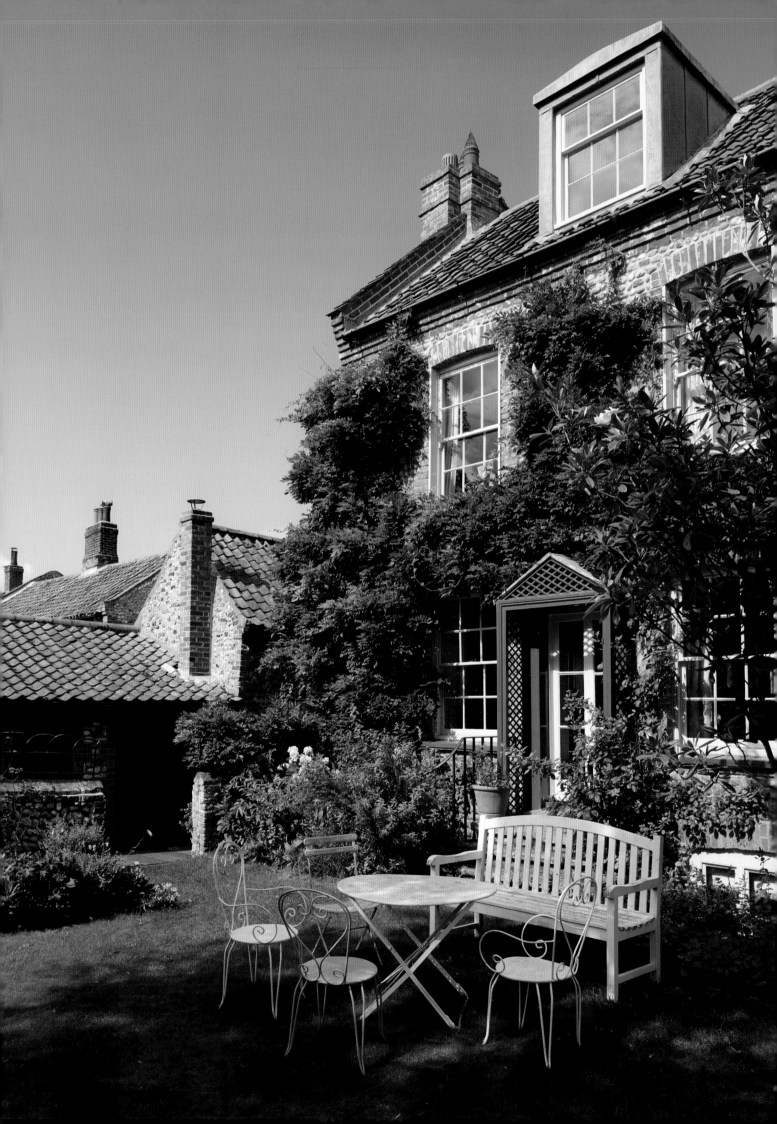

She examines the colours of the changing sky and incorporates them into her paintings of local life. Her home, she says, is never finished because personal needs have changed over the years.

building materials in Ireland, she loaded a truck, uprooted the rose bushes and a singular, delicious peony tree and hightailed it back to Norfolk – driving the truck herself!

The house is a mixture of sea-captain eclecticism (from a former owner) and genteel femininity. From the north, it looks out over the somewhat bleak but beautiful marshes that stretch to the North Sea, and from the south, the garden meanders from formal to wilderness, encompassing a unique view of an old windmill that sits alone to the east.

Raffaella explains how the diversity in this landscape keeps her anchored to the county she has inhabited since she was three years old. From her window, while she writes, she is distracted by the gargantuan cargo ships that pass on the horizon en route to Rotterdam, and by the ever-changing colours of the sea lavender and grasses of the marshlands. These views have inspired many of her novels. Her characters evolve out of this landscape, soft and salty, their emotions shaped by the tides and the driving wind; but always grounded, anchored to this outpost of England.

There is a continental flavour to the house that flows through various passages and opens into beautiful rooms adorned with Raff's own paintings. From the bathroom, a view of the garden from a Juliette balcony is charmingly reminiscent of a colonial scene in perhaps the Himalayas or a Sri Lankan garden.

Raffaella has recycled curtains from the car boot sales of stately Norfolk homes. She never looks at magazines for inspiration, but spends any free time wandering art galleries and absorbing the colours and shapes of her favourite painters. She collects tiles from Cornish family holidays and uses them to mosaic bathroom walls. She examines the colours of the changing sky and incorporates them into her paintings of local life. Her home, she says, is never finished because personal needs have changed over the years and she loves to blur the boundaries between garden and interior. She hunts the Broadwick Street market in London (where she has an apartment) for interesting fabrics. 'It is the painter in me that makes me want my home to be colourful. I might find some vintage fabric and then I will need, say, a blue vase, and then I will tie it up with a memory of people that have passed through my life. I love collecting things from artist friends.'

She is inspired by the Bloomsbury Group and Charleston House, as so many true Bohemians are, but Raffaella has inherited her father's licence to be a free spirit and her mother's talent as a prolific writer and journalist. Scribe Royalty, no less! Her kitchen authentically denotes her occupation. Notes and pens randomly decorate work surfaces, hastily half-eaten breakfasts remain like still lives on the table – abandoned for a sudden inspiration to garden or attend to a sick hen. Random vases containing sudden bursts at wild flower arranging sit on window sills – a distraction she succumbed to while searching for the disabled hen. And her favourite dahlias host a mini flower display in a burst of orange happiness.

Upstairs William Morris wallpapers have been untouched since the Rathcavan days, vintage dresses hang on Chinese screens. Her lurcher, Havoc, follows her around the house, occasionally sniffing out a lost toy, while the pug dallies in shadowy corners with an expression of acute chagrin aimed directly at the lurcher.

All is well in this menagerie. There is nothing that would suggest otherwise. She is slightly disgruntled because she is waiting for some chandeliers to arrive and perhaps she is a little disturbed by the chaotic state of her daughter's bedroom. But a passion for change motivates Raffaella and her attention often flutters beyond her windows to the north … waiting for a gift from the marshes and the empty grey sea.

'I am quite itinerant in my soul, but because this landscape is always changing I never have to leave.'

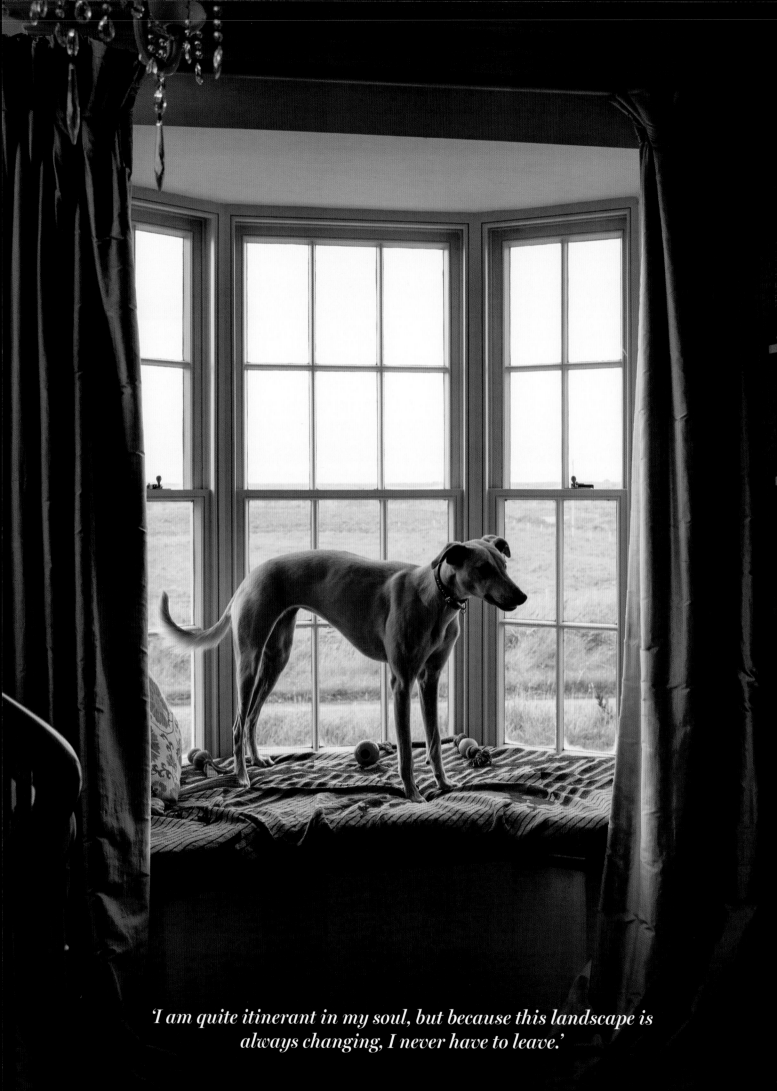

'I am quite itinerant in my soul, but because this landscape is always changing, I never have to leave.'

*A throne and a good
book – always a
perfect combination.*

George Barker - To My Mother

Most near, most dear, most loved and most far,
Under the window where I often found her
Sitting as huge as Asia, seismic with laughter,
Gin and chicken helpless in her Irish hand,
Irresistible as Rabelais, but most tender for
The lame dogs and hurt birds that surround her —
She is a procession no one can follow after
But be like a little dog following a brass band.

She will not glance up at the bomber, or condescend
To drop her gin and scuttle to a cellar,
But lean on the mahogany table like a mountain
Whom only faith can move, and so I send
O all my faith, and all my love to tell her
That she will move from mourning into morning.

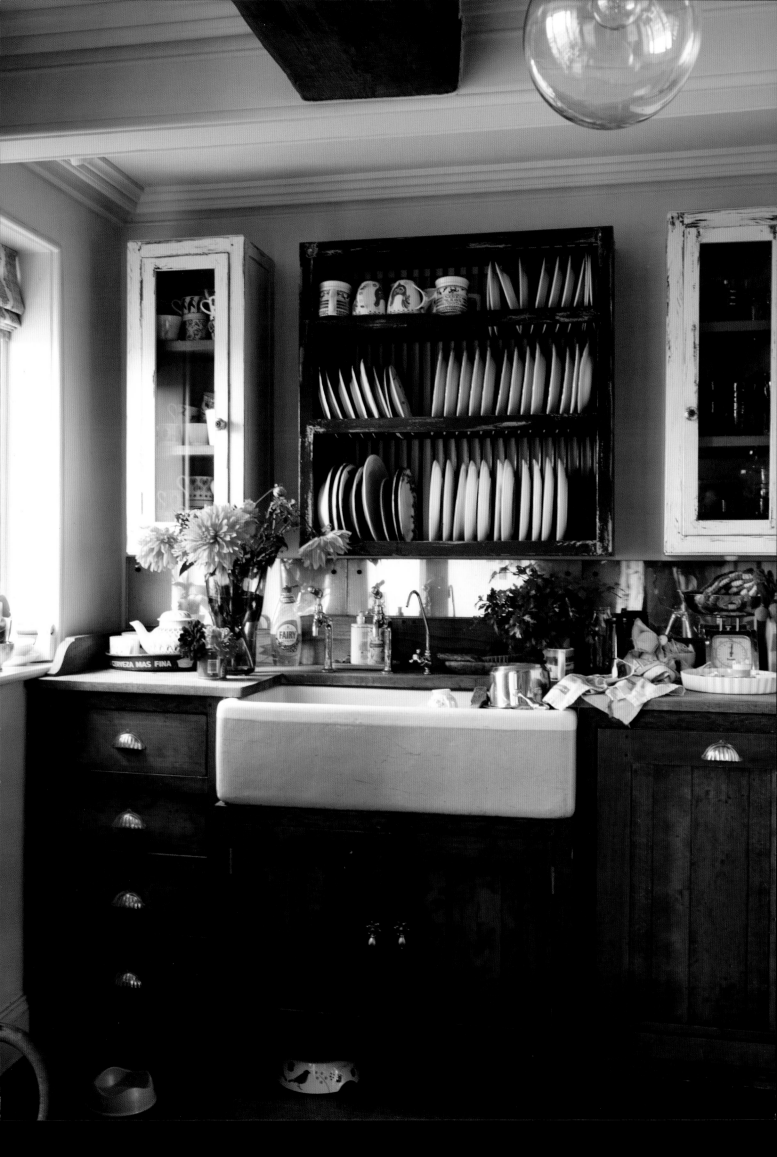

SIMON FINCH

Antiquarian Book Dealer / Curator / Publisher / Traveller

THE DAY I VISITED SIMON FINCH HE SEEMED A LITTLE DISTRACTED BY THE TRULY cataclysmic events that have been shaping his life over the past decade. He is clearly a man who has lived a full life and largely on his own terms. In literary circles, he is considered one of the top antiquarian book dealers in the world, a reputation that has been earned through his indisputable talent for having 'a nose for a book'. He bought his first rare book when he was twelve years old and by the time he was seventeen, he was running for the big boys and earning a substantially higher salary than the average 1970s teenager.

In 1983, Simon started his own business in Fulham's Hollywood Road, and went on to open several other shops in the West End and Notting Hill. The film of that name was loosely based around his loveable, discombobulated character.

In 1998, Simon decided he might become a country gent and made a perfunctory decision to follow up some house details he had picked up from a friend's coffee table. An inveterate traveller and self-confessed urban beach bum, he set off with his young son, Jack, and his dog for the three-hour journey that would take him to Norfolk and finally to a location south-west of Cromer. There he found Voewood, the magnificently eccentric Arts and Crafts manor house that immediately arrested him with the dart to the heart. Simon was struck by the proportions of the house, its complex brick work and the potential in the sunken, walled garden.

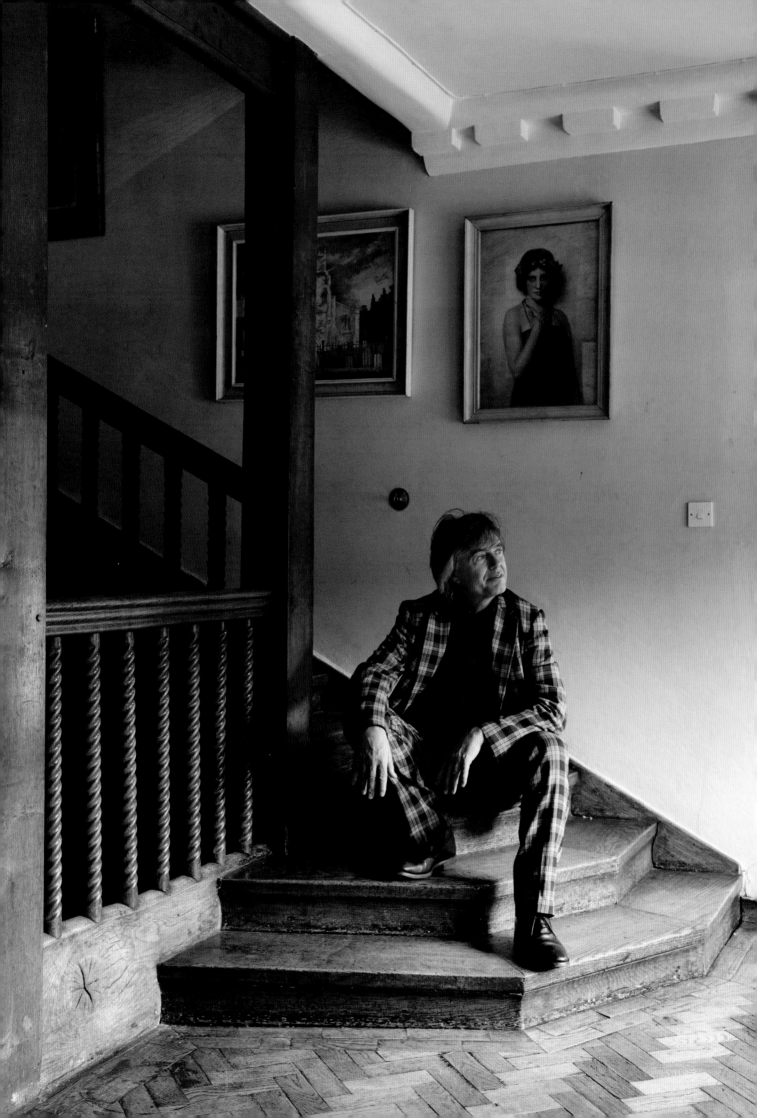

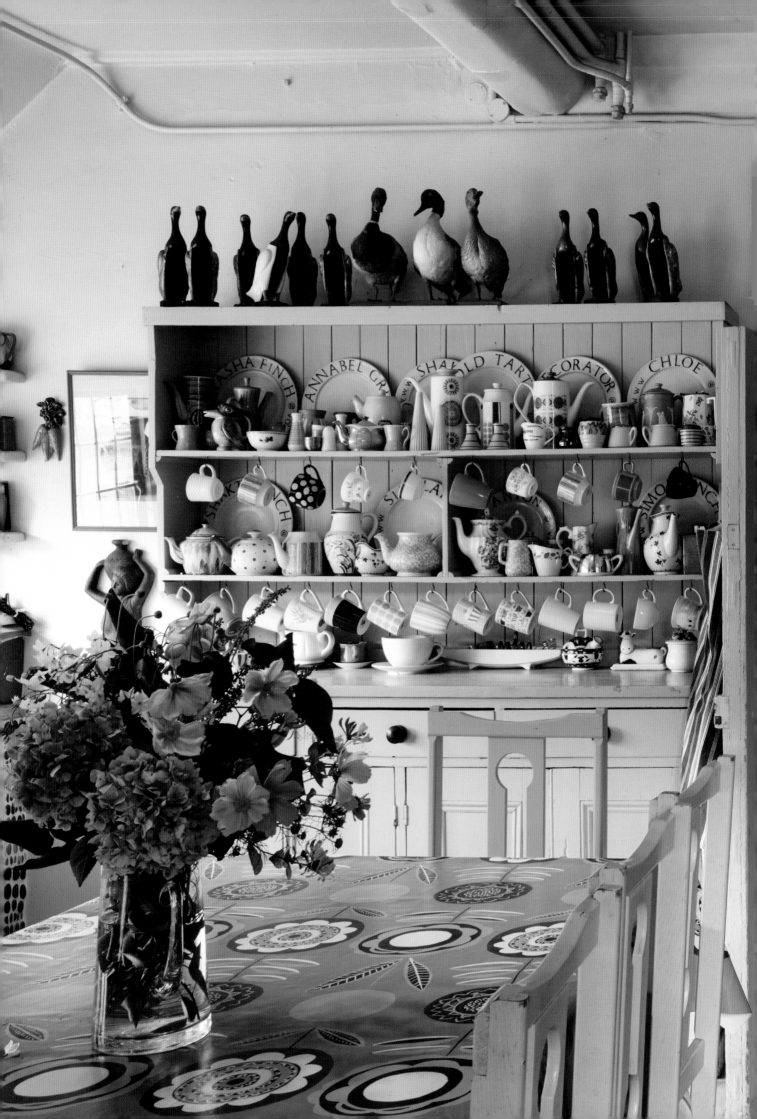

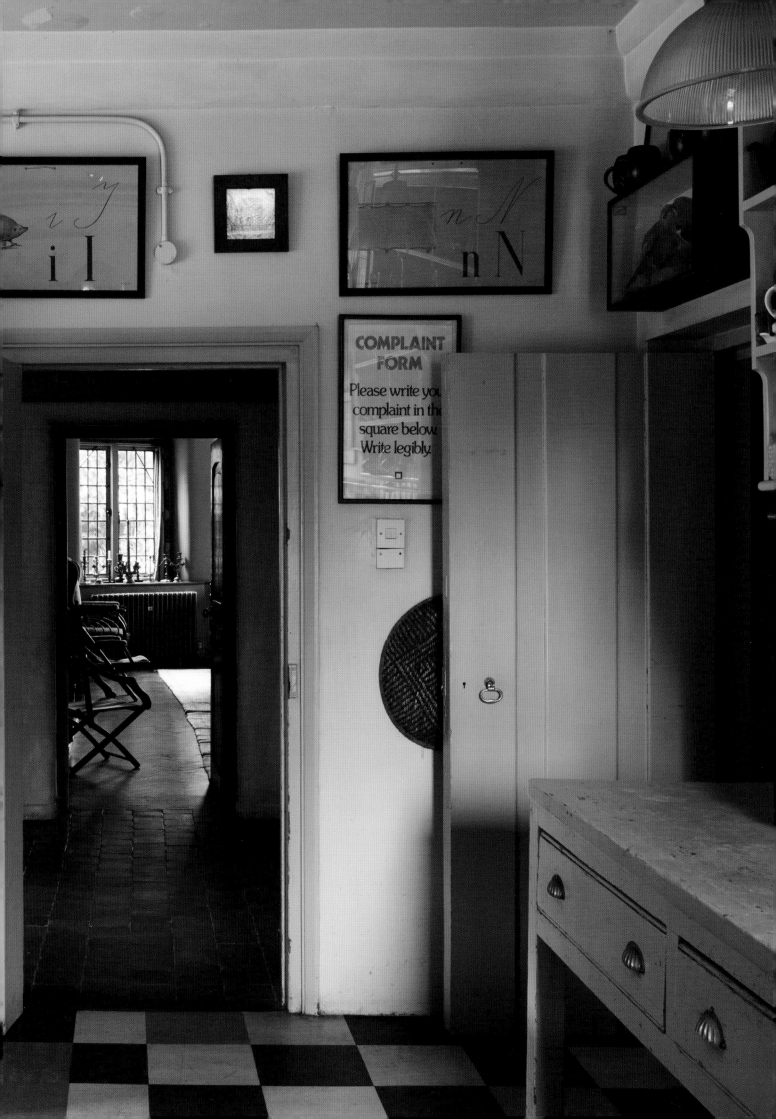

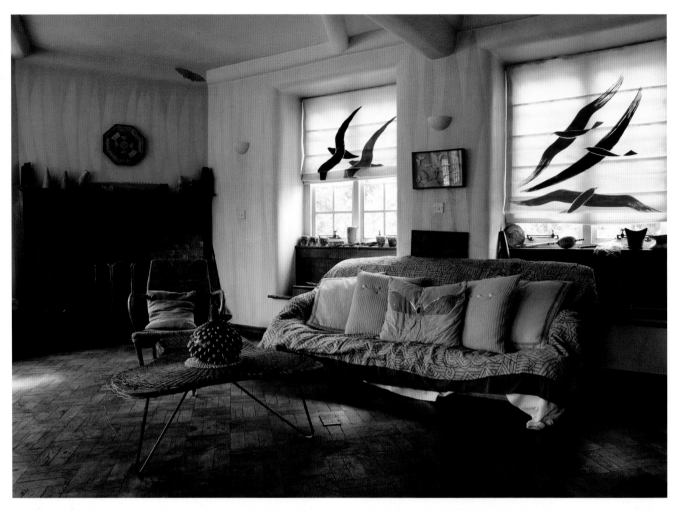

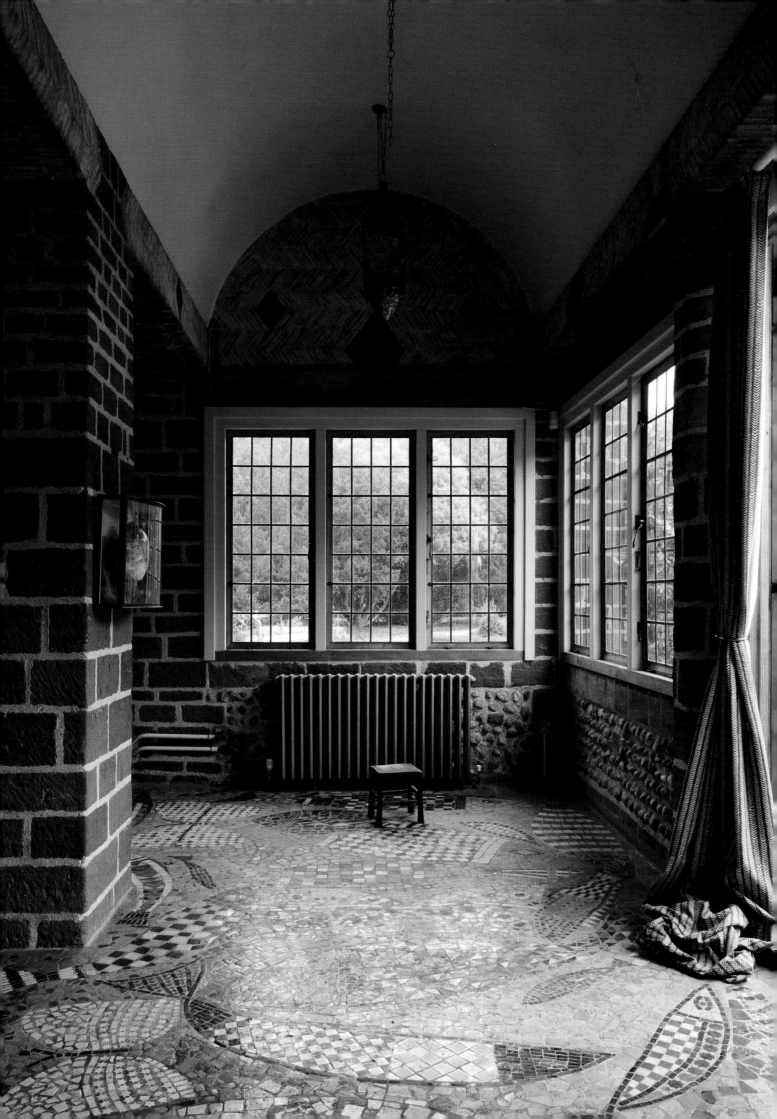

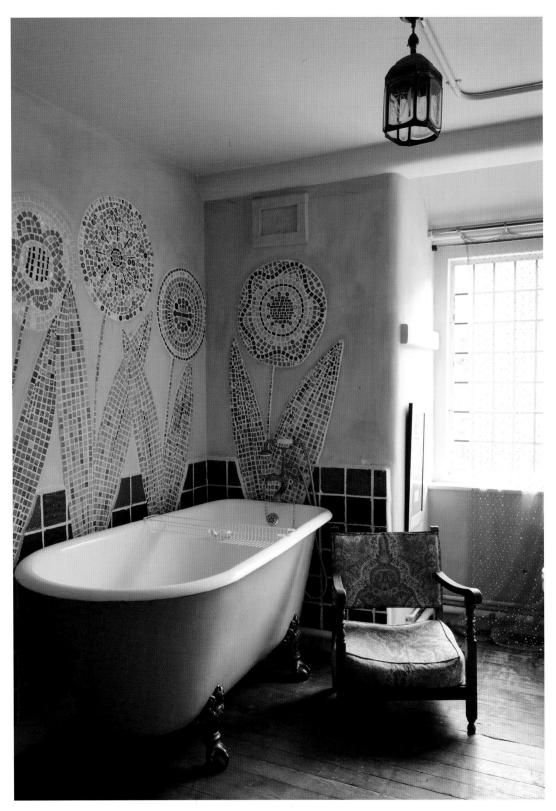

The light streams into the rooms from several directions thanks to the fabulously eccentric design created by the 'butterfly' plan on which it was built, with two splayed wings, one on each side of the main building. Mosaics by Annabel Grey and artwork and artefacts from friends and creatives whose work Simon admires fill the space.

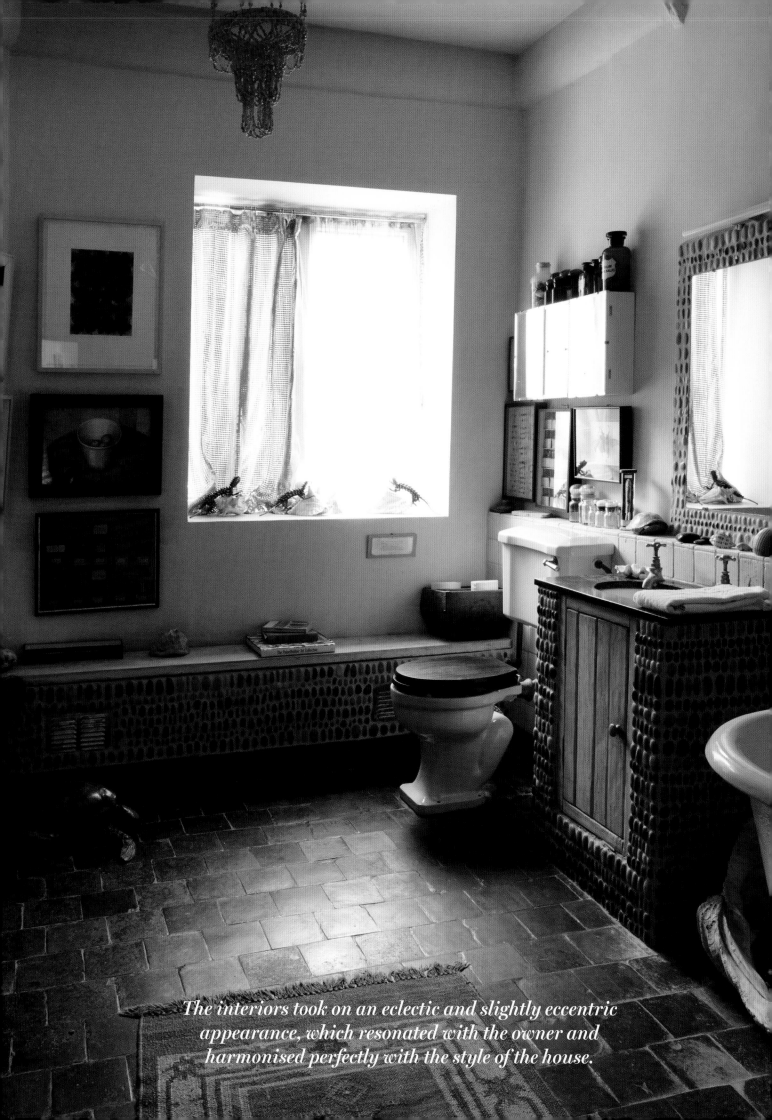

The interiors took on an eclectic and slightly eccentric appearance, which resonated with the owner and harmonised perfectly with the style of the house.

Previously a boys' private school and later a sanatorium, it would require a humungous effort to eradicate the institutional atmosphere and restore it to a condition suitable for family, friends, artists, intellectuals, vagabonds and curious stickybeaks.

True to his modus operandi, Simon decided to 'wing it' and made haste to the local agent to place a deposit – jumping in the car with Jack and forgetting the puppy entirely. 'I paid significantly less for the house than I have been known to pay for a rare book.' Returning to the house, he discovered the puppy obediently waiting by the front door so he took this as an auspicious sign that it was all part of a divine plan. 'I had no idea of how I was going to live in this house at all!'

Back in London he resumed the life of the itinerant book dealer, club owner, publisher (he had more wings than his newly acquired country seat), crossing the planet on the quest for love ... and rare books, but returning to Norfolk late on Friday nights with furniture and Art he had stored in various disseminated properties around Europe. Using his 'wing it' theory, he employed the talents of artist friends and associates and gave them carte blanche to decorate a room of their choice while being as true to the actual period of the house as possible. As a result the interiors took on an eclectic and slightly eccentric appearance, which resonated with the owner and harmonised perfectly with the style of the house. Job done and mission achieved.

Except there was more. In the summer of 2011, Simon – in collaboration with festival curator Clare Conville – hosted the first ever Norfolk literary festival at Voewood. Turning the house and gardens into a spectacular three-day event attracting a serious crowd eager to participate in the masterclasses from authors such as Louis de Bernières and the Bohemian literati. This summer event would last for three more years while the Voewood vessel gathered momentum as a nucleus for mindful practices such as yoga, meditation and marriages.

Meanwhile Simon, as the captain of this ship with a whole fleet of other industries in tow, ran metaphorically aground by way of the pirate vessel (Unscrupulous Bank). 'I am not a business man. I follow my passions: books, art and music. I tend to spread myself too thin.'

This ruthless sabotage resulted in the closing of his numerous book shops and ultimately a period of collapsed sails and still waters. Simon did what all men do when they have run aground. He retreated to his shed. Simon's shed is a modest annexe attached to the main house. Perhaps we could call it the casualty wing, but more appropriately it might be named the comfort zone, the think tank or the nest. For at these moments – when life rains fire and brimstone and one is exposed to the bare bones of self-examination – what does a man of words do, but make a nest and take up the pen. This is how I find him, his stationary Harley hugging the annexe wall, his head churning with possibilities for his new plans for Voewood as a country club; his pen releasing small anecdotes of promising memoirs to his Facebook page, like the day he picked up a hitchhiker on the M4 and discovered him to be London gangster Charlie Kray, back from his ten-year ''oliday' in Parkhurst prison! Or his meeting with rock legend Patti Smith the morning after 9/11. But his first love is undoubtedly the dedication to his home, which has been a most reliable and resourceful mistress, and the solidity behind his relationship with his son.

'Now we are focusing all the energy at Voewood. It is an astonishing structure of the Arts and Crafts period, literally rising from the turnip field it was built on. The fortune that built the house was made by the paper mill owner and publisher Edward Lloyd. (One of his most profitable lines was pirating editions of Dickens.) When I bought it in 1998 it had been in institutional use all its life; I was lucky to happen on it. It represents everything that I would like to express in my career, and I know that its full blossoming is yet to come; it is a powerful creature and will guide us on the way. It has hosted some wonderful arts festivals as well as films, retreats, weddings, house parties and shenanigans of all kinds. We will deal in books and art from here and feel our way towards the next right thing. It is difficult to balance business and ideals but in the end there is only one thing to express. One love.'

WENDY WHITELEY

Artist / Gardener / Muse

TO SAY WENDY WHITELEY'S LIFE HAS BEEN A HELTER-SKELTER RIDE IS SOMEWHAT of an understatement, and perhaps it is some small coincidence that she lives almost next door to Sydney's Luna Park overlooking the harbour at Milsons Point on Sydney's North Shore. The iconic laughing face that forms the entrance to the fun fair is modestly upstaged by the mystery and loveliness of Wendy Whiteley's Secret Garden; located just a short walk around the corner in Lavender Bay. The garden, created over two decades to Wendy's vision, was originally a disused railway sidling – a rusting dump of land bordering her beautiful bay. A challenge indeed, requiring more than the average green finger!

But it wasn't on a whim, armed with trug and trowel, that she stepped out one sunny morning to sow sweet peas. It was with the serious intent to deal with her demons, to feel grit under her nails, to heave away the past and take a swipe at fate, to stand alone in grief and to harness despair as a force to create beauty from a derelict site that was symbolic of her life. This and the memory of her favourite childhood book was her motivation.

Her late, the celebrated Australian painter Brett Whiteley, died of a heroin overdose in 1992. They were separated at the time but their bond was Herculean. Wendy was his muse, his beacon and his anchor. The passion they shared for art was equal to their mutual love for adventure, which included regular forays into the world of experimental drugs. Their daughter, Arkie, was born in November 1964 and during this decade

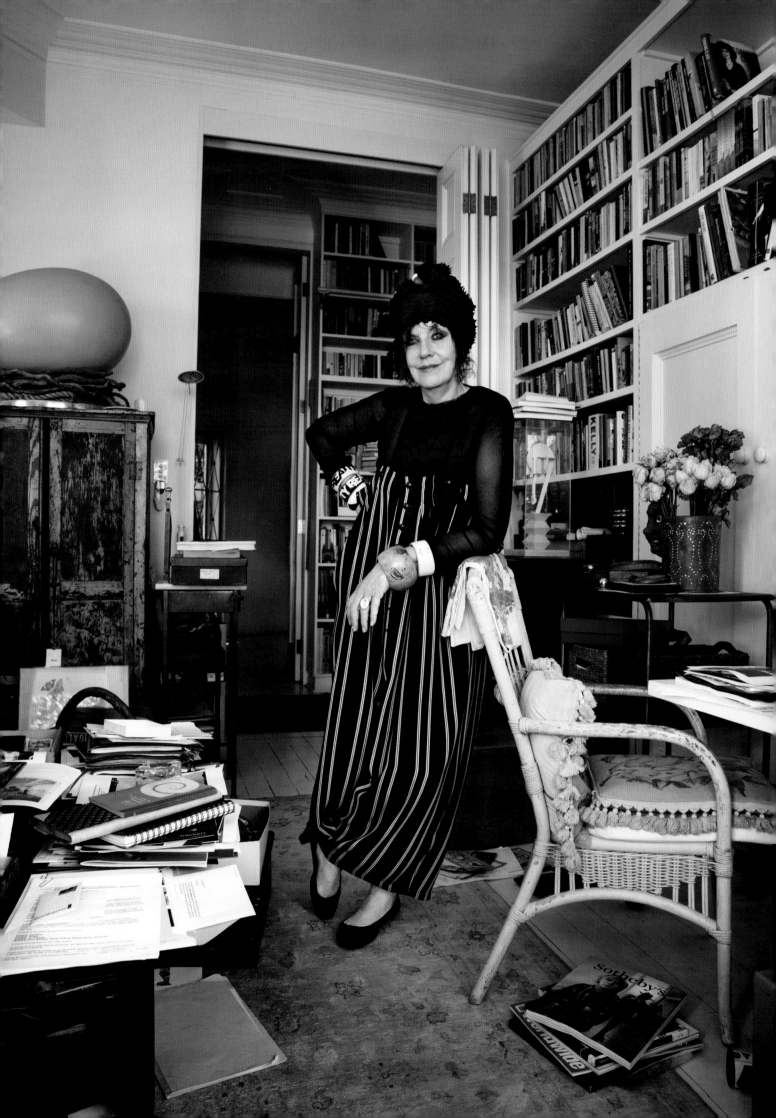

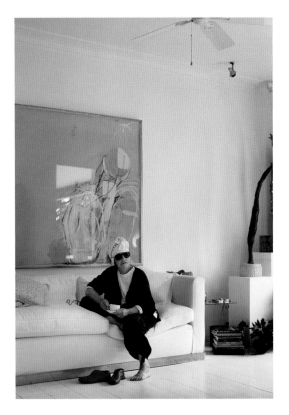

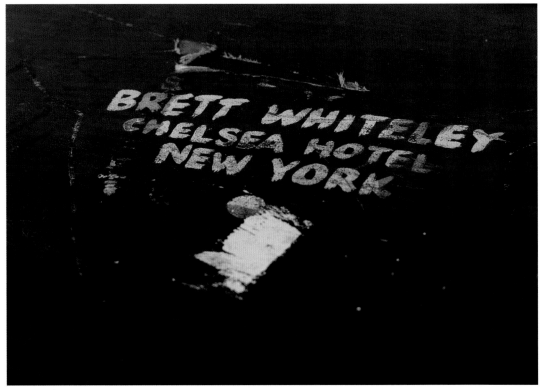

For a decade, Wendy and Brett travelled the world with their daughter, Arkie, and the home Wendy now occupies alone is filled with artefacts they collected over that time. It might be an Indonesian lion or aa Ching dynasty plate but they belong in the space along with striking works by her late husband, who died of a heroin overdose in 1992.

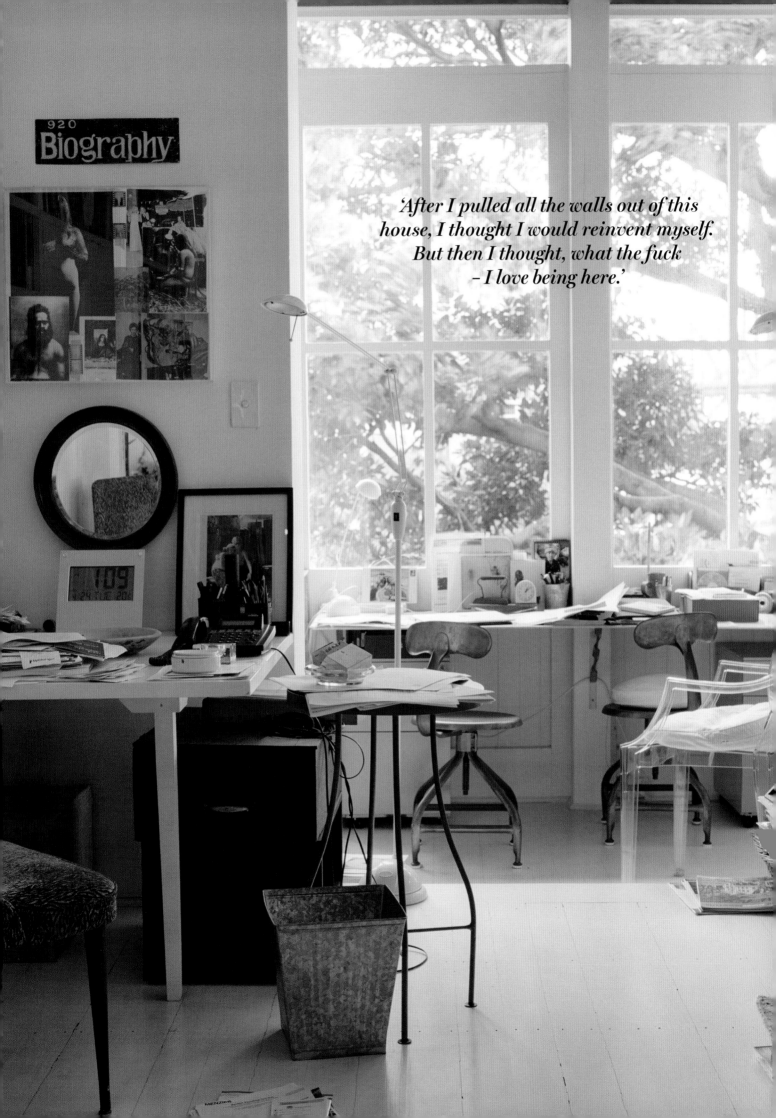

'After I pulled all the walls out of this house, I thought I would reinvent myself. But then I thought, what the fuck – I love being here.'

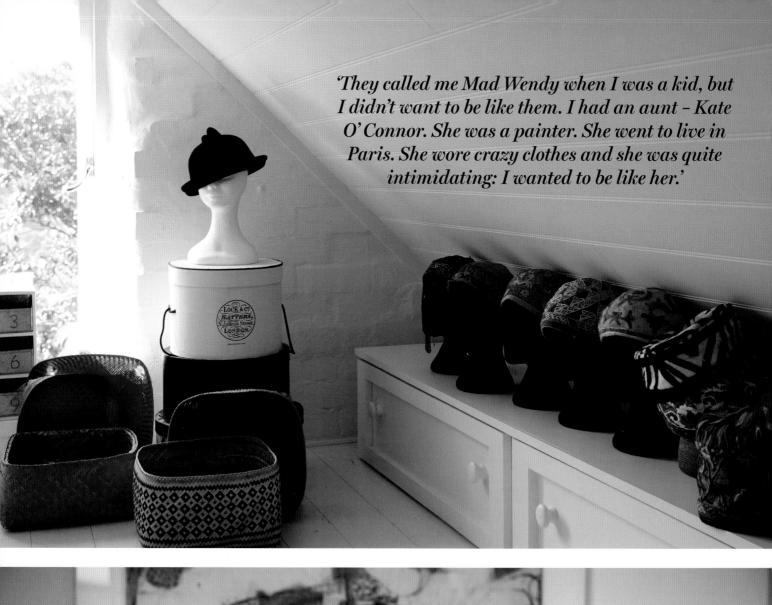

'They called me Mad Wendy when I was a kid, but I didn't want to be like them. I had an aunt – Kate O'Connor. She was a painter. She went to live in Paris. She wore crazy clothes and she was quite intimidating: I wanted to be like her.'

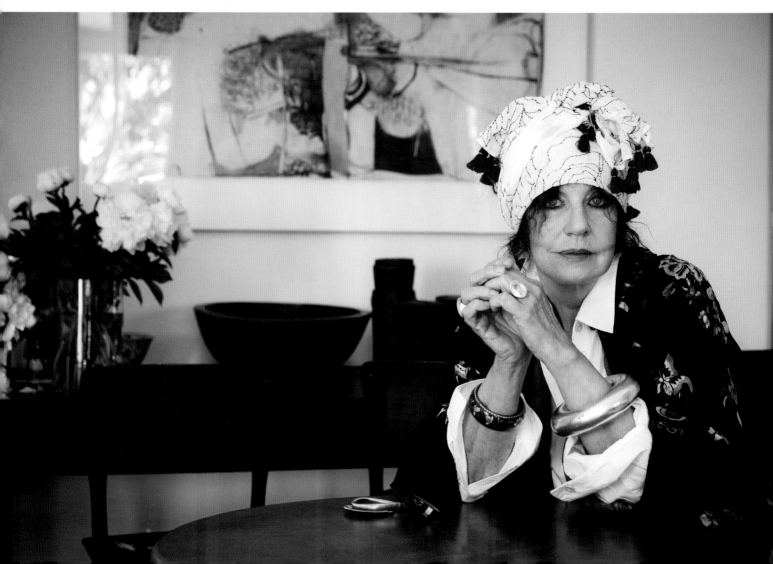

the three of them lived like vagabonds as Brett's intrepid brush strokes found new canvases in far-flung cities. Together they wanted to eat up the world. Like novelist Frieda Lawrence, they travelled light, with rugs, sarongs and bric-a-brac that spread a homely altar wherever they put down a tenacious root. They set up homes stretching from Notting Hill in London (where Arkie was born) to the penthouse at the Chelsea Hotel in New York and a hut in Fiji, where Brett got busted for possessing opium and the family had to flee back to Sydney.

Here they purchased the once ramshackle house that Wendy now inhabits alone. The house had been divided into two apartments and for a while they shared the building with a three-legged dog, a mad parrot, and the eccentric family that owned them. To this house they added a tower with a lift shaft that propelled them from basement studio to attic bedroom. They employed a loveable rogue builder to gut the entire building and put it back together very, very s-l-o-w-l-y and then Brett debunked to a studio in the city to paint while Wendy, frustrated by a lack of progress and an argumentative contractor, self-medicated with perhaps a little too many illegal substances and took to vacuuming 'dirty' leaves from her street at four in the morning.

With Brett living in the studio, Wendy found the resolve to unshackle herself from her 'black dog', complete the design of the house and build a stronger relationship with her actress daughter. But tragedy struck after the couple divorced in 1989, when Brett was found dead, alone in a distant motel room. During the endless legal battles over Brett's estate, Wendy kept a dignified distance and used this as the impetus to begin her garden.

Arkie eventually won her father's inheritance from a third-party claim, and set about turning his studio into a museum and cataloguing his work. But it had taken its toll, and in 2001, she was diagnosed with adrenal cancer and died three months later on 17 December, having experienced what short-lived happiness she could find in marrying the man she loved and passing the care and curatorship of her father's gallery onto her mother.

Wendy explains her relationship with her home: 'The garden, the studio, friendships, somebody's life, are all those things that keep you going. I don't feel any great urge to actually paint again. I want to just go and be the mad old bag lady in the garden. I love the fact that Arkie participated in it a bit and loved it. Sometimes I suddenly realise I'm talking about her or Brett as though they're still alive. And in a way they still are. And then you realise that they're not there anymore, except in your memory. Or in your bones. In Arkie's case, she'll always be there. And in Brett's case, he'll always be there in part of me.'

From where she sits now in her white world, doe-eyed and turbaned, the scent of her favourite lilies permeating a humid Sydney afternoon, it is hard to believe that her life has been anything but orderly. The walls of her rooms are adorned with artefacts collected over the family's nomadic period through Africa and India in the sixties and seventies. Her shelves are labelled and her accessories co-ordinated and decoratively hung amidst striking works by her late husband, Ching dynasty plates and Ethiopian masks. A carved Indonesian lion languishes in a corner of the living room, unearthed from a ditch in Bali with the help of a team of road workers. Her life now revolves around continuing work and events in the garden along with her supervision of the Brett Whiteley Studio Museum in Surrey Hills, Sydney.

Who knew that Wendy's ultimate gift to her city would become a public sanctuary for peace and contemplation and a final resting place for the ashes of the two people that she loved most in the world?

Her house and garden exude the inexplicable essence of her huge spirit and her will to survive against all odds. A true Bohemian, unconcerned for her place in a changing society, she carries her own fearless flame – behind which her vulnerability is apparent in the sympathetic union she has created between nature and Art. To walk through this enchanted space is food for the soul, connecting us to the spirit of the family. One leaves a little braver, a little closer to the possibility of triumph over adversity, a little more hopeful for humankind.

'One day I shall be under a tree there myself,' she laughs. You guess which tree! 'I think I've got a good eye, and I think I've spent my entire life training it. It's a visual head, mine. I've been training my eye for a long time, looking at museums and things. With Brett, that was our life. To learn to see was the only thing that I learned at art school that's of any use to me whatsoever, apart from how to mix paint, which took about five minutes.'

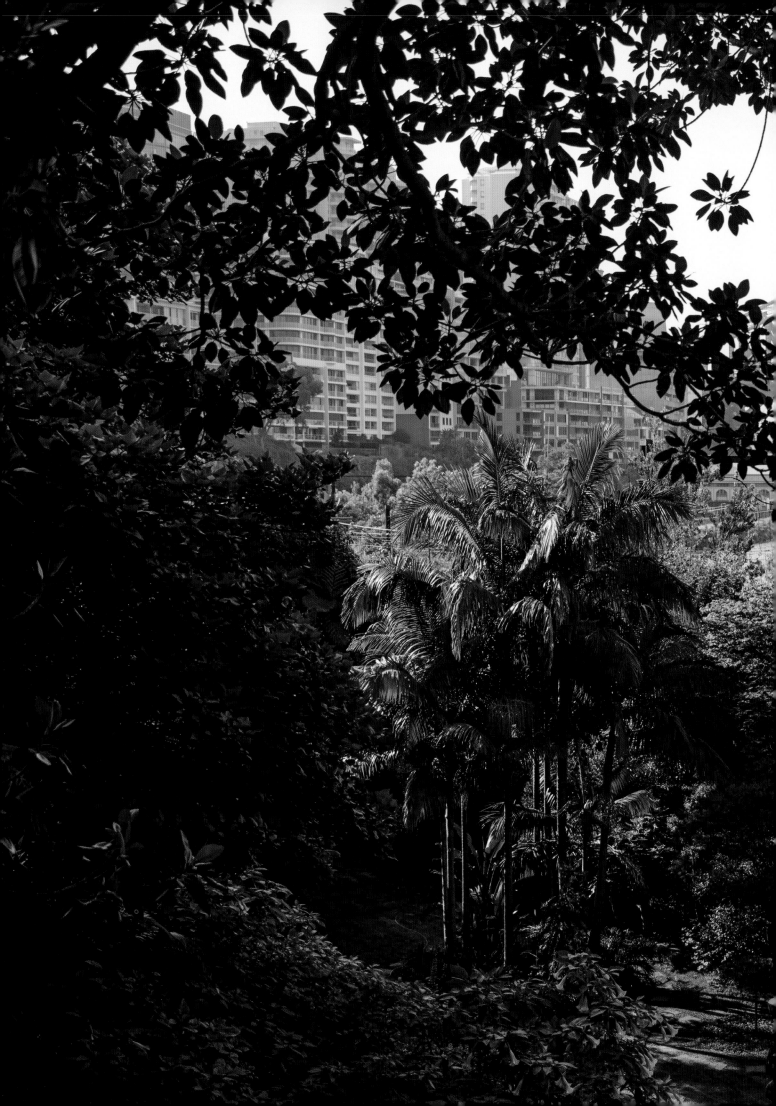

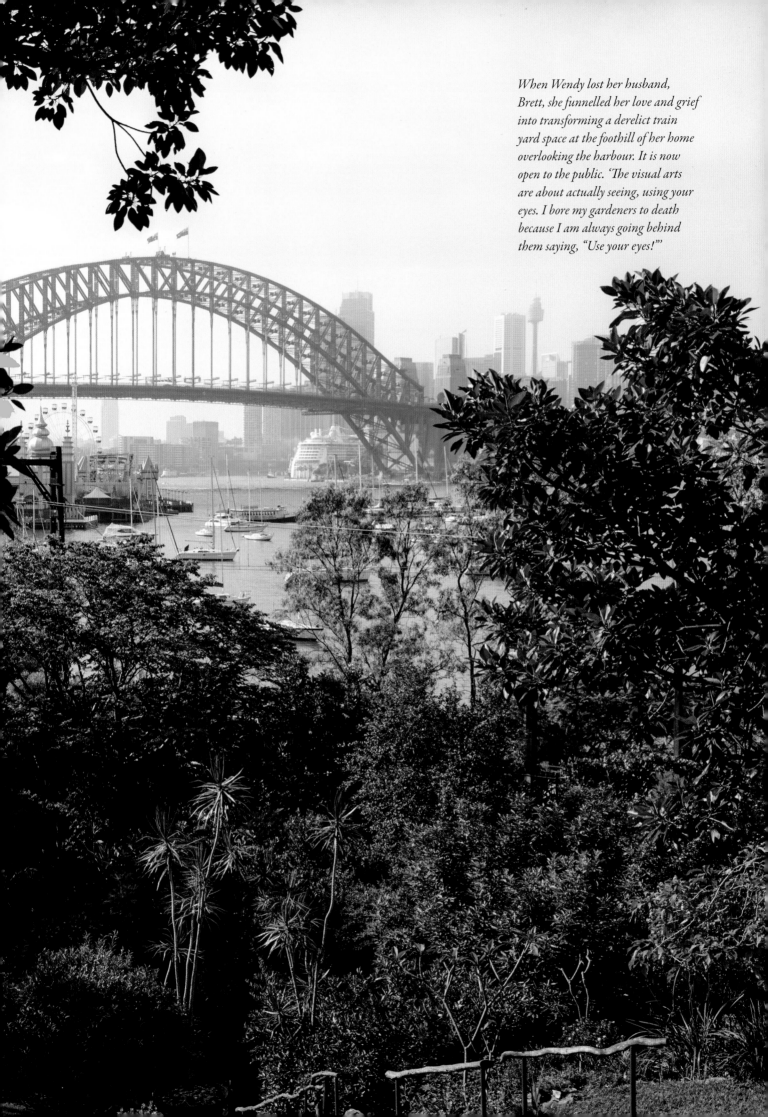

When Wendy lost her husband, Brett, she funnelled her love and grief into transforming a derelict train yard space at the foothill of her home overlooking the harbour. It is now open to the public. 'The visual arts are about actually seeing, using your eyes. I bore my gardeners to death because I am always going behind them saying, "Use your eyes!"'

GRIFFIN DUNNE

Writer / Producer / Director / Actor

THE ETIOLATED CROWN FROM THE DUNNE DYNASTY THAT SITS AT A PRECARIOUSLY jaunty angle on Griffin Dunne's head does not begin to reveal the lustre expected from such an infinitely rakish heirloom. But look beyond the burden of inheritance into a pair of intensely sparkling eyes and a face that expresses an amused yet wearisome take on life, and you will see the genuine sparkle of the Dunne legacy.

Griffin is enjoying this time. As well he may – for life in the Dunne family has not been the joy-ride we expect to be due to Hollywood families. Growing up in Los Angeles in a well-appointed home where his father, the charismatic novelist and producer Dominick Dunne, held nightly soirées for the famous and infamous of Hollywood royalty, it's not hard to imagine a small boy and his siblings hiding at the top of the stairs, waiting for the moment when they'd be summoned for a walk-on part. 'He was the Art Director of our lives.'

And they would all have to play their respective parts. In October 1982 Griffin's sister, Dominique, was tragically murdered by her ex-boyfriend. An unfair trial and the dismissal of important evidence resulted in the defendant receiving a shockingly lenient sentence. At the time, the LA courts were thoroughly misogynist and soaked in celebrity culture. Dunne, driven by pain and fury, seized the baton for revenge and used his position as a correspondent for *Vanity Fair* to tell of the injustice served on his family, with devastating effect. But from that point, both parents became important voices for victims' rights, something Griffin is extremely proud of.

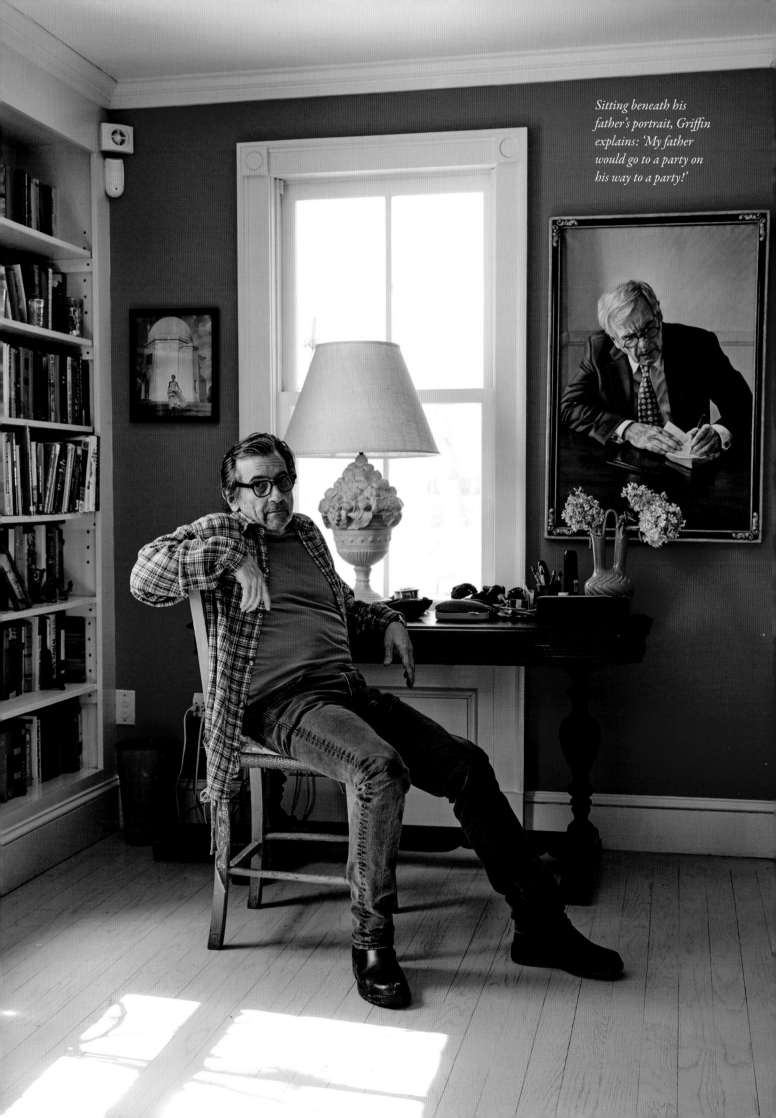

First editions are always something to treasure, especially when they sit with other treasured objects.

A New Yorker with a passion for the city and a love of fresh air and open spaces, Griffin is not lonely, although alone on the farm, where he sprinkles subtle touches of his wry New York humour. He declares that he will never sell the farm and can see his daughter, Hannah, raising children there one day.

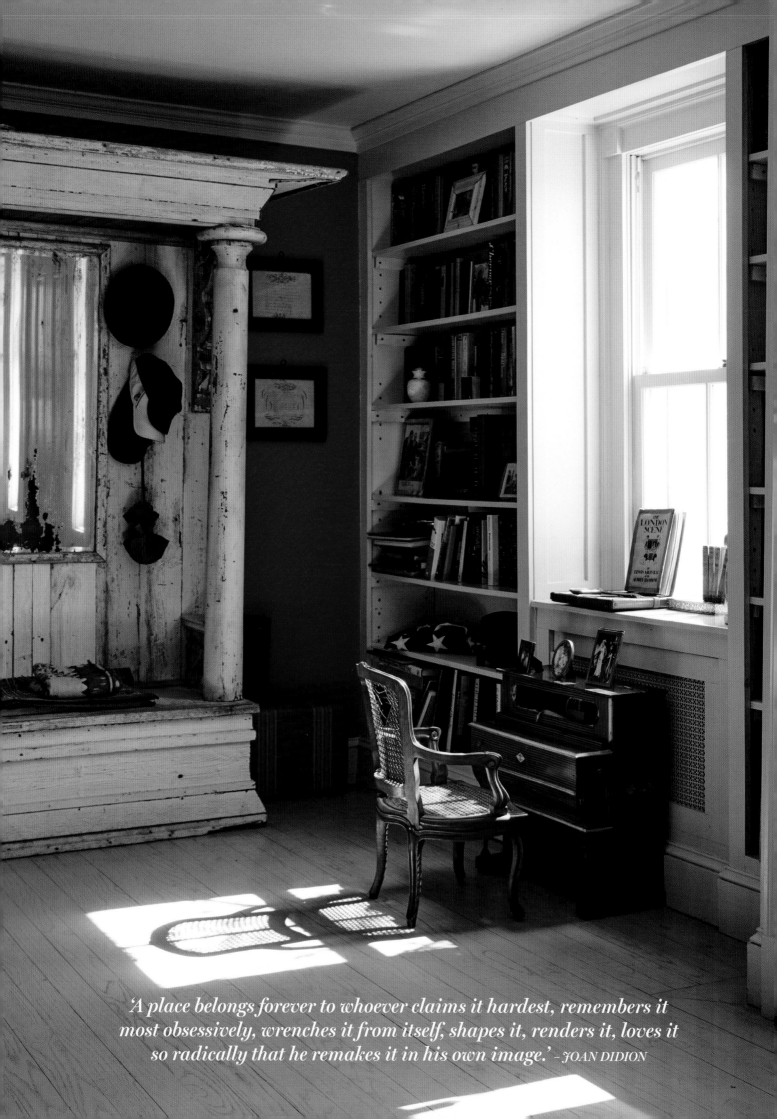

'A place belongs forever to whoever claims it hardest, remembers it most obsessively, wrenches it from itself, shapes it, renders it, loves it so radically that he remakes it in his own image.' – *JOAN DIDION*

Griffin refers to his early home life as a 'house of secrets'. 'My father was deeply in the closet for thirty years.' His parents divorced when he was ten and Griffin became the carer for his two siblings. He refers to this time as the 'Lord of the Flies' period. His beautiful, half-Mexican mother, Ellen (or Lenny, as she was known), was a huge influence on his early life, creating an artistic and vibrant atmosphere around the home. But she was to become seriously ill with MS after the divorce and really at this point the family was blown apart.

These days, with gained wisdom, Griffin feels more for the Irish in his blood and has become acutely aware of the trap in repeating patterns of nurture. 'I have gone in the opposite direction as a father. I am wilfully transparent with my daughter Hannah. I am studying Chekov now and I realise that we are either fighting with, or succumbing to our parents on a daily basis and when they are gone, they are even more in our lives.'

Hannah was eight when Griffin moved to this farm in Rhinebeck, with his childhood friend, film producer Charlie Wessler and the dog from Charlie's film *There's Something about Mary*. Charlie lived in Cameron Diaz's trailer for eight years before he built a house. Between them they collected a menagerie of animals, from donkeys to ostriches, with another dog, Lucy, who was to become Griffin's best friend. 'Hannah had her eighteenth birthday here but she forgot to invite anyone, so at the last minute, Anna, my ex-wife, worked the phone and acquired tents, ribbons, balloons, and so on, while Hannah put the word out ... The lawn was littered with bodies in the morning. Even today, I run into adult kids who tell me of the night they passed out on my lawn!'

Griffin explains he has always been impulsively lucky with real estate, but similar impulsive decisions involving marriage have not been so successful and today he lives on his farm alone, except for Charlie with whom he suppers once or twice a week. As a New Yorker, his habitude has been peripatetic between his work in the city and his love of the great outdoors. He once moved to the Hamptons with his first wife, but quickly discovered he was having to greet the people he crossed the road to avoid in NYC! So one day when he was called out of a meeting by his friend, writer Scott Spencer, to view a farm for sale in upstate NYC, he didn't waste any time. Sitting in a worn Adirondack garden chair overlooking the luminescent pond, Griffin went into a trance-like state and with quivering voice declared: 'I can see Hannah raising her children here. This is home! This is forever!' Scott, considering things may be moving too quickly, replied, 'Hey man, you know you can get these chairs anywhere!'

He says he has never been lonely here. Down on his luck and snowed-in with money worries, he spent an entire winter at the farm on his own. 'Lucy was with me; she kept me going night and day.' (A moment's pause absorbs the melancholy, as Griffin remembers his loyal companion who has only recently collected her wings.) He has plans for the property, but they are long term. As a writer, it suits him to sit at his desk, overlooking the barn, and dream about how he could fix up the interior one day. But the reality is, the workmen would disturb his equilibrium and he thinks it pretty perfect the way it is now. 'This is my forever home. I feel more for this than anywhere I have ever lived. It is about the people in my life – some of them gone. I feel I have peaked with this. I will never sell it. It has been the best decision I have ever made and my friends will confirm that.'

For the moment, though, Griffin is starring in Jill Soloway's Amazon TV series *I Love Dick* with Kevin Bacon and Kathryn Haun. Among other projects he is co-producing, he also finds the time to direct a documentary on the life of his iconic aunt, Joan Didion. Based around her early career as a journalist, and later her book *The Year of Magical Thinking*, the filming progresses, is due for imminent release and is a further poignant and personal window into a family blessed with creative genius coupled with more than their fair share of pain.

At the farm, a portrait of Lenny, painted in 1959, sits high in her place at the head of the table, hands on her hips as if impatiently waiting for dinner to be over, that she may jump off her stool and involve her family in an Irish jig. There are spaces in this home that do seem to be waiting to be filled with something: the next dance; the next chapter; the next puppy; the next project; the next summer and the next time Hannah walks through the door, dumps her bag in the hall and shouts: 'Hey Dad, I'm home!'

'Every day in my life I watch over Hannah. It is a rite of passage for every girl to have a bad boyfriend.'

SALLY CAMPBELL

Textile Designer / Traveller

SHE APPEARS AS A SCARLET BEACON OF FIERY TENACITY. STRONG WILLED, A STRIKING appearance, quick-witted with lightning retort. She thinks on her feet and with those provisional roots in Sydney's sandy soil, she can be here and gone, like a summer bush fire. It might take her only ten minutes to pack a suitcase, ten more to get to the airport and WHOOSH! she is on her way, the minutes counting down until her cerebral reservoir is replenished via the desert sands of Gujarat and Rajasthan in India.

1971: Like an Antipodean Dick Turpin, Sally arrived in London in the early seventies and high-jacked her future for the next six years by scouring the Paris flea markets for bargains and pitching a stall at the flyover on the Portobello Road. Moving in with avant-garde artist Andrew Logan, she opened a shop in Chelsea's iconic Antiquarius, selling art deco lamps and decorative, fifties high kitsch. Under the same roof, British rosebuds Edina Ronay and Pattie Boyd, were establishing careers in vintage fashion. Did she even stop for lunch? It is doubtful. It was the early seventies, the rock 'n' roll era. The King's Road was thumping on her doorstep and while we were humming the chorus to 'Grocer Jack', the Aussies had sneaked in and announced themselves like a flock of black cockatoos. Innovative, determined, outrageous, opinionated and oh so refreshingly un-English!

2015: Sitting in her garden where her partner – documentary film-maker, Greg – had laid the table. Sally remembered the day that Ringo and Maureen Starr wafted into her Antiquarius shop dressed in Gohill boots

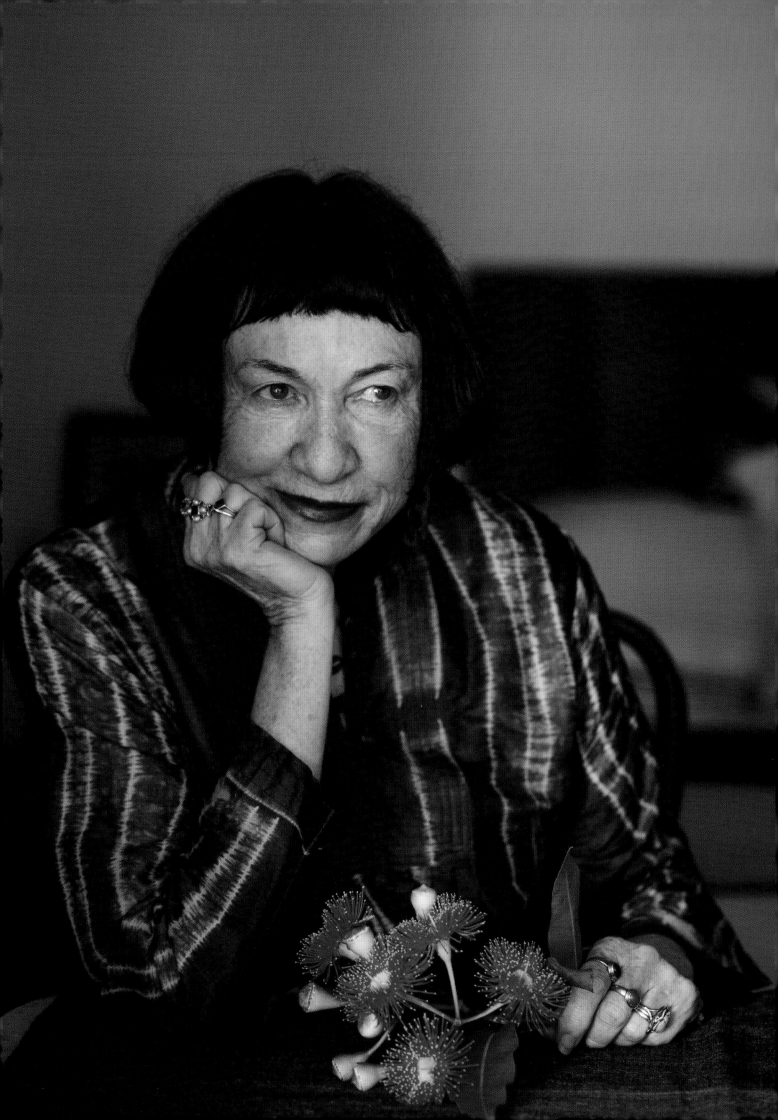

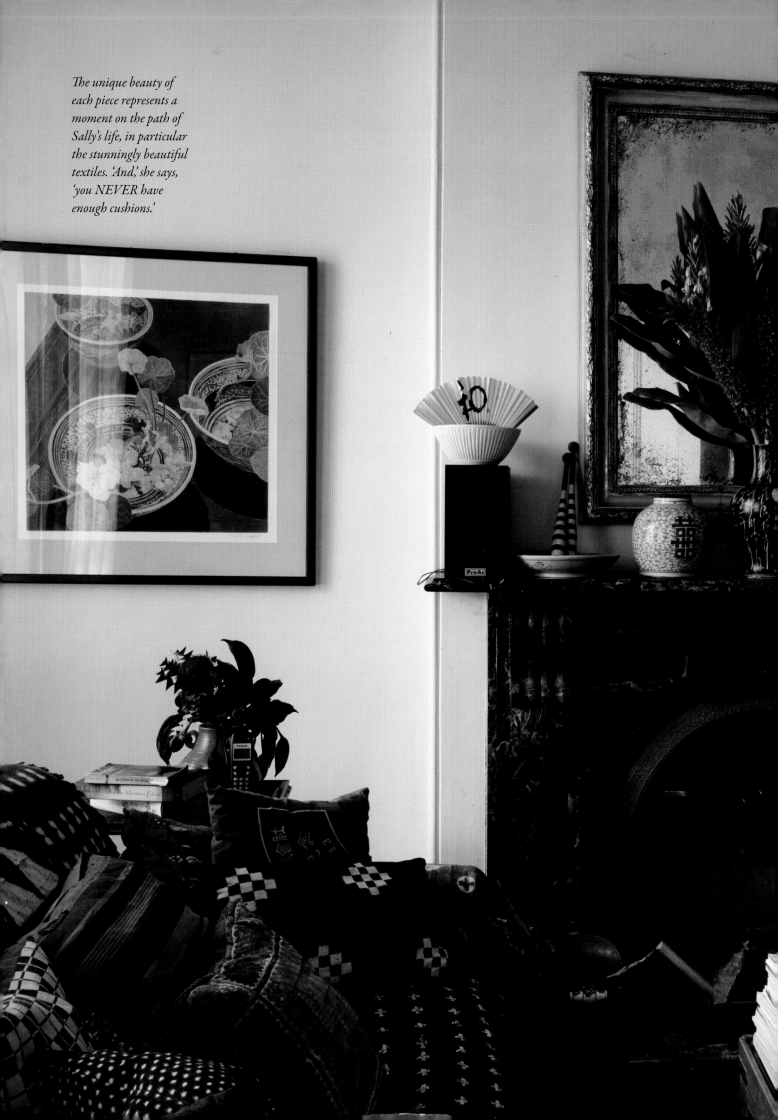

*The unique beauty of
each piece represents a
moment on the path of
Sally's life, in particular
the stunningly beautiful
textiles. 'And,' she says,
'you NEVER have
enough cushions.'*

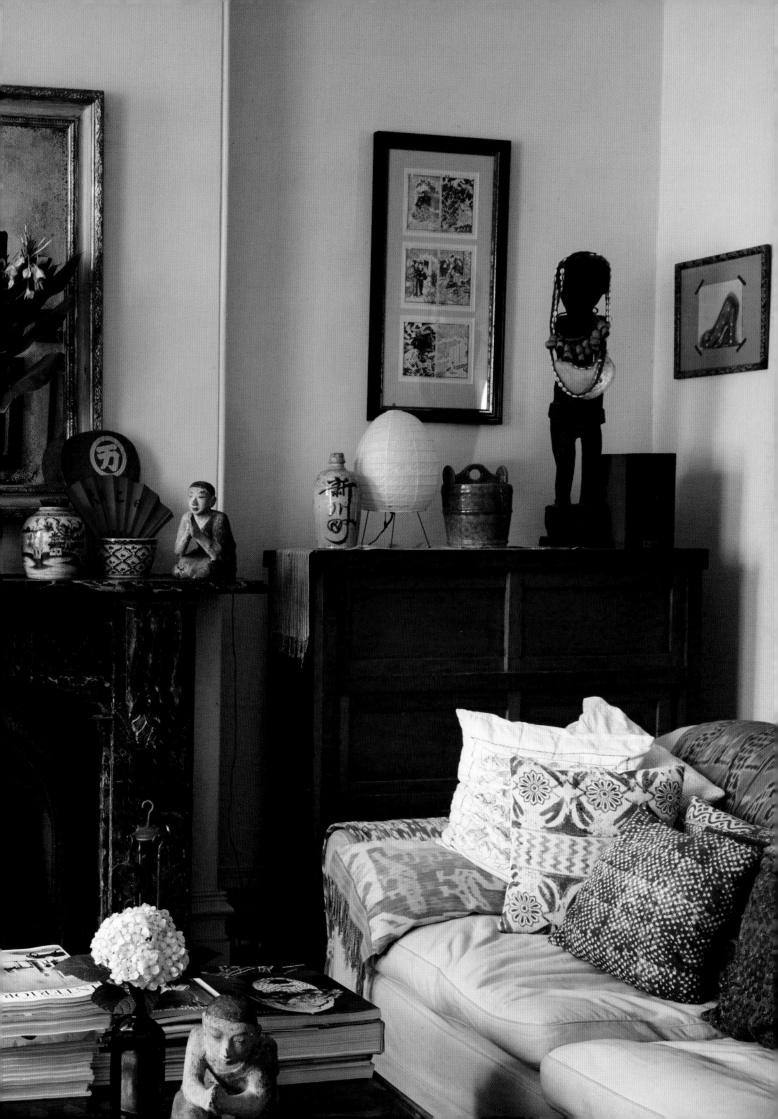

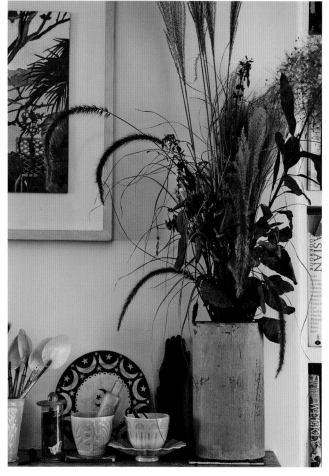

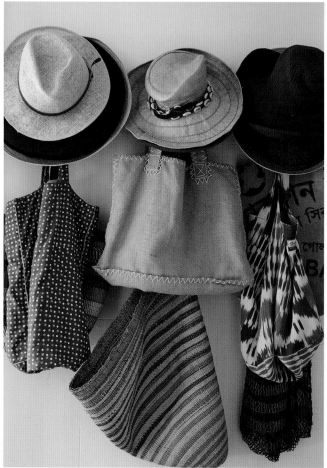

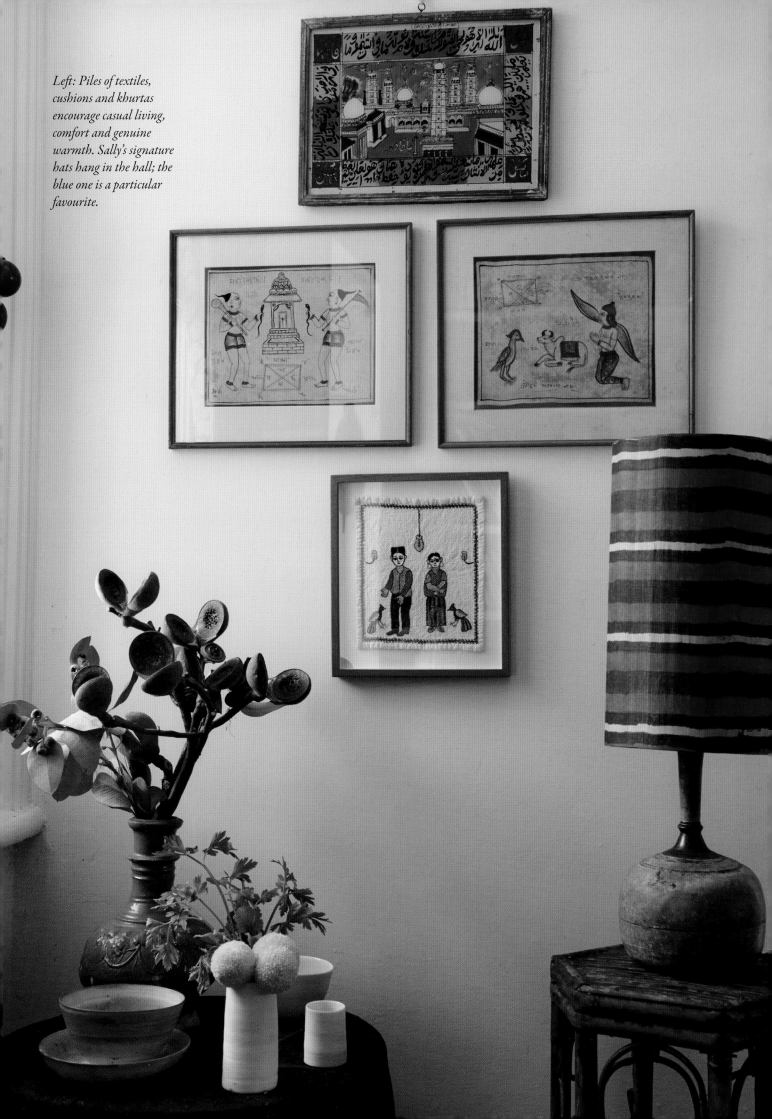

Left: Piles of textiles, cushions and khurtas encourage casual living, comfort and genuine warmth. Sally's signature hats hang in the hall; the blue one is a particular favourite.

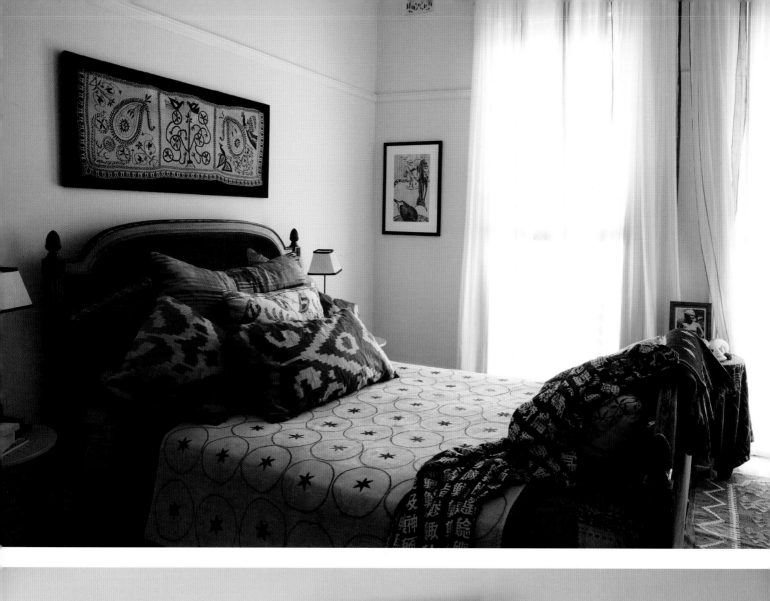
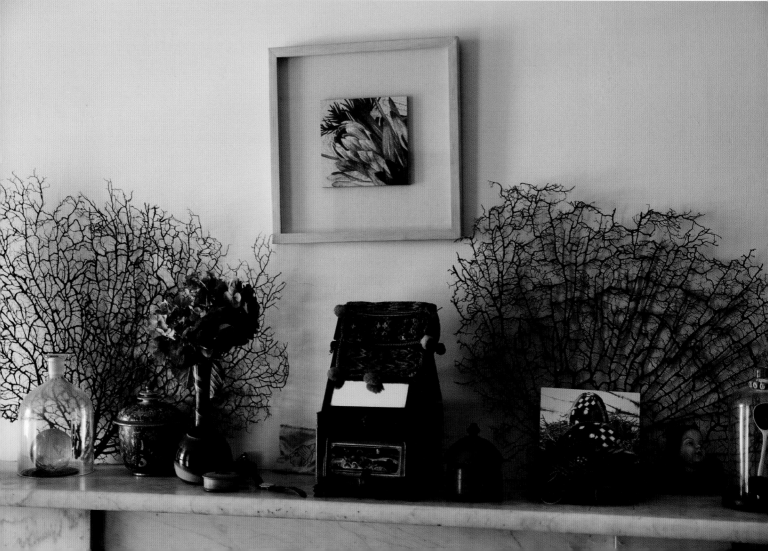

'Give me fever! Red in bed. Always an inspiration, toss and turn to a stormy riot of richly textured rubies, crimsons and scarlets. All hand-stitched and hand-woven into the dowry of your dreams.'

and Granny Takes a Trip suits, from the iconic King's Road tailor. Happily high on acid and with royalties rattling in their velvety pockets, they bought her entire stock.

In the next breath she and Greg explained how, as novice traders, they designed their first collection of textiles out of India, and waited in the Mumbai heat while their delivery wallah made umpteen diversions to celebrate Holy Ganesh (the Elephant God of good business) festivals in every single tiny village between Jaipur and Mumbai. What should have been a twenty-four-hour journey turned into a ten-day wait on the dock!

By 2015, Sally had been trading out of India for nigh on eleven years and 'Even now you can't guarantee anything turning out how you planned it.' Like the red planet, Mars, there are untapped pockets of mysterious territory within Sally Campbell. There are volcanoes, valleys, deserts. Conversation dips into cool canyons of calm, then out comes a story told with such passion, then fury, and always ending with the funny side up!

1980s: After six years trading in London, the loose roots syndrome returned and Sally headed home for Sydney. So what next? 'I kind of fell into everything I did.'

She met Greg on the sets she was decorating for Vincent Ward's film *The Navigator*. They fell in love but were barely able to consummate their affair due to the whole film being on night shoots. During the days, Sally was running around and burying herself in old barns and run-down pubs looking for props and locations.

'It was before the Americans came. There were no prop houses. You just had to find it, so you went out west!'

1990s: By the time she was production designer for the Wim Wenders' film *Until the End of the World*, she pretty much knew where to find anything, from a fifties petrol pump to a stuffed ostrich! The film was a trilogy which took three years to make, under intense pressure. One couldn't afford to be late with anything – it simply cost too much money – and there was no language for 'that's impossible!'. With that kind of pressure, even the strongest spirit can crumble, and disaster struck when Sally was diagnosed with throat cancer in the late nineties. So again the desert beckoned! This time it was India.

Armed with her sketches, some samples, her dreams and a determination to beat a sketchy prognosis, she and her rock-steady man began a new adventure in textile design and were probably the originators of the very first conceptual 'pop-up' shop in Australia. Her beautiful home is now filled with the last fifteen years of her endeavours. Piled high in her office – which Greg controls with a kind hand and a keen eye – is all her latest stock. Jewel colours from Rajasthan; cushions, throws, flowing khurtas, all designed by Sally and made by village artisans, nurtured every step of the way by a caring couple aware of keeping a sense of integrity in all that they do.

Her home, she says, has a thousand tales to tell and every single piece has a story behind it. There are many places to find solace in Sally's home. Beautiful niches, shady corners and all about are strewn her exotic textiles. And there are stories; her home reverberates with a thousand chattering village artisans in every beautiful adornment. The manner in which she arranges things is by no means contrived. Things can be gathered from walks along the seashore, through the bush or jungle. What is apparent is that her eye has considered the beauty and texture in each piece and, when placed all together, these choices give us a glimpse into the diversity of her life's journey. In turn, these experiences are woven into the richness of her uniquely beautiful textiles.

Sally is well now. Her home, like her career change, has given her peace, for now she fills it with passion, so it gives back to her with love. It will be there for every rover's return. But for now she is busy planning the next trip to India. We wait for where she 'pops up' next.

BRUCE GOOLD

Artist / Textile Designer / Fixer / Curator / Aussie Icon

EVERY YEAR IN DECEMBER, I DREAD THE MOMENT I LEAVE MY HOME IN FRANCE and prepare to take the twenty-six-hour flight to Australia. I know, when I get there, generally in a thousand ragged pieces, that after a week of idle decomposing, I will shed a rather spiteful and sickly European skin and begin to feel at one with nature and completely regenerated by the magnitude of the jovial Aussie spirit.

From our respective chrysalides of grey – damp and bleary-eyed – the Fishmonger and I emerge like pale grubs into our verdant paradise. Our European winter clothes are dispatched into a dark corner of the closet, and our tropical, summer pieces come roaring out of the old camphor chest at the bottom of the bed.

Among this collection are the vintage Bruce Goold Mambo shirts I gathered from retro shops over the eleven years we have spent together in Australia. Before that, I collected them in the eighties and nineties for TV commercials and films I was designing in Sydney. I kept as many as I could. These vintage shirts, with their uniquely Australian designs, embody the essence of this wonderful country. A man in a Mambo shirt is a man who is proud of his place in the puzzle of life. He makes a powerful statement to a geographic attachment, and so for me, Mikey in his Mambos claims our right to be here in this beautiful part of Australia that is Byron Bay.

In the hubbub of Palm Beach — an escapist peninsula on the furthest outreaches of the Sydney coastline – residents travel by inclinators to reach their houses, perched high above the beach. On an unusually flat, quiet

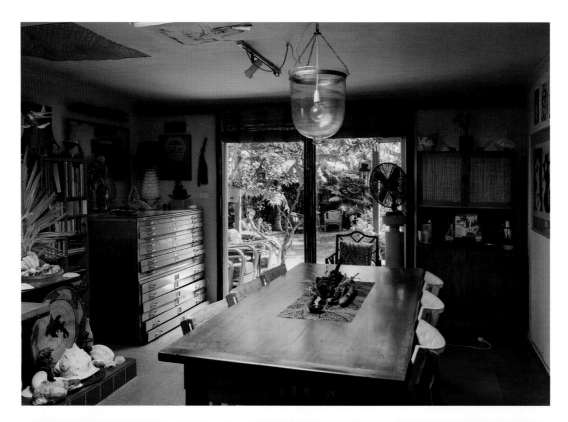

Uniquely Australian, light touches of Bruce Goold's tongue-in-cheek sense of humour can be found in his collages and creations. His Mambo shirts (right) are expressions of the Aussie spirit in textiles, and every creative should have one. They shout sunshine and individuality, intricacy never getting in the way of impact.

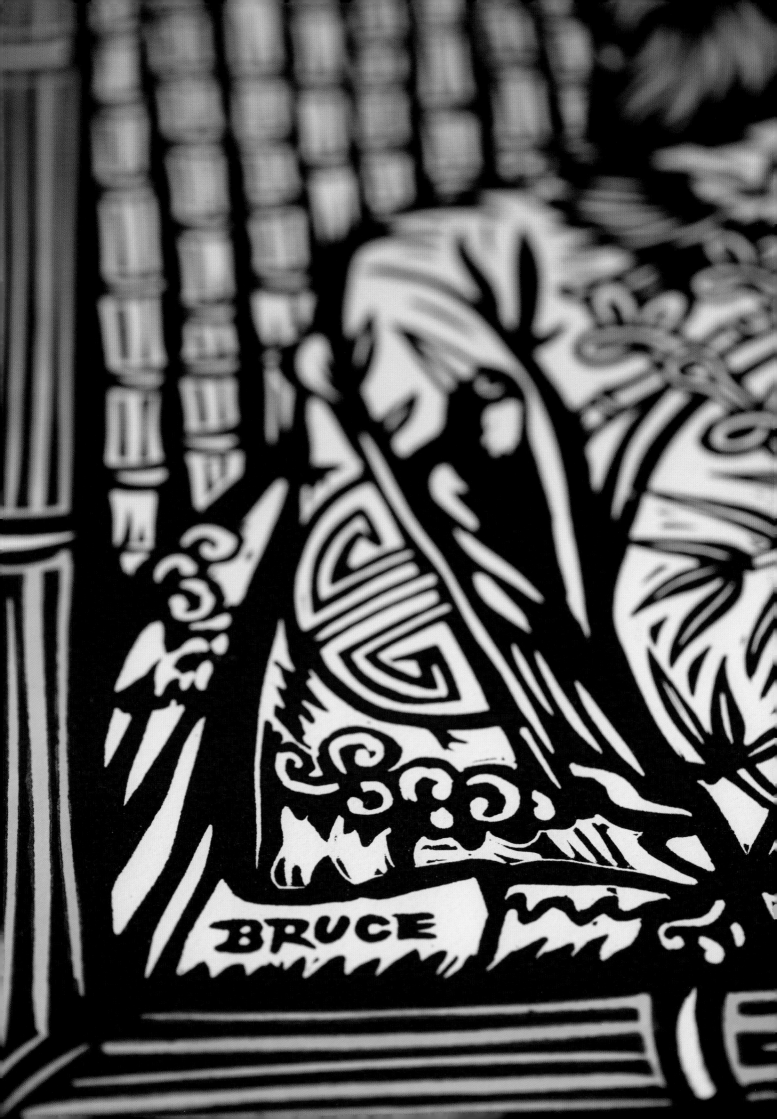

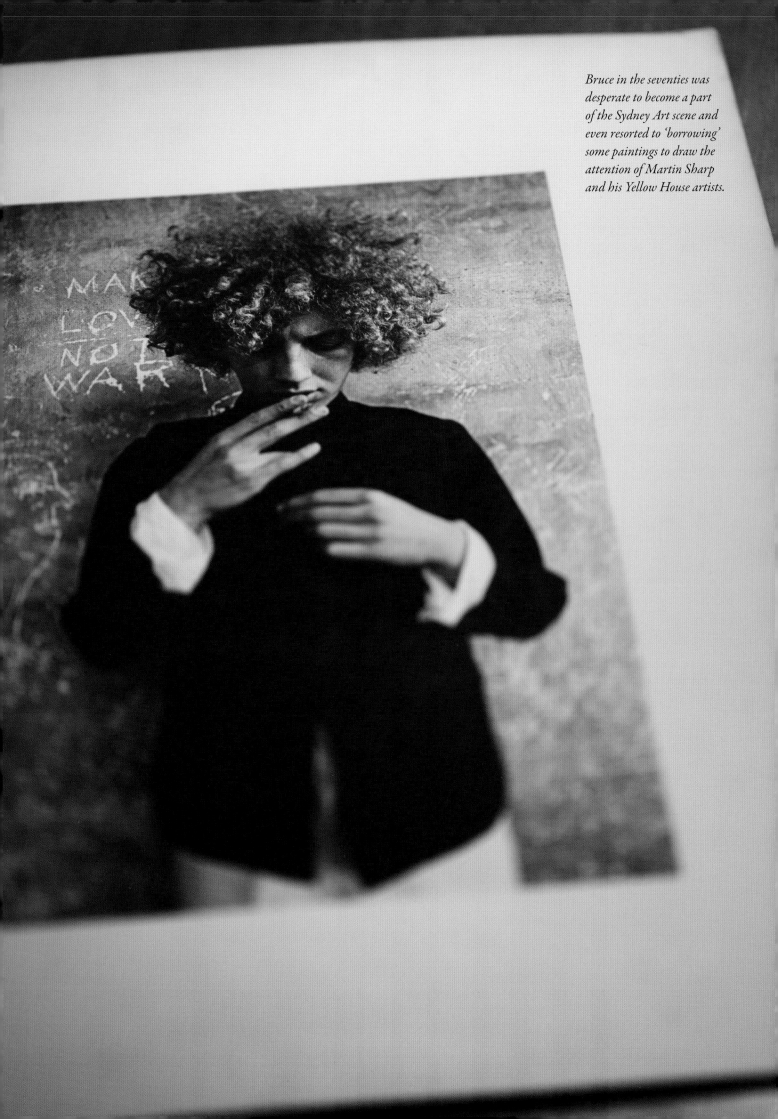

Bruce in the seventies was desperate to become a part of the Sydney Art scene and even resorted to 'borrowing' some paintings to draw the attention of Martin Sharp and his Yellow House artists.

lane of 'restored' weatherboards with perfect lawns and pale grey decking and sitting back from the road in a modest, but by no means apologetic, state of 'undoneupness' sits a little pink weatherboard with a brass plaque announcing 'Goold Interiors'. It is polished and proud and although the encroaching undergrowth threatens its heraldry, it is a shiny prelude to the treasures and extraordinary creativity of the incumbent within.

The son of a furniture designer/interior decorator and as adept with his paperhanging skills as with a paint brush, Bruce was a founding member of artist Martin Sharp's famous Yellow House. Sharp's idea was a 1970s homage to Vincent Van Gogh's unrealised dream, a living installation of multimedia artwork. A twenty-four-hour happening where rumours promised 'the wildest, most way-out wonders of the week'. It was a destination for lone taxis to deposit curious voyeurs and fellow artists like Bob Dylan and Allen Ginsberg in the wee hours of a Sydney morning. Every room of this establishment was individually decorated by its members, from Australian artist Brett Whiteley to film director Peter Weir. In the middle of this mélange was the seventeen-year-old Goold – beautiful, anxious and determined to have a part of this developing Sydney Art scene in any way possible. Friend, photographer and fellow founder Jon Lewis explains how they came to earn their stripes.

'Bruce and I, slightly intoxicated, scaled the roof and made off with two of Mart's paintings when the opening was shutting down, then stashed them in my mum's car and drove around, laughing and carrying on, but soon began to fear the worst (gaol) and decided to return them. Little did we realise how difficult this would be. Eventually we left them under a sapling at the rear of the gallery and made our getaway. A few days later, Bruce and I visited the gallery and confessed. I remember a wry smile spread across Mart's face. Bruce and I were in!'

Over the next three years of the gallery's brief existence, Bruce became the fixer/finder/installer for every backdrop or prop that was required for changing exhibits. He scoured the local markets and auctions, sourced the red velvet drapes for the Magritte room; painted ceilings and bejewelled costumes. When research for new ideas was wanted, Bruce knew of obscure rare bookshops, run by little old ladies, for the perfect edition. He was the connection, the man who could acquire anything, the decorator who could turn a garden shed into a forest for a party! A super stylist, curator of fantasy and a living work of art in his own right.

Later, inspired by Margaret Preston's paintings of indigenous flora and fauna, Bruce turned to textile design and lithograph and gathered acknowledgement for his extraordinary work in lino cuts, which he applied to his designs for the Mambo shirts in the early nineties. To my knowledge, there's not a self-respecting creatif on the shores of New South Wales who doesn't own a Bruce Goold cushion or has not covered a chair with his fabric.

He is forever inspired by his finds along the Palm Beach shore and his forays into the Avalon Red Cross shop for medical ephemera. All these 'found objects' are recycled and provide the inspiration for new ideas. His walls are decorated with such tongue-in-cheek creations as the 1930s death mask of Napoleon in his Ray-Bans and the boomerang and bow saw forming the perfect shape of Ayers Rock. He contributes enormously to Australian culture, from his collection of prints and designs in the National Galleries to his beautiful underfoot mosaics at Sydney's Darling Harbour. He is meticulous with detail in his work and in his stories of fellow artists, who he feels privileged to have known and worked with. His memory for these times is as sharp as a tack.

A modest man, Bruce prefers acknowledging the achievements of his friends than bragging about his own. But like his retiring cottage, which has absorbed his genius for forty years, he's in danger of being lost in the encroaching tangle of lesser artists with louder voices and Instagram at their fingertips! I have been touched by the intimacy and humour in his work; by the way he tranforms discarded objects into items of captivating beauty. I also saw a light perhaps a little dimmed by the fear of sudden extinguishment were it to blaze a trail. One might be correct in assuming his best is yet to come. Bruce carries a peculiarly fine Australian uniqueness. A man of many passions, quietly inspiring, fixing us up with his limitless imagination and resourceful ideas. His consumer footprint is small but his dreams are evident in both his dedication and his ravishing fabrics. Australia, this man is a national treasure. Cover a building in his waratah and let's have a Brucie day!

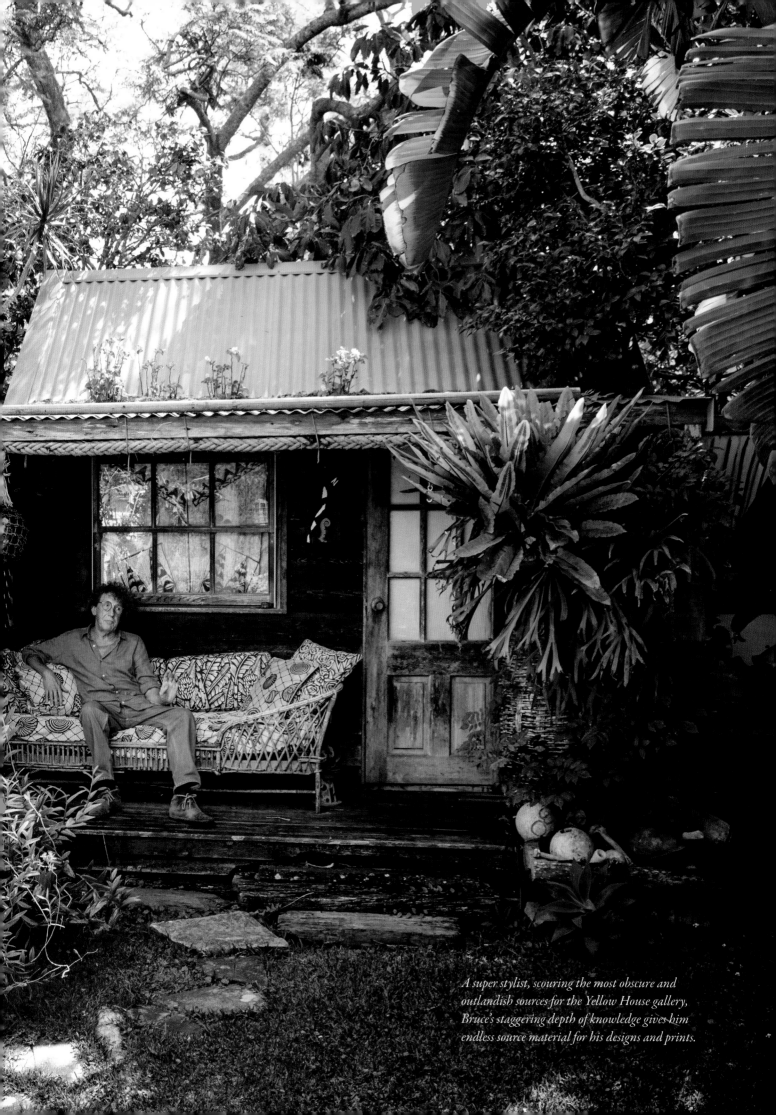

A super stylist, scouring the most obscure and outlandish sources for the Yellow House gallery, Bruce's staggering depth of knowledge gives him endless source material for his designs and prints.

BARRY & GRACIE OTTO

Father / Veteran Actor
Daughter / Young Director

STANDING IN THE PORTICO OF THE OTTO HOME I AM MESMERISED BY THE PEELING patina of the fading paintwork and as my eye travels through the labyrinth of cobwebs to the ancient hanging porch lamp, I am drafted back more than a few decades to a mysterious house I was infatuated with on Wandsworth Common in London in the late seventies; a house I fondly referred to as the Addams Family house for its louche effrontery to remain gothically original in a street where the upwardly mobile had shiny brass door knockers and whiter than white windowsills. I imagine this a place where spiders have raised their families over decades, and bats gossip over the season's best catch.

 Gracie Otto opens the door and I am immediately relieved to find that this house, true to its roots, is just as original on the inside as the façade led me to hope. Gracie, however, is fresh as a daisy! She shows a confidence that exceeds her years coupled with a girlish playfulness that implies she might still spend happy hours kicking a ball along the passage and breaking a few ornaments, given the chance. Passing through the house I quickly discover that, apart from a sizeable collection of paintings depicting Victorian ladies draped in languid poses on every available wall space, there has been no attempt to garnish this house with anything remotely frivolous or decorative in the twenty-eight years the family have lived here. There is an honesty to this edifice that speaks of a commitment to keeping it real. A no-frills house with both feet grounded in the distant past.

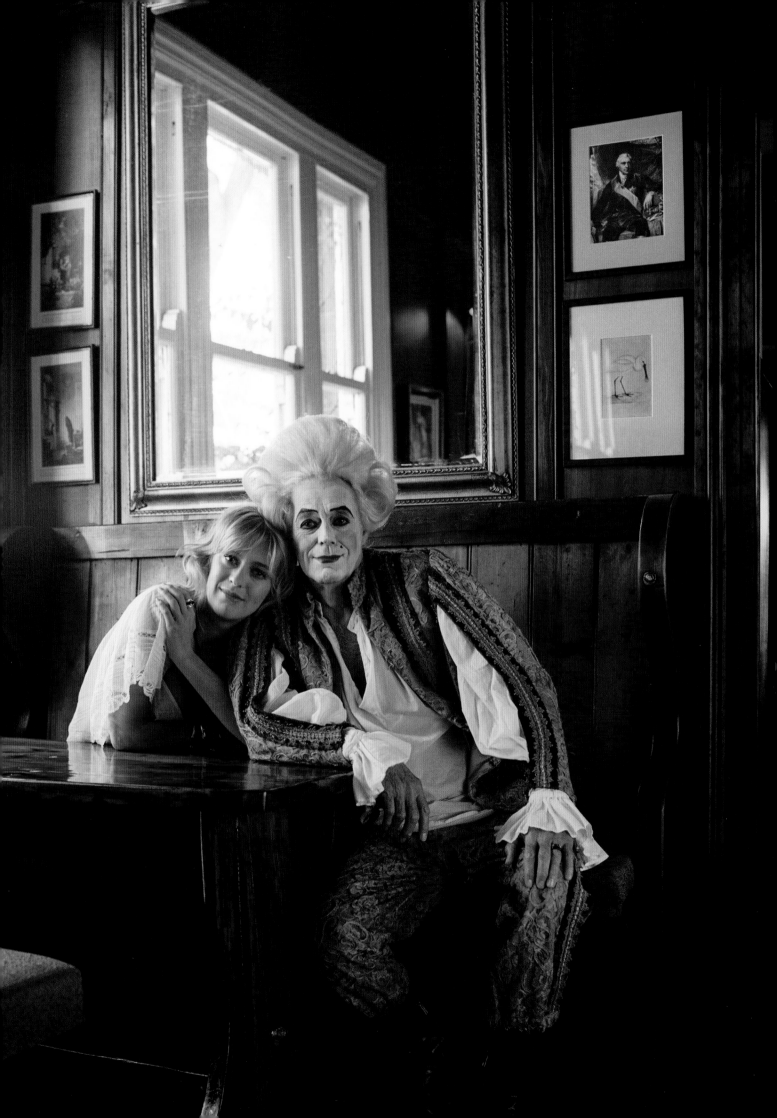

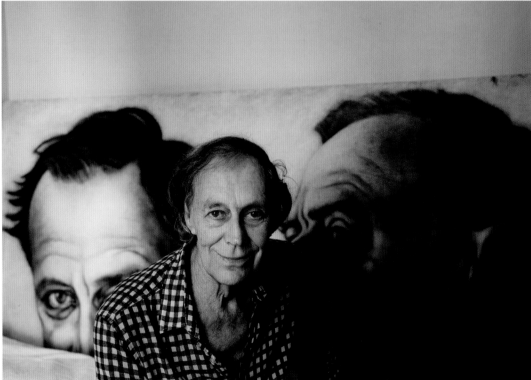

In this home, passion is found in the occupants individual creations. Devoid of anything remotely trendy, this house reverberates in echoes like the worn treads of old theatre boards.

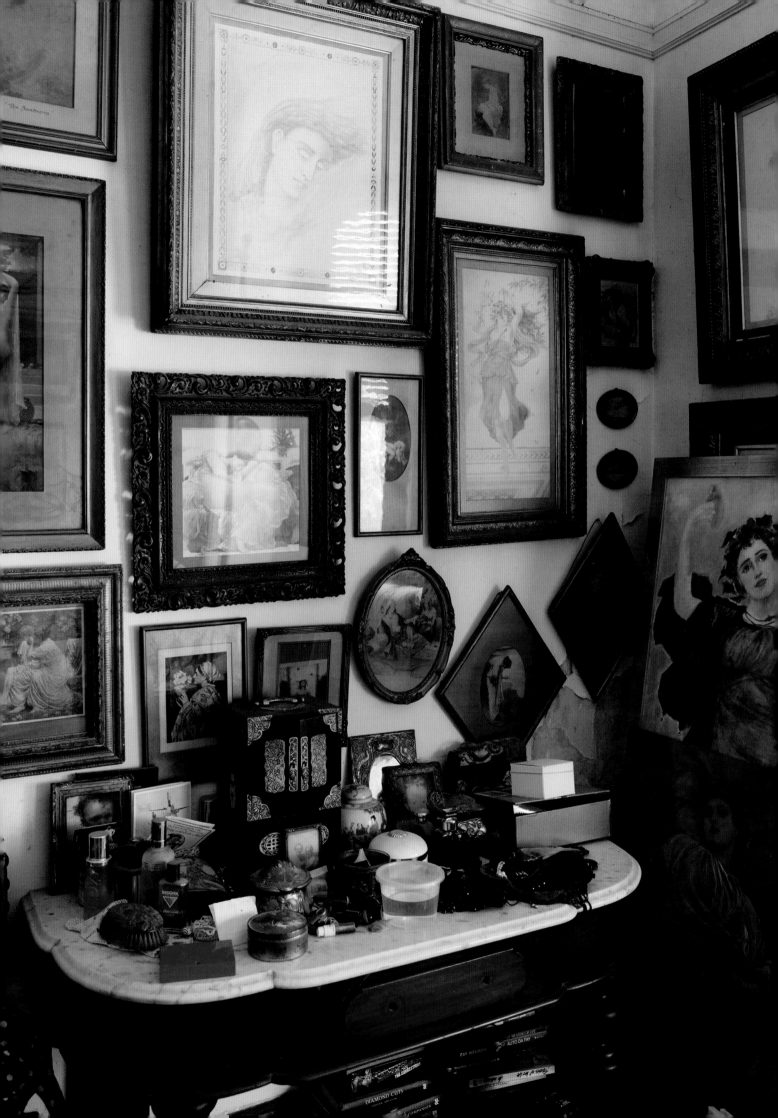

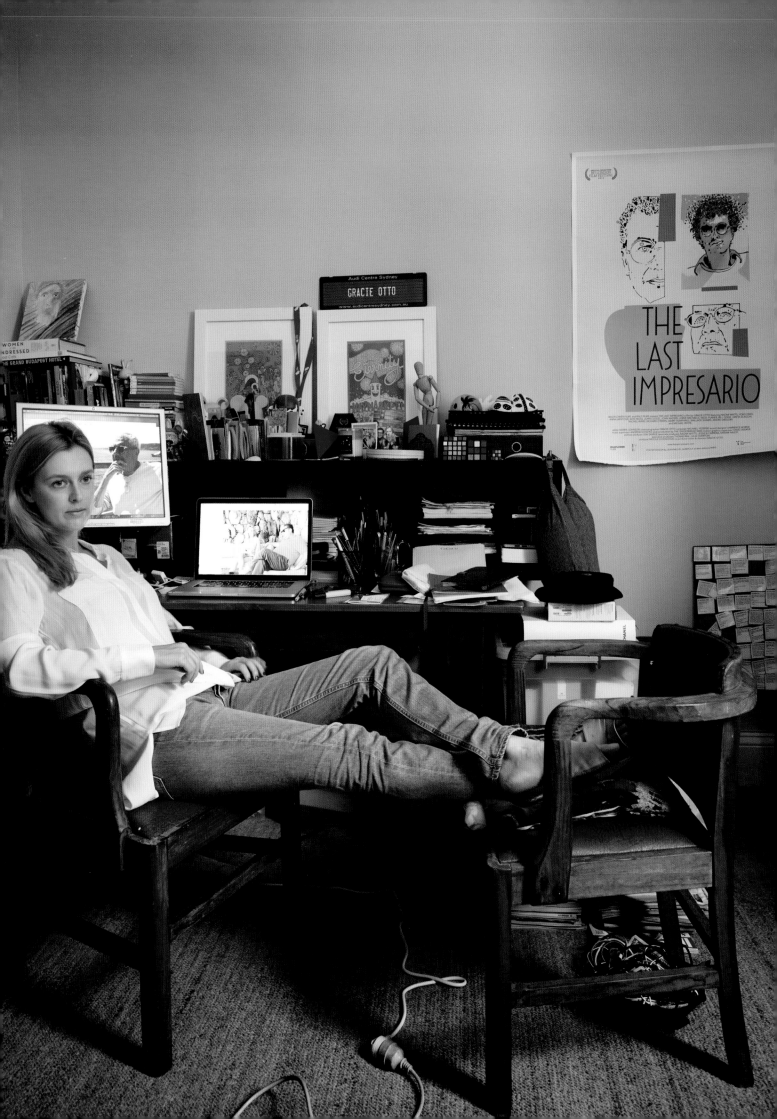

> *'Everyone has to start something.*
> *I have had enormous support from my family*
> *but I think Dad thinks I am still a virgin, and Mum thinks*
> *America is entirely Trump country; and as much as I*
> *loved my life in Sydney, it was time to go.'*

Gracie's father, Barry Otto, Australia's beloved veteran thespian who has channelled characters from *King Lear* and *Uncle Vanya* to the bumbling hunchback in Jocelyn Moorhouse's recent film *The Dressmaker*, greets me in the kitchen, then quickly hurries me out to the adjacent chapel in the garden, explaining en route that he prefers to paint these days. And here within, beyond the creaky door, rests the source of all those languid muses. Barry's love for Pre-Raphaelite art has induced a feverish passion in him to reproduce the work of our best-known nineteenth-century, opiated brotherhood from Rossetti to Millais. But Barry's current works – of which he is the proudest – are the achievements of his youngest daughter Gracie.

Gracie Otto, soccer fanatic, documentary film-maker, is set to kick her ball right out of the Hollywood park. In the spring of 2010, after making a succession of small, emotive films, Gracie was in Cannes when she met ageing impresario Michael (Chalky) White. They arranged a dinner date and Gracie spent the interim days discovering who this elegant elderly gentleman – who claimed to count Kate Moss, Jack Nicholson and the late Margaret Thatcher amongst his best friends – actually was. On the night, come time to pay the bill at the arranged rendezvous, Michael's credit card was declined and Gracie had a sudden insight into the man behind the posture. Gracie has found her new project and, true to her breeding, she is going to keep it real.

'Everyone has to start something,' announces Gracie. 'I have had enormous support from my family but I think Dad thinks I am still a virgin, and Mum thinks America is entirely Trump country; and as much as I loved my life in Sydney, it was time to go.' Her mother, Sue Hill, is a stalwart of feminist theatre in Australia, having saved the former Nimrod from extinction by raising money from a co-operative of fellow actors and crew to purchase the building and reform it as the much-acclaimed Belvoir Street Theatre of today. Sue's role as the mother lode in this home is definitely the motivating oil in the Otto machinery, although preferring a background part, she is gone before I am able to lick the end of my ballpoint.

Gracie has been to the USA before, but after a series of bad boyfriends she returned home and now she has done with the boyfriends and her new obsession is to uncover the story of the man who lives behind the shiny façade of fame. She sets about interviewing at least sixty-five people who know him well and discovers that she has run into another mother lode: a man who has been the catalyst to the success of so many household names, but whose own life has unravelled since his halcyon days in the theatre. *The Last Impresario* documentary will occupy Gracie's every moment for the next four years. She will garner recognition as a talented film-maker and one day she will fulfil her dream and live in Paris.

For now, Gracie's room is currently empty, as the City of Angels has called for her stateside. So this home is a stage set for the family players who come and go, each with their own purpose, like the rabbit in *Alice in Wonderland*, they shuffle down passages, tapping at their watches. Tardiness will not be tolerated! There is barely time to consider the prospect of a smidgen of renovation and all the dishevelment that might involve. Where a crack appears, another framed, laudanum-infused Rossetti beauty will cover it and dreams will play out in the old iron bed, the clocks will need winding, and before you know it, she will be home again with more stories of conquest, delight and probably some rejection; for that is the way of LA. Comforting then to know that little changes at chez Otto.

Michael (Chalky) White died in Ojai, Los Angeles on 7 March 2016. Gracie saw him to say goodbye.

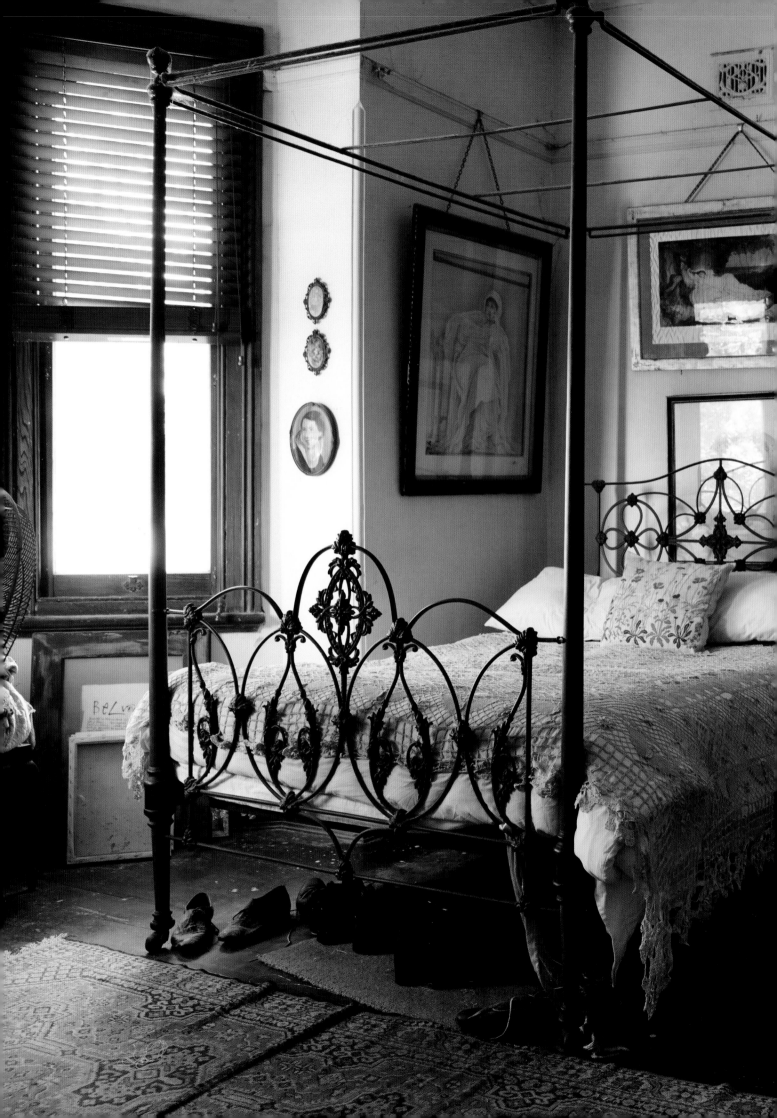

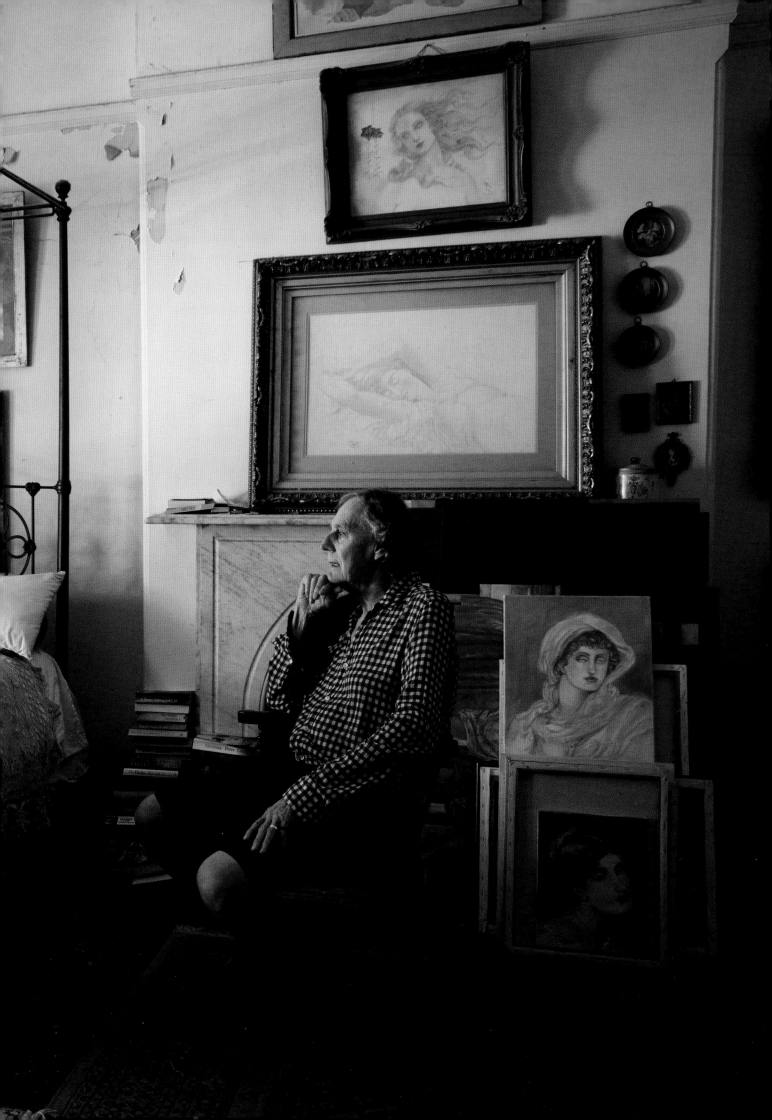

VICTORIA ALEXANDER

Photographer / Author / Atmosphere Consultant

VICTORIA ALEXANDER HAS LEFT A STYLISH PAPER TRAIL AROUND SYDNEY OVER the last three decades. Her daughter learnt to walk among the brick dust and rubble of her mother's first renovation project in the early 1980s. The Russell was a fusty Victorian edifice located virtually under the Harbour Bridge but suitably placed and with enough character to attract a woman looking for a challenge that involved getting her hands dirty. Under the gentle eye of reform, Victoria's establishment rapidly gained attention from the media and Sydney witnessed the birth of its first boutique hotel.

The next, and perhaps her most notable, renovation was The Bathers' Pavilion on Balmoral Beach. The Bathers' was built in 1928 following the extension of the Sydney tramline to the outer reaches of the city and the gentle slopes and dunes of Mosman. The building is of impressive Moorish design and looks directly over the calm waters of Edwards Beach; inches from the sand and surrounded by a park that hosts flocks of white cockatoos and colourful parakeets. Discovering this vision in dire need of a facelift, Victoria immediately saw a way to realise her dream of creating another small hotel, combining her love of design and her passion for food under one exotic roof. She acquired the lease but the first flush of excitement was nipped in the bud almost overnight. Her plans to refurbish the building were vehemently opposed by a handful of rigid residents. It would be ten years before plans were approved to Victoria's specifications and work could begin. Once

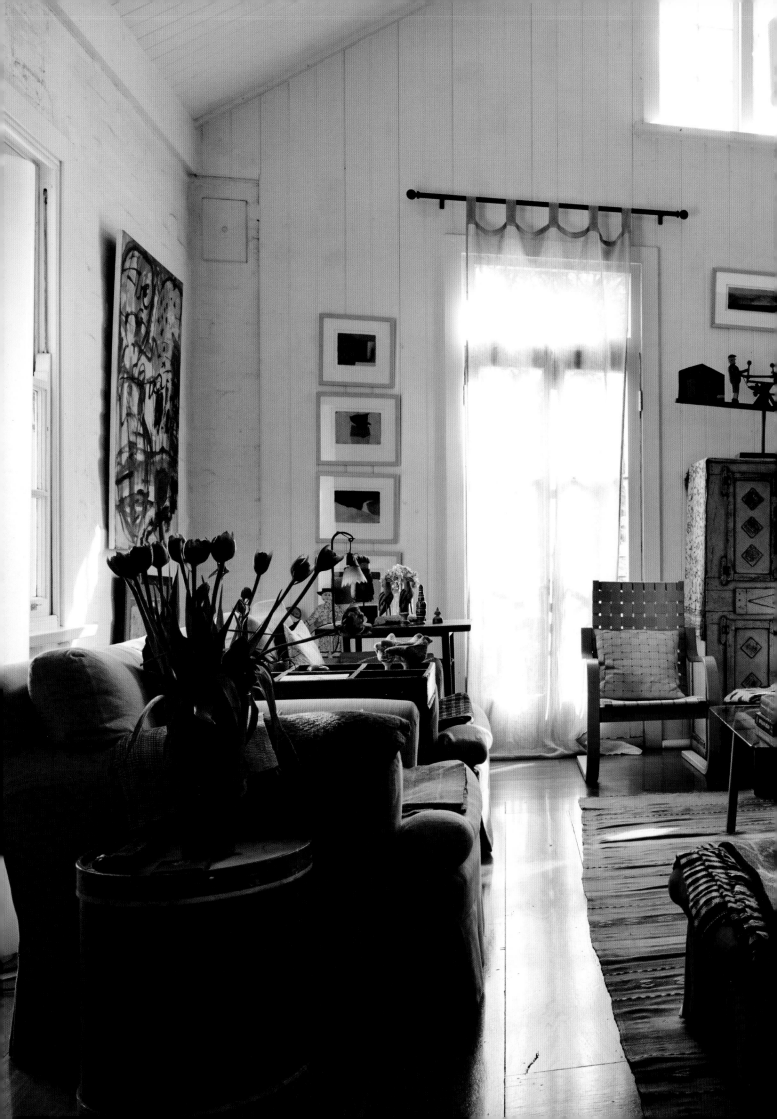

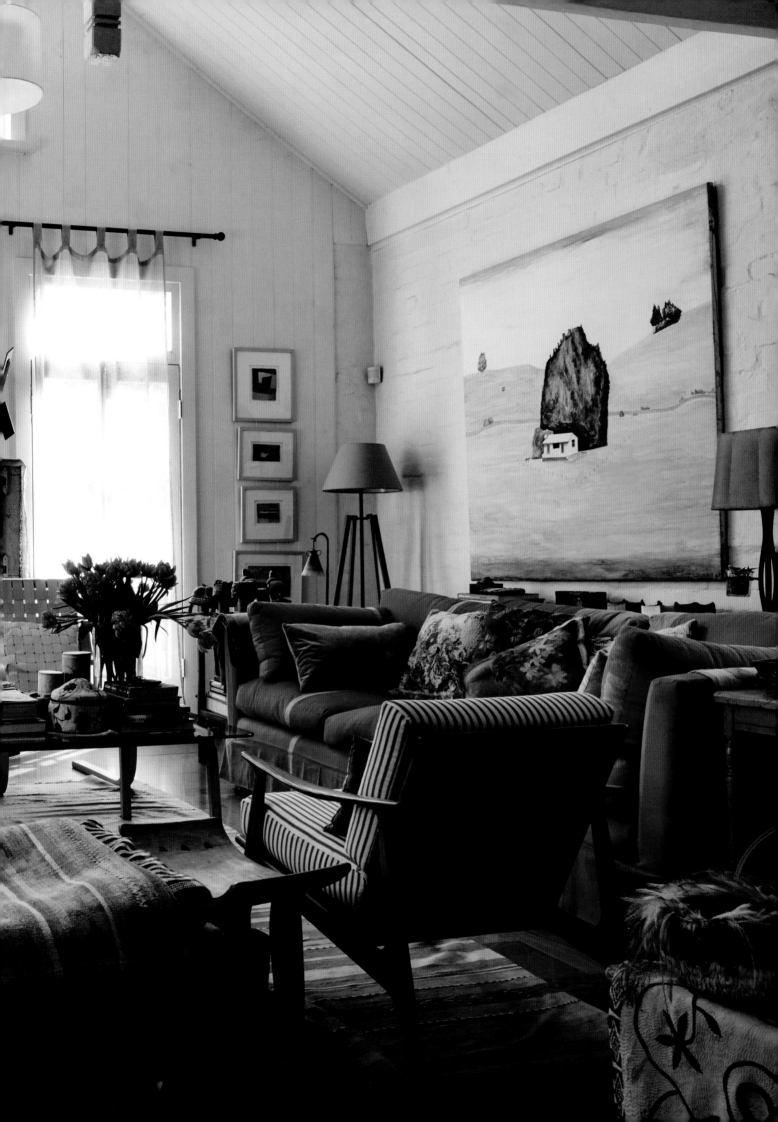

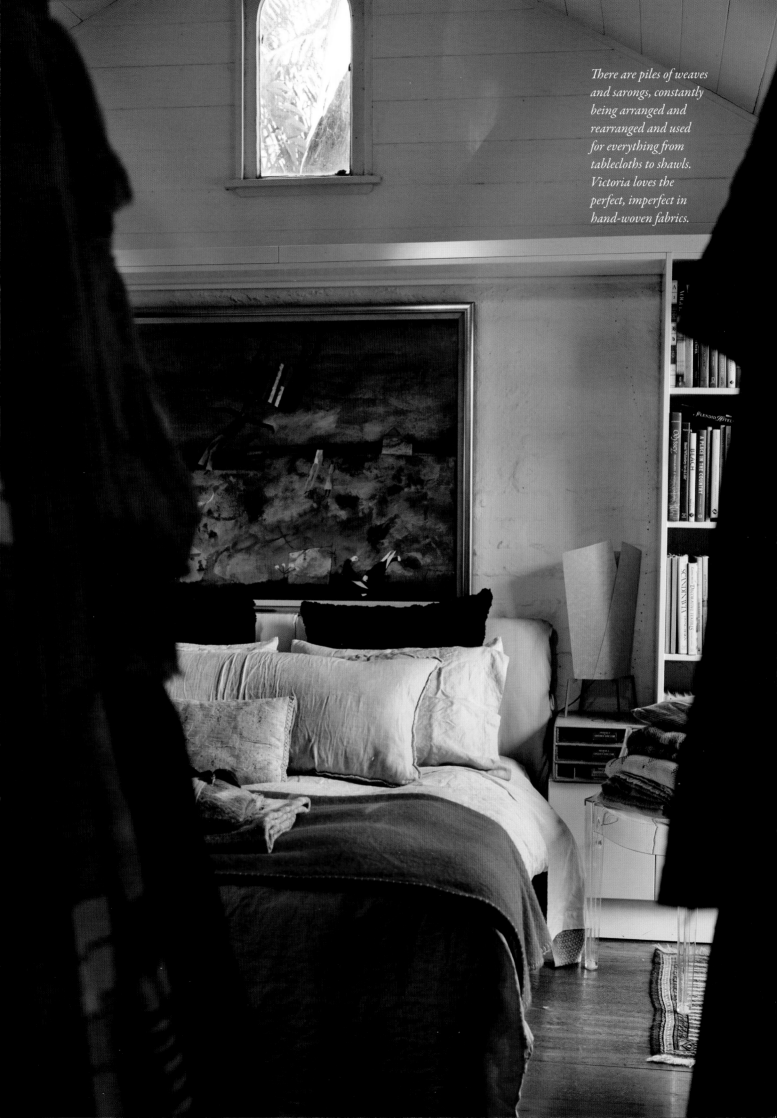

There are piles of weaves
and sarongs, constantly
being arranged and
rearranged and used
for everything from
tablecloths to shawls.
Victoria loves the
perfect, imperfect in
hand-woven fabrics.

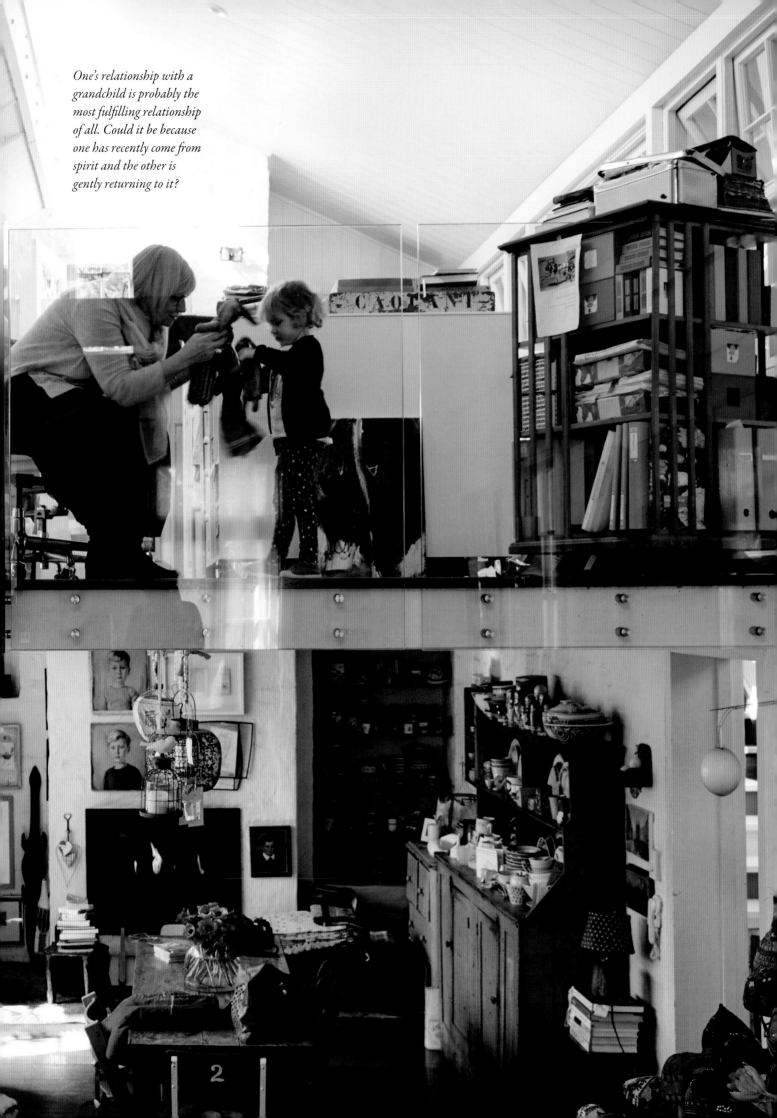

One's relationship with a grandchild is probably the most fulfilling relationship of all. Could it be because one has recently come from spirit and the other is gently returning to it?

completed, both city and beach were well acquainted with her trials and tribulations and could not wait to beat a path to the door. Under the fifteen years of Victoria's supervision, The Bathers' became a Sydney icon with the *New York Times* writing it up as the most quintessential Australian experience.

So today I am remembering the first time I breakfasted at The Bathers' Pavilion. Stepping straight off the beach after a swim, swathed in a sarong and sitting at a rustic table, my straw hat swinging from the back of a mismatched chair, surrounded by paintings that could have been the work of the best of the Bloomsbury Artists. Gazing out onto an azure ocean, sand between my toes and a plate full of something exquisite – with eggs sunny-side up! I remember feeling rather smug and proud of my Antipodean roots. I might have just returned to Oz from Blighty, but that miserable, grey mirage was rapidly being replaced by blue skies and some dynamic Aussie innovation. No coincidence then that today I am visiting the Sydney home of the pioneer lifestyle innovator, photographer, cook and author of four exceptionally beautiful books.

Sadly Victoria came unstuck with her partnership in The Bathers' in 2003. It came as a terrible blow to someone who had given so much of her time to developing a vision. 'I suffered an excruciating double betrayal over the business, and that was the end for me and any vision I had of future plans for The Bathers'.'

Coupled with this, she had lost her ex husband, the father of her three children. Victoria had run aground. For an intrepid woman who has travelled through sixty-three countries – some of them, in her youth on a mere five pounds per day – it was unthinkable to accept that she was defeated at this point in her life. Over a day she completely unravelled. 'I cried from a place I didn't know I had inside me,' she explained. 'And then I had to get up and get over it all. I made myself a cup of tea and resolved to live entirely in the moment.'

She drank the tea from a blue and white CorningWare cup and saucer that belonged to her late mother; a cup that she kept for posterity and never used. But on this day it served as the chalice of reason and support. After all the years of running a staff of over a hundred people seven days a week, Victoria discovered her maverick soul and adopted a uniform of fisherman's pants and a Gap t-shirt; this became her daily attire for the next four years. She embarked on a BFA Honours degree, as a mature student, at the National Art School, straddled a wooden donkey for the duration and learnt to paint, a course of action she feels she probably should have taken when she was eighteen.

'My look is layered. I can't bear the word cluttered. Layered means it has all been considered.'

Now her books are her passion and her reason for travel. As she travels so she collects, she loves tracing tribes and discovering enduring cultures, photographing and recording the authenticity and rituals in their daily life. Next stop is Namibia and there she will undoubtedly find more treasures that will arrive months after her return, wrapped in layers of sacking, laced with a mile of blue string, and smelling of hot earth and mothballs. Textiles have always been a huge inspiration to Victoria and everywhere in the house there are piles of weaves and sarongs, constantly being arranged and rearranged and used for everything from tablecloths to shawls. She loves the perfect imperfect in hand-woven fabrics and she may wear something one day and the next it may cover her bed. Her home is a moveable feast, layer upon layer she builds like a bowerbird, her nest that she shares with her children and friends when they visit, and her grandchildren, with whom she immerses herself completely. For a child, this house is a Pandora's box, an ever-unfolding origami of stories and wonderment. Everywhere a small bird or a cloth rabbit, stones, shells or beads. The children will grow up with these things. Their grandmother will tell them the stories of their origins. She will show them the tiny embroidered flowers on the shawl from Kashmir and the importance of the wobble in the wooden salad bowl that never stands straight. Victoria, in her way, is creating another generation of Australian innovators.

'An instant fix can take ten days, but if you want harmony you have to be patient. That's the difference between a house and a home.'

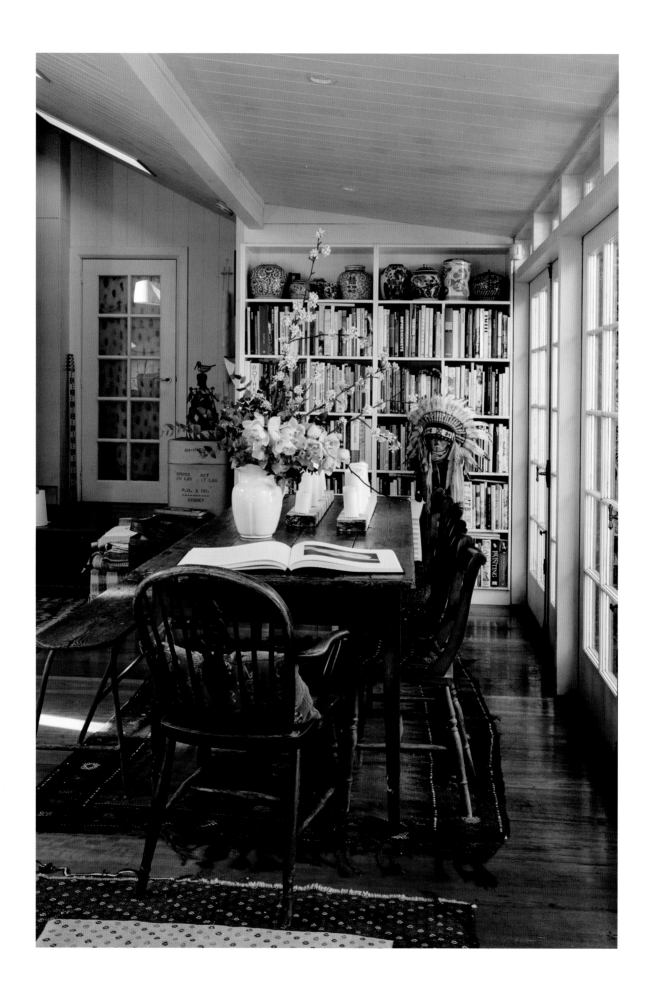

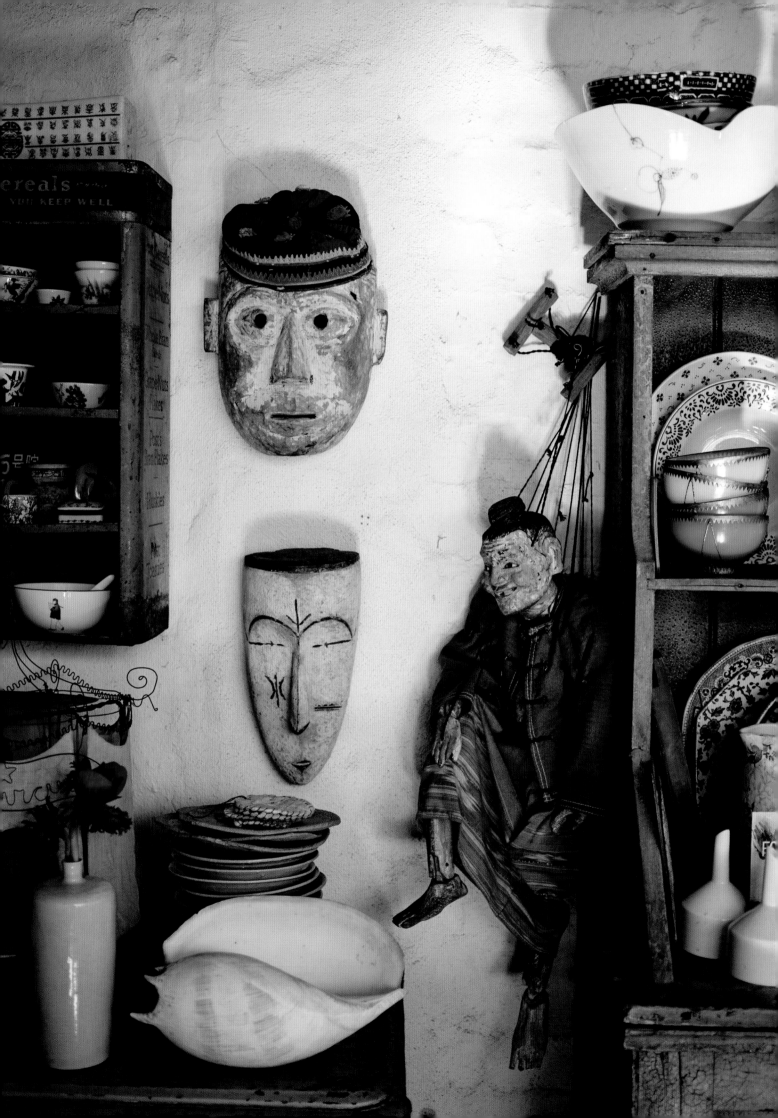

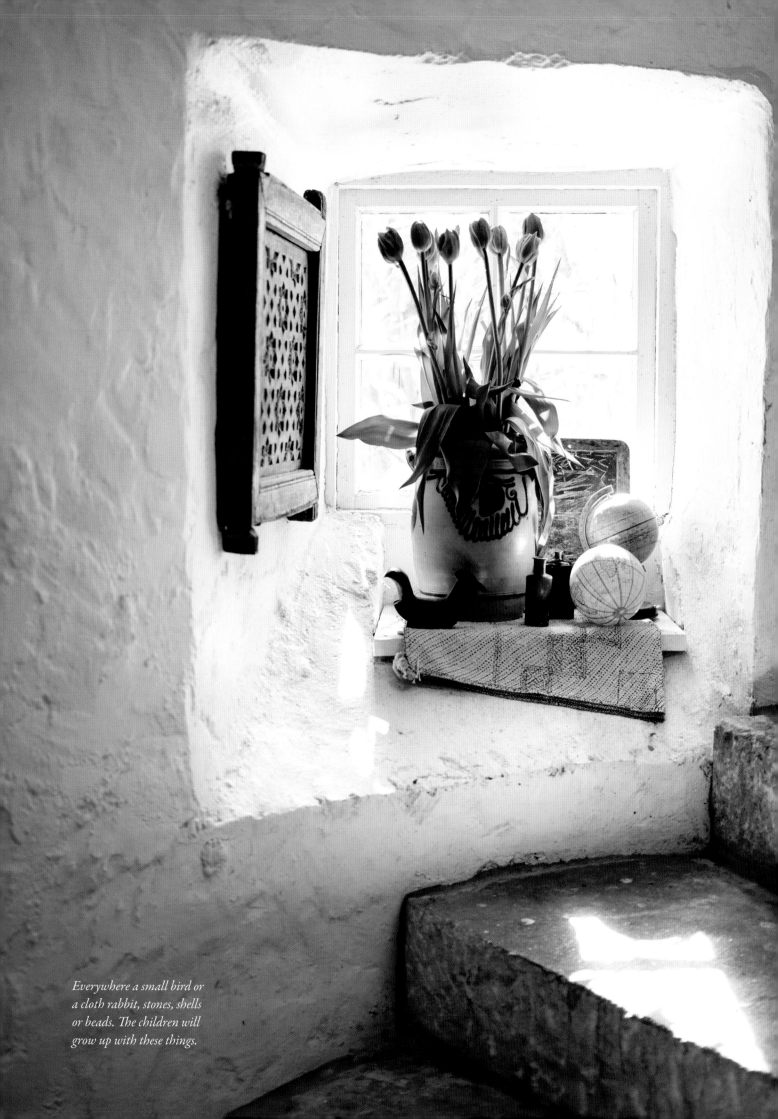

Everywhere a small bird or a cloth rabbit, stones, shells or beads. The children will grow up with these things.

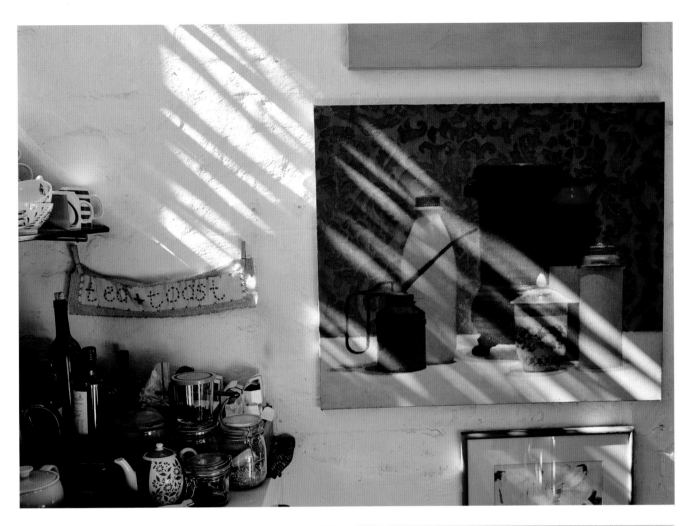

JOHN DUNBAR

Artist / Innovator / Teacher / Mentor

SOME PEOPLE SPEND THEIR LIVES TRAVELLING THE GLOBE COLLECTING ARTEFACTS, stories, ideas. John Dunbar manages to collect double the quota of those earnest globetrotters, and he rarely travels far outside London. He moved into this apartment on London's Maida Vale in 1971 and has since had five landlords (shrugging off one hefty attempt to evict him). Everyone from British gentry, rock stars, misfits and London's illustrious ladies of the night have dallied here or been the subject of John's frantic sketching and are more than likely preserved, in various stages of inebriation, in one of his three hundred little black note books that occasionally reveal themselves, begrudgingly, to some of London's keenest Art voyeurs.

JD, as his good friends know him, has been the intermediary and facilitator for collaborative relationships between artists and 'the business' for over four decades. In 1965, aged twenty-one, he kick-started the Rock Art scene by setting up a conceptual gallery in Mayfair. Indica opened its doors to a private viewing in November of that year and Swinging London's illuminati – accompanied by some very 'dodgy geezers' – piled in. Also there were his eighteen-year-old wife, Marianne Faithfull, and their infant son, Nicholas.

Later, it was here that JD introduced his friend John Lennon to Yoko Ono, for whom he was hanging that famous exhibition. Ono handed Lennon a piece of artwork with the framed word 'Breathe'. He panted like a dog and the rest is rock history: six months later, they were an item.

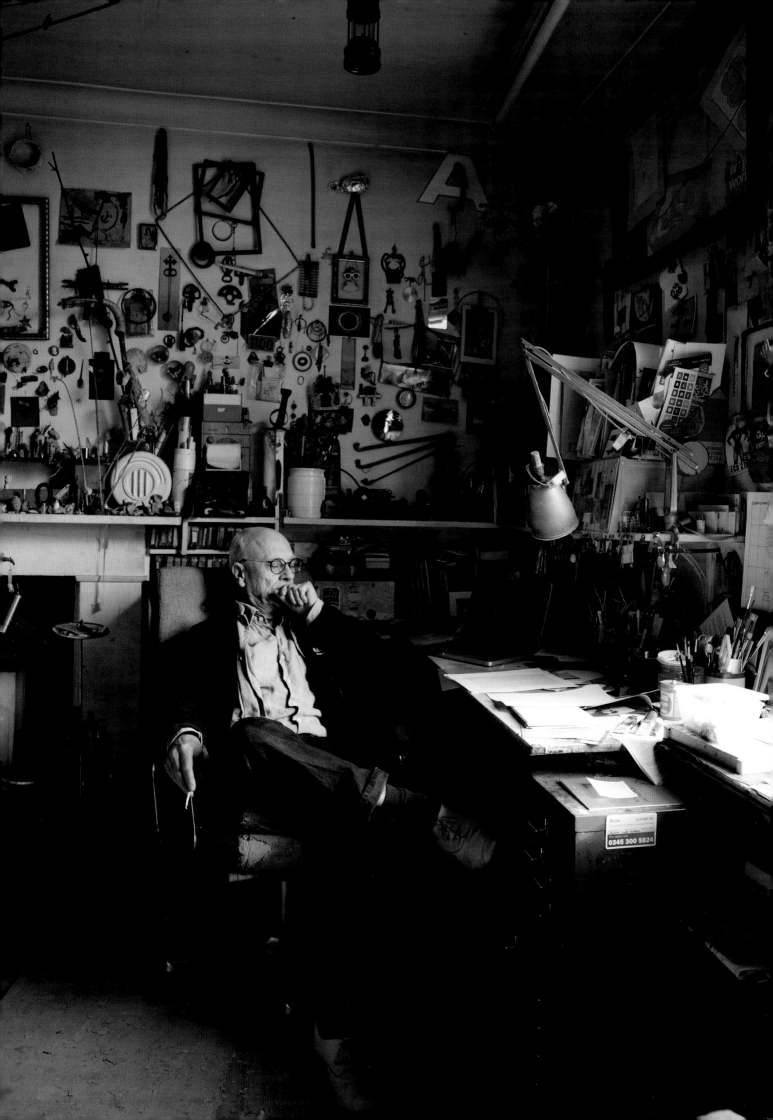

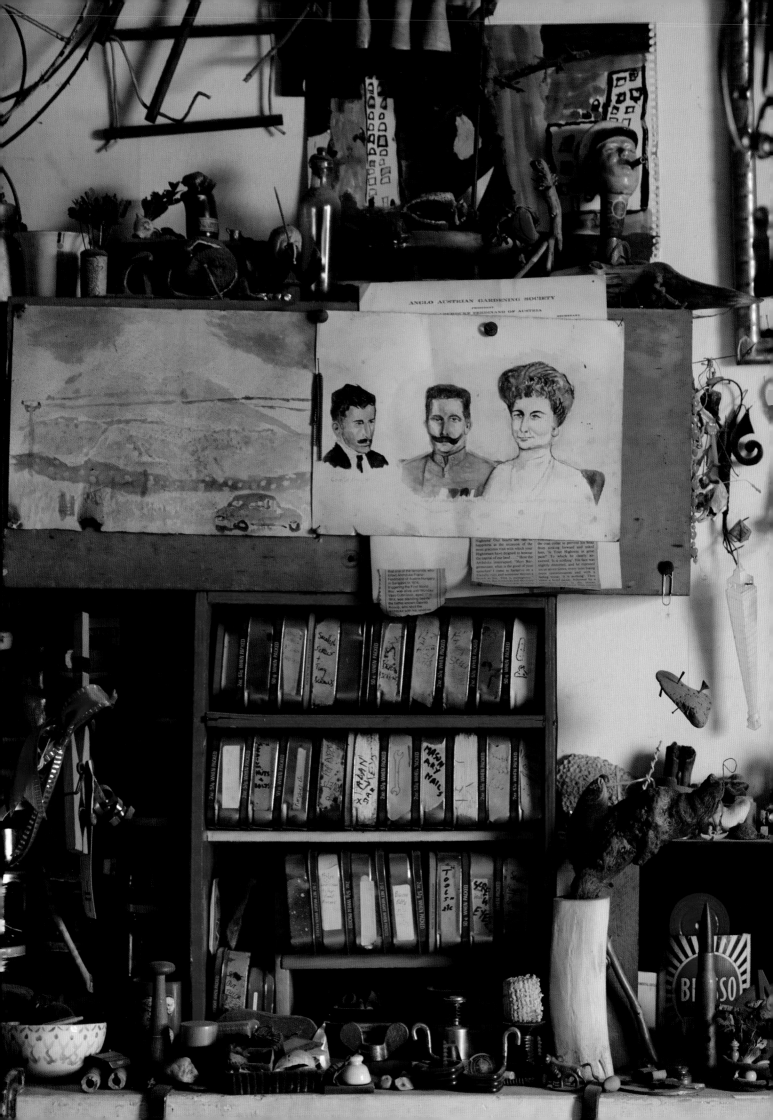

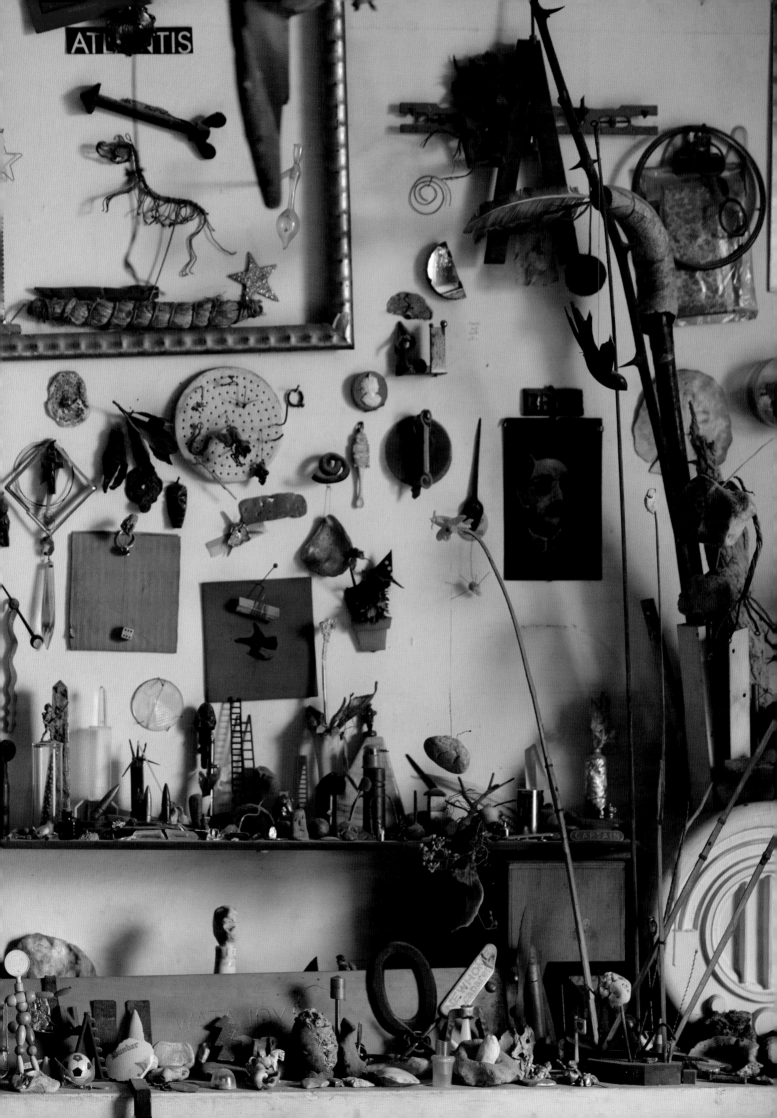

Fundamental to the Rock Art scene in the mid-sixties, JD's apartment has been the backdrop for an array of rock stars, among them Rolling Stone Keith Richards (top). A great observer of people and collector of everyday items, the heart of his home for the past forty years is JD Wall (previous page).

John was never motivated by money, or its attendant trouble and trappings. 'Luxury is hard work. All those journalists knocking at your door wanting a piece of you!' He was only ever interested in the Art and the people. In 2014, in a show he named Remember When Today Was Tomorrow, John exhibited part of his legendary archive of drawings and handmade films at London's England & Co. Gallery and sold a substantial number. He is still a regular on the social scene, attending private viewings and nipping out to Soho's nocturnal institutions, like the Colony Room. But he spends his days quietly editing his own rogue's gallery of work ready for future exhibitions. These days his eye is cast towards the US. But he baulks at offers when things start to focus on name-dropping and celebrity. His 1966–76 archive is a private look at the cutting edge of the London Art and Music world, the lives of his Beatle buddies, and jaunts across Europe with poet Allen Ginsberg, art dealer Robert Fraser and collector Peggy Guggenheim. He uses photos with his sketches but never wanted to thrust a camera into people's faces, being happiest in a corner sketching the moment. Known for his relaxing presence, he has a talent for drawing people out of themselves and this makes him a very attentive listener.

In his London apartment, which has gently evolved over four decades, it is impossible not to mention the overwhelming presence of the JD Wall. It featured heavily in the above exhibition and for many years has been the defining installation of his life. This is where he mounts his *objets trouvés*, imagining them as monumental pieces and including tiny people to elaborate on the scale that we might glimpse our own lack of importance in the scheme of things. I ask if he ever worries about accidents, or pieces going missing. 'I have had one hysterical girlfriend who threatened to burn the house down when I wasn't there. That obviously wasn't going to work.'

I confess to wondering where a woman might fit in around this carefully arranged chaos. Even with the lightest, most aerodynamic feather duster wafting in swirls around the perceived mundanity of everyday items, I can see John's pain at the thought of almost half a century's worth of hard-to-come-by, meaningful pieces ending up in the sink! To some it may seem that the bald mannequin with the red-painted nipples has been dumped on the stairs until a suitable position was located; I can vouch that she's been there since 1973.

By the early eighties, JD set out to seek scrap building materials, emptying the contents of London rubbish skips, then driving them, in an unreliable motor, to a remote part of Scotland where a friend had given him some land and a caravan. The caravan was eaten by a herd of goats so, unnerved but determined, JD began to build a studio above the river Deugh. When his London landlord installed double glazing, the old windows went north with other architectural salvage. This project was approached with the same dedicated momentum as his drawings and became the decade of the dumpster, involving friends and family spending holiday time between sliding naked down the river banks and creating a unique building in remotest Scotland. I ask if it is finished; his reply is affirmative. 'It doesn't have a bathroom yet, or a loo. But we always have the river!'

On his fifth roll-up we broach the subject of his ex-wife, Marianne Faithfull. Clearly they were right for each other but fame, publicity and Mick Jagger came between them and they were separated by the end of 1967.

After that, he closed the gallery and disappeared from public view, deciding to 'leg it' and travel for a couple of years, meeting up in Paris with his friend, the conceptual artist Sophie Calle. Both artists have a compelling intimacy with places, coupled with an extraordinary ability to find inspiration in times of adversity. During Marianne's subsequent lost years, John took custody of Nicholas and went on to have another son, William, with his second wife. There were inevitable regrets that fate threw such a spanner into the couple's works but Marianne still refers to JD as 'My John' and John wears a wry smile and soft eyes when he speaks of her.

His home reveals his moods. Nostalgia drapes its diaphanous dust sheet everywhere. A stranger might think things have been left in a careless manner; perhaps, but they have endured. They are constant, the fabric of his life, and every last piece has a story. His work comes from a time before Art was motivated by exhibitionism or celebrity and waits for a time when they may be reinvented. The inspiration lodges between these realities.

The journey back to his mother was a long one for Nicholas, but with the arrival of grandchildren, what seemed broken has been repaired, recycled, reinvented. As in life, so in Art; it's just a matter of being patient.

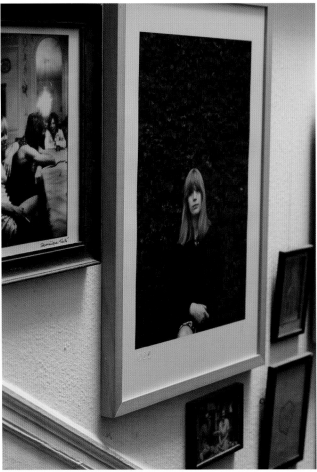

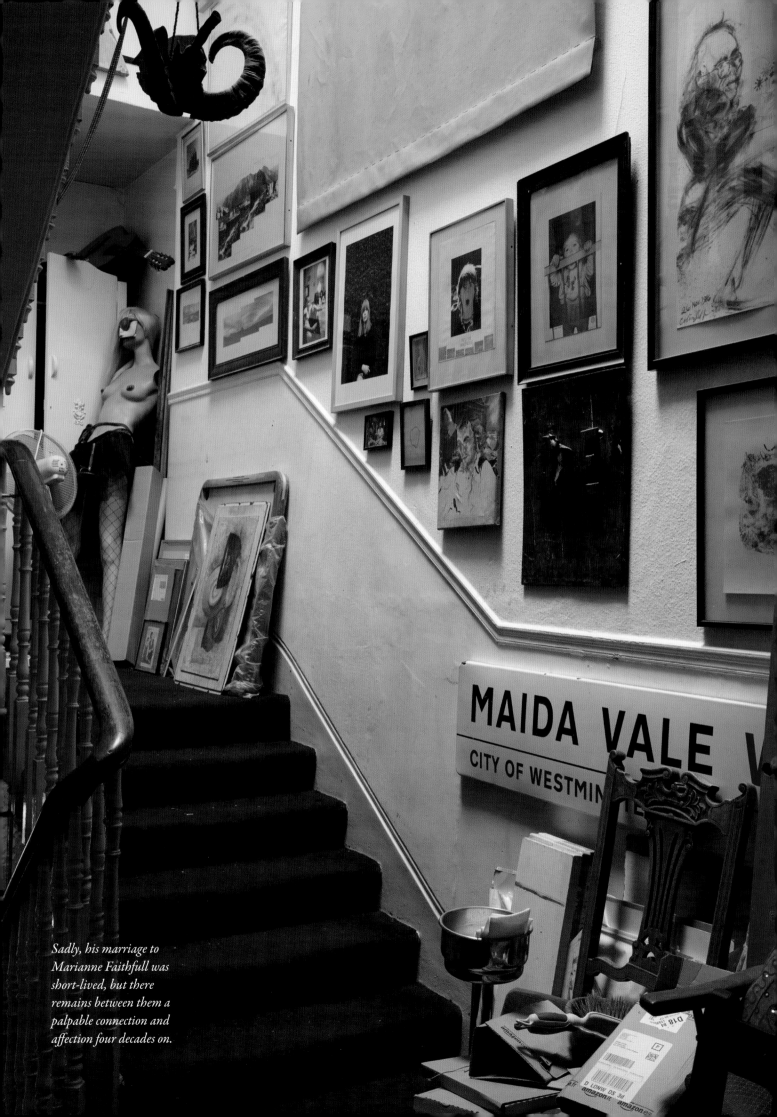

Sadly, his marriage to Marianne Faithfull was short-lived, but there remains between them a palpable connection and affection four decades on.

MAIDA VALE
CITY OF WESTMIN

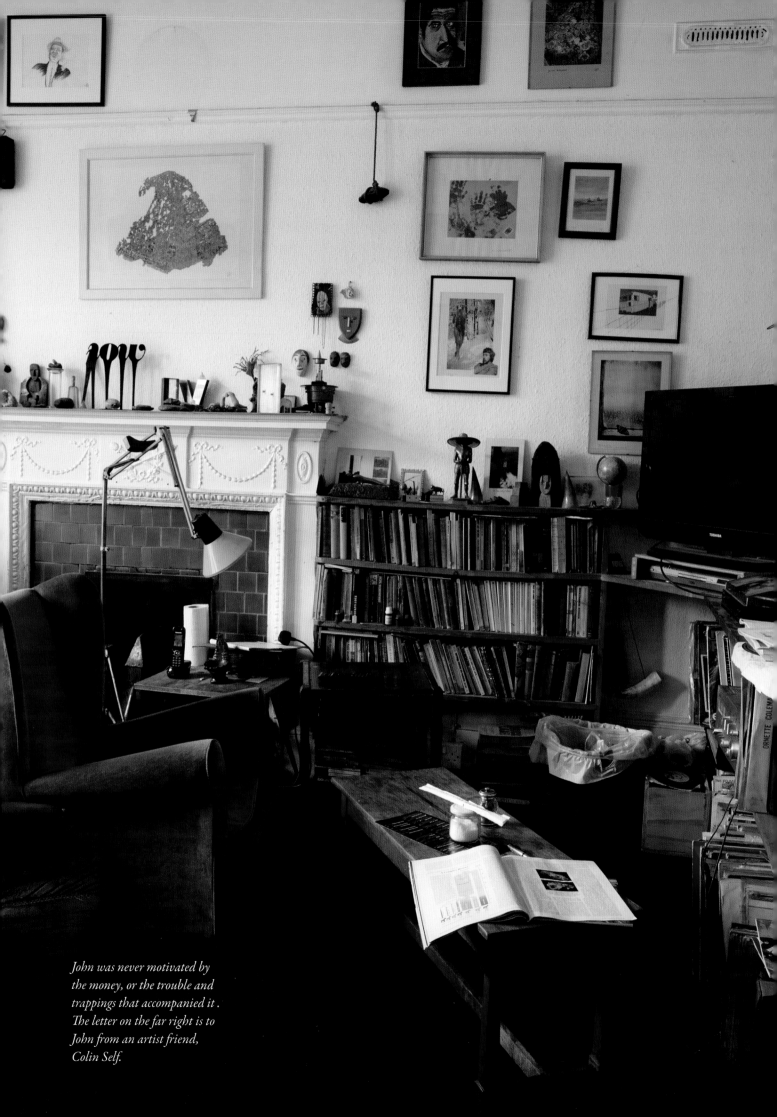

John was never motivated by the money, or the trouble and trappings that accompanied it . The letter on the far right is to John from an artist friend, Colin Self.

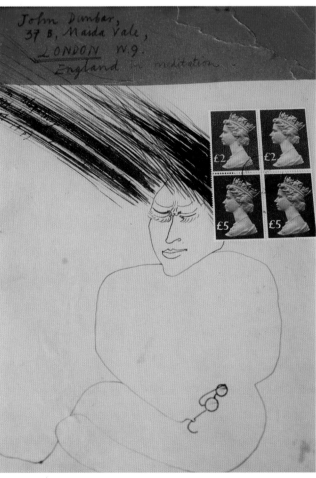

PATRICK DEEDES-VINCKE & ISABELLE TOWNSEND

Curator / Manager / Producer
Mother / Activist / Beauty / Actress

COUNTING THE ORANGE PUMPKINS PILED SO PERFECTLY ON THE BLUE AND WHITE dish, I am curious to find out how this couple, who seem so comfortable with each other and so infinitely at ease in their Arcadian surroundings, came to give up a racy life between Paris and NYC and check into a bijou gate house surrounded by parkland in the grounds of the elegant seventeenth-century Château de Courances, west of Paris. Isabelle: a rosy-cheeked earth mother, provider of homemade soup and crusty bread, a mother of two girls and committed to the school run each morning; yet in her loving hands are the tendrils of a tenacious ghost wound through the fabric of an intriguing history. The daughter of Group Captain Peter Wooldridge Townsend, a British Royal Air Force officer, flying ace, equerry to King George VI and ill-fated lover to Princess Margaret. Patrick, her husband: strident, alert, every bit the Renaissance man, his hand diligently on the wheel that steers this verdant estate into the future in conjunction with keeping an eye on tradition and respect for the bones of the edifices. Who are this glamorous couple that seem to have exchanged their exotic plumage for a comfortable if compact nest away from a world that is hungry for the slightest whiff of celebrity connection?

In the late eighties, Isabelle was one of a few European models under contract to Ralph Lauren. Also based in Paris, Patrick was a photographic agent producing for Ralph Lauren at the time. Both of them having Belgian blood inspired a mutual friend to suggest to Patrick that they might have rather a lot in common. Patrick was

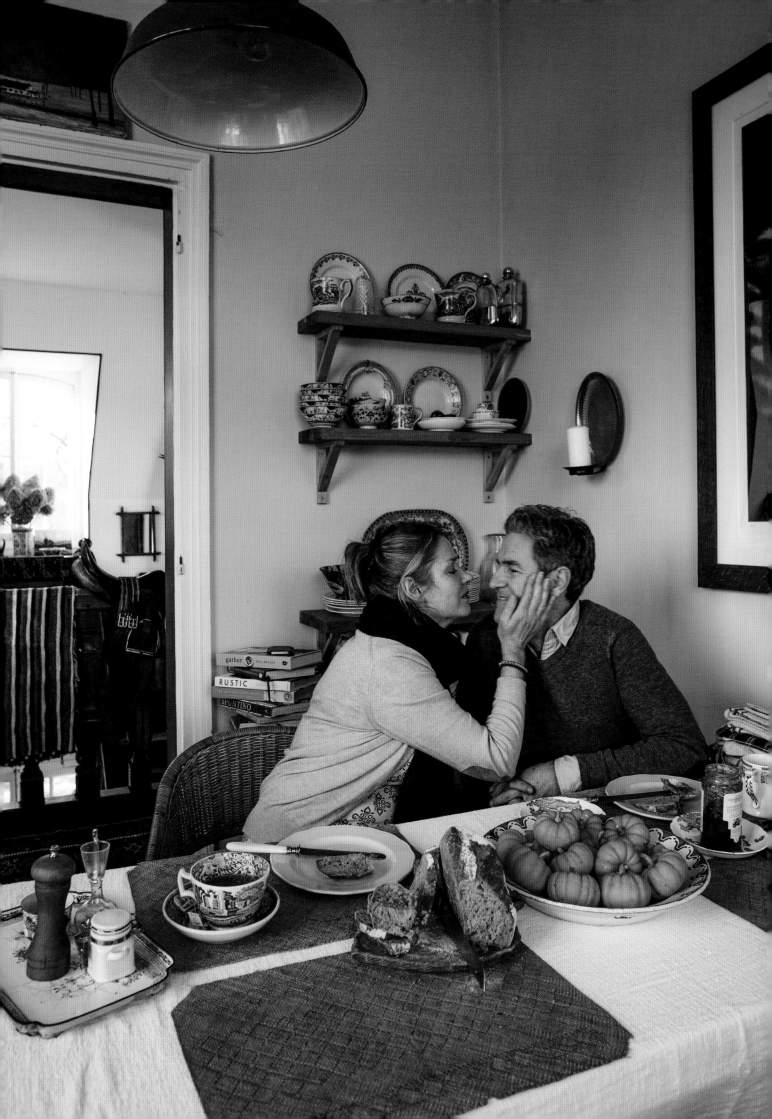

A wintry day – a welcoming potage!

smitten, but quickly determined Isabelle was out of his reach. 'I was a married man. I had another life!'

Forward ten years and Patrick, post divorce, gets a call from Isabelle but doesn't respond because she now holds a position atop the highest pedestal in his imagination and there is no way he is going to subject himself to embarrassment. But after seven hours of churning the idea over in his mind on a flight to NYC, he decides to bite the bullet. It is six in the morning when Isabelle answers his call, bleary eyed and a tad hungover. 'Patrick Who?' says she. His nerve has fled, what was he thinking? His wits jump to the rescue and he feigns a mythical casting and asks her to attend. She flies across town but he has disappeared. Later she calls him again, suggesting they meet for a drink. All is set in motion for a future together when Patrick is invited back to Isabelle's penthouse apartment and discovers her taste for mid-century furniture, which he already lusts over while Europe has yet to catch the bug. Patrick admits to have still been firmly in his shabby chic period.

Where is all this mid-century splendour now? I ask, as I look around the grace-and-favour gate house at its eighteenth-century interior peppered with a touch of English and Oriental. Patrick has spent the last four years renovating the cottages and stables on the estate. This house was almost derelict inside and needed hours of patience and hard work to get it ready for the family. 'It was important to me to reflect the mood and period of the estate in this lodge. I love to be somewhere where I feel the spirit of a place. I am a caretaker, I pass through but I restore as I go and try to leave it with a sense of the period in which it originally flourished. Once the house is happy again I need to move on.' This revelation brings forth a despondent sigh from Isabelle!

They moved to Château de Courances after renovating the ravishing Moulin de la Tuillerie at Gif-sur-Yvette, Essonne, outside Paris; the only home the Duke of Windsor and his Duchess Wallis Simpson ever owned together, and which they used as a weekender from the early fifties until his death in the early seventies. The house entertained its fair share of glamorous guests. Isabelle's father would visit frequently, Maria Callas, Sir Cecil Beaton, Elizabeth Taylor and Richard Burton were often there for weekends. American decorator Billy Baldwin said of his hostess's taste: 'Most of the mill was awfully tacky but that's what Wallis had – tacky Southern taste, much too overdone, much too elaborate and no real charm.' When Edward died, and after a series of different owners, the mill was claimed by the French government, left abandoned and patrolled by a hearty herd of goats until 2006 when Patrick and Isabelle came to the rescue. Together they restored the house and the gardens to their former glory and temporarily moved into the outbuildings, as they passed the property onto the Landmark Trust, the British company's first venture into the management of French rentals. For Patrick and Isabelle it was a labour of love not only for the beauty of the place but for Isabelle's link through her Royal connections. She says that growing up she was not aware of her father's former life. He was very happy with her mother and to her he was an impeccable father, a prolific writer, an activist for peace, and an inveterate traveller. His last book, *The Postman of Nagasaki*, is a poignant look into the bombing of Hiroshima through the eyes of an injured sixteen-year-old postman.

Patrick, born to a Belgian father who worked for Unilever, grew up in South Africa, moving home every eighteen months, and finished his education in Edinburgh. Isabelle dreams of a permanent home like the French farm where she and her sisters were raised, with animals in the barn and roaming hens. Perhaps this time her dream will be realised as they have found another sleeping beauty to renovate, just a stone's throw from Château de Courances. Patrick feels his duties have changed from his original hands-on position. He will still oversee the gardens and developments and Isabelle will continue to take advantage of the farm's seasonal organic produce while hoping she might finally put some extensive roots down and liberate her collection of mid-century treasures from storage at last. 'I really want to make the next home ours.' Meanwhile she is currently touring and rehearsing two plays, an adaptation from Virginia Wolfe's book *A Room of One's Own*, directed by Irina Brook, and a comedy, *Coronation Chicken*, which will keep her busy with extensive travel.

So who'll do the school run? 'You are asking me?' enquires Patrick. 'I am able to multi-task very efficiently, I just lose the human element. I work on automatic pilot and come out thinking about what I lost in the rush!'

'I love to be somewhere where I feel the spirit of a place. I am a caretaker – I pass through but I restore as I go and try to leave it with a sense of the period in which it originally flourished.'

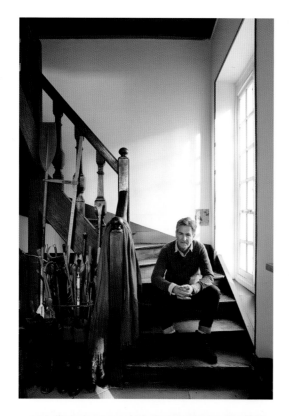

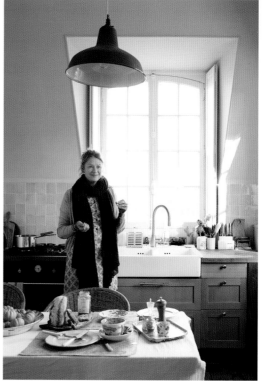

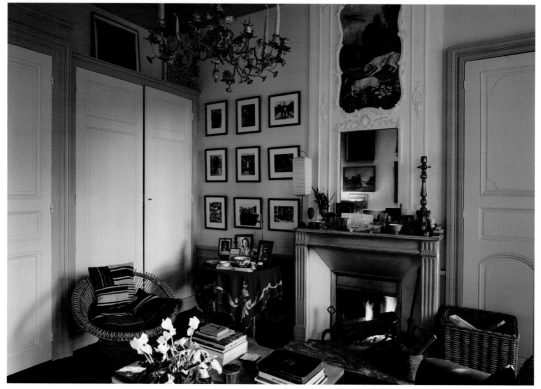

Beside a hall stand that speaks of country-estate living hangs the hunting coat given to Patrick by the son of an old hunting buddy, on the death of his father. Right: Isabelle's Dutch desk – gifted to her by her mother but originally belonging to her grandfather – is usually much messier than this.

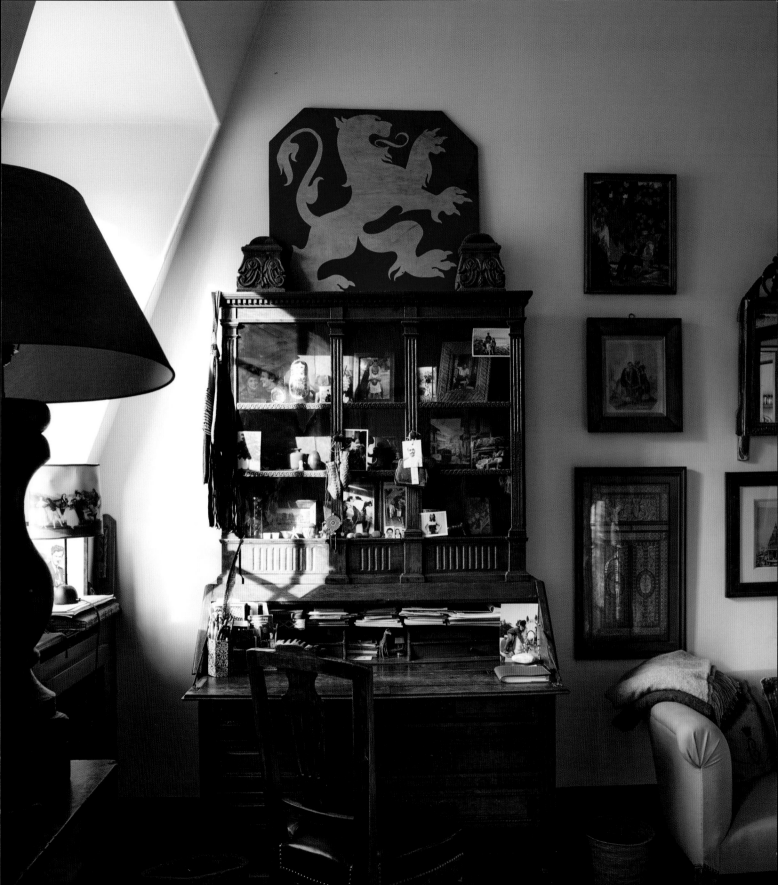

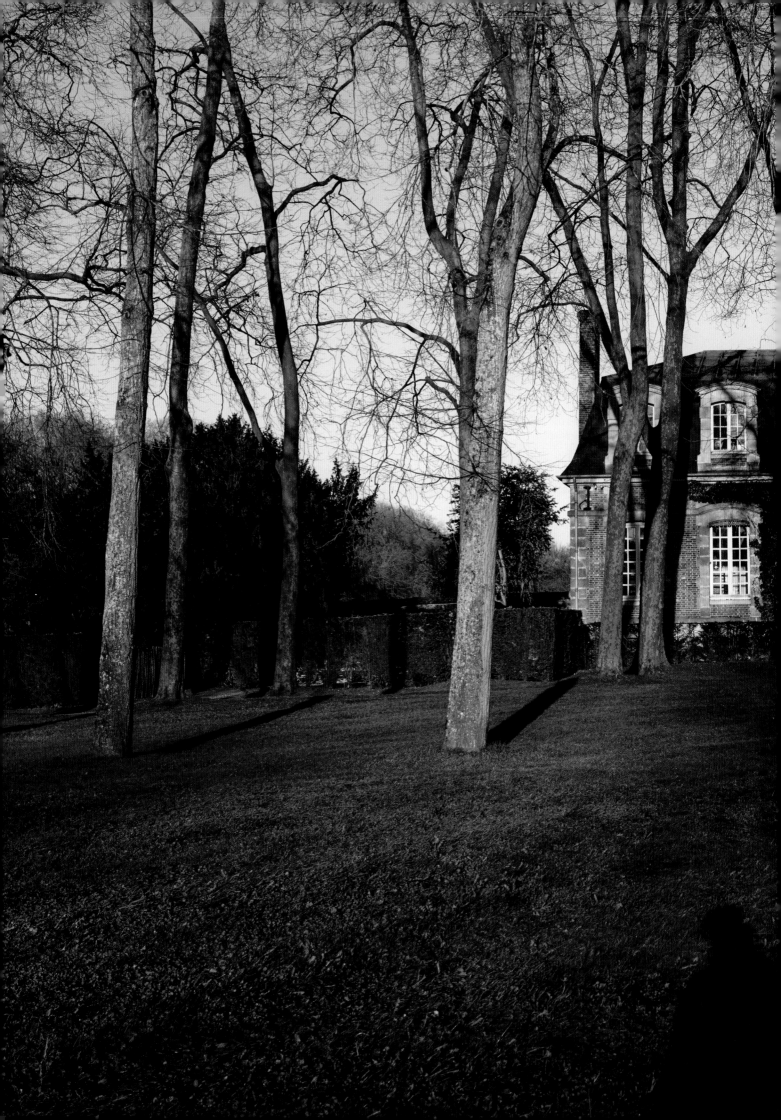

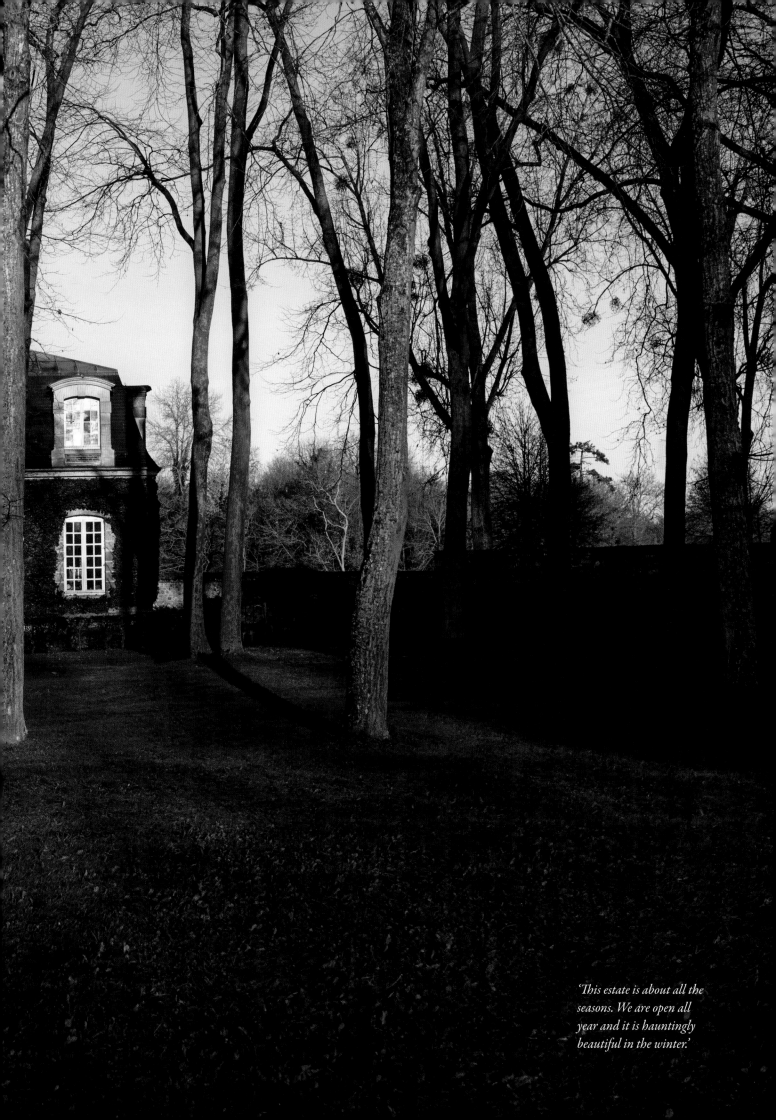

'This estate is about all the seasons. We are open all year and it is hauntingly beautiful in the winter.'

NANCY HOWARD

Artist / Weaver of Dreams / Philanthropist

NANCY HOWARD'S WEST LONDON COTTAGE MATCHES HER TINY NEW YORK FRAME. Stepping off the pavement, under her bower of blood-red roses, the first thing that hits you as the front door opens is the comforting aroma of Nancy's chicken soup. For me, over the years, this nourishing potage has been the cure for a litany of maladies from a filthy flu to a break-up with a bad boyfriend. Nancy's friendship has sustained me like a maternal band aid across the world as I inevitably endured the lumps and bumps of my hopelessly itinerant life. Into the wee hours I have sat with the indomitable Tony Howard (Nancy's late husband, known as 'Mr Grumpy'), listening to him chastise me for choosing my men in the same way I chose my wardrobe! This adorable couple were mentors to a parade of rock 'n' roll miscreants beating a worn path to a bowl of comfort over three decades. With me forever will be images of the three children with Chelsea scarves marched off to the football ground by their dad, with rosy cheeks and eyes bright with excitement. Images that hang like a favoured and rarely worn hat in the passage of our memories. Images so many of our circle share. How many of us entered those portals and left feeling warm inside from Nancy's offerings or with our ears burning from the verbal boxing they had just received? But we kept going back for more and every year we chose a pair of silly socks or a mad bow tie for our Mr Grumpy whom we loved unconditionally, like the rare cactus we kept on the sill for its annual flowering!

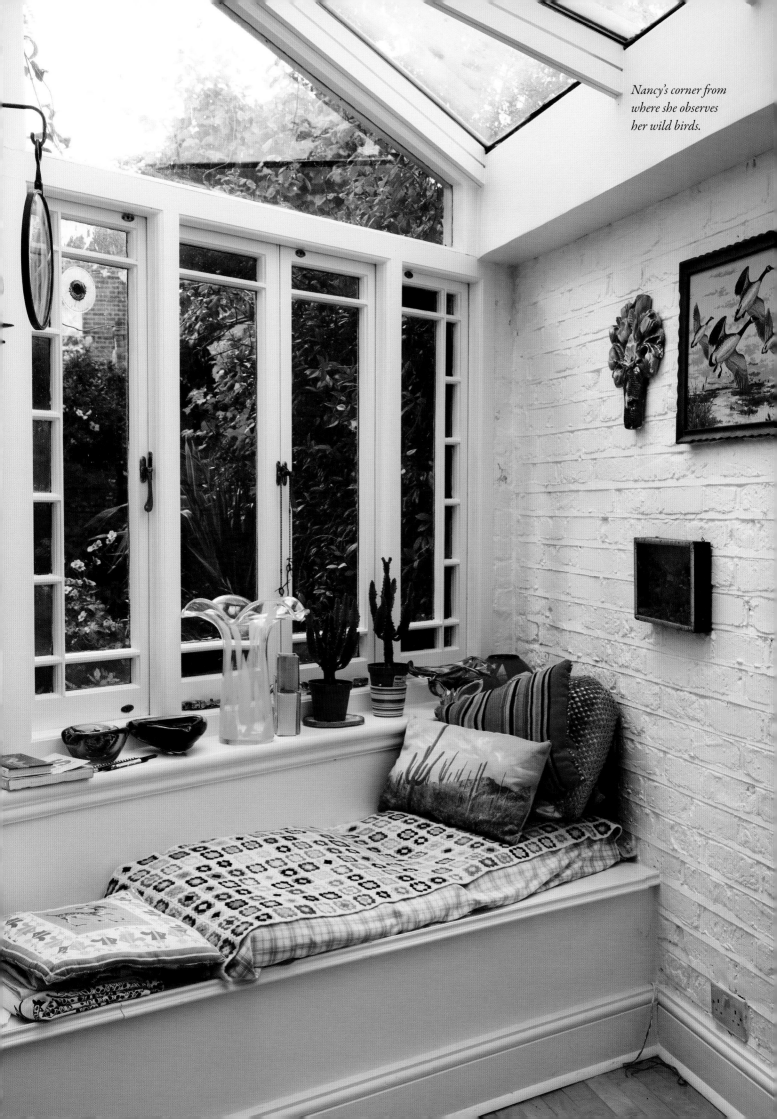

*Nancy's corner from
where she observes
her wild birds.*

'I don't go looking for parties any more. I figure the party is where I am at!'

Tony Howard had a big heart, a short fuse and a long list of principles. While he was on the road – managing Marc Bolan, Tom Robinson, or tour manager to Pink Floyd – Nancy kept the home fires burning in conjunction with running a children's model agency, virtually on the back of a tissue box. When he was home, Tony put the use of his comprehensive record collection to a weekly jive night called 2is in Tottenham Court Road. These events gave all us girls a chance to glad rag it up and put on our dancing pumps while Tony and his partner Jeff Dexter played an alternating rotation of forties, fifties and sixties music to die-hard Teddy boys and their loose-limbed molls. On the road, Tony held a harder line towards the company of women, and was an advocate of the 'no ol' ladies on the road' principle. He believed the wives and girlfriends of band members upset the vital dynamic of the tour. It was tough at the time but, on reflection and from what I remember of those rock 'n' roll years, he was indisputably correct.

With a child on her hip, Nancy made notes and confirmed bookings, baked cakes and made calls to various clients and ad agencies promoting her kids. In tandem with this, Nancy was and still is the eternal charity shop hunter for fashion. Her style has always been unique; she could look elegant wearing a grain sack, by virtue of the way she tied or accessorised it. With her Hepburn elegance, she was the epitome of style. Her house was full of music, rock memorabilia, vintage finds, delicious meals and colourful conversation. Tony was a lucky man. Their bond was unbreakable; they were a united front, parted only by occasional distance but always in finite step with each other. The touchstone to a generation, we dared to think they were forever.

But life can change on a sixpence and Nancy lost Tony in 2001. For a while it was touch and go with Nance, while her close friends waited and hoped she would pull through. Over the ensuing months, Nancy packed up the family home, sent Tony's humungous record collection to storage, closed down her agency, sold the house and acquired the bijou cottage she occupies today. Slowly, ever so slowly, she began to regain some of the chutzpah she had mislaid.

It began with a collection – a picture here, another there – and soon she had recreated, with a pile of bright images, the colour she imagined was gone from her life. Then she faced a blank wall and began to paste. Within a week she had transformed a perfectly plain kitchen wall into a work of art. She flung open the double doors and carried her colourful Mexican theme into the garden. There she stood and contemplated her life and decided it was worth continuing. Soon her decorations livened up the walls of bijou hotels and cutting-edge hairdressing salons, pop stars' homes and hedge funders' mansions. Her instinctive interpretation of a client's personality was a glamorous revelation, a secret indulgence – bathrooms and loos being a favoured location for a Nancy bespoke wall.

This cottage reflects the happiness and security of the past and moves through a gallery of old family portraits to the contentment she has found in the present. Five years ago she met her old university friend Gus Roth and they rekindled their student romance. Gus moved to the UK and together they both continue to visit their respective families in Florida. Nancy's newly acquired passion for weaving means that the entire family – down to her two young grandchildren – cut quite a dash in their tweedy scarves. Her home is peppered with nostalgia and, though she has downsized considerably from the three-storey Chelsea home she shared with Tony, she has managed to fit in the old familiar pieces that we all knew so well; among them, the Art Deco shell bed Tony bought as a bachelor. The rock 'n' roll years are behind her and today the miscreants and misfits have been replaced by the respectable young. The adult children of her model agency are often in touch, eager to revisit the tales of their glamorous infancy.

Every summer, Nancy and Gus host the Howard family picnic in Holland Park and, almost from out of the bushes, old friends appear and reunite over the indestructible memories of the chicken soup coupled with Mr Grumpy and his good advice. Gus wears the face of tolerance with a broad smile and helping hands and Nancy, in the middle of it all, distributes her goodness. Loved and protected by so many, Nancy, the tiny, determined hand inside the elegant vintage glove.

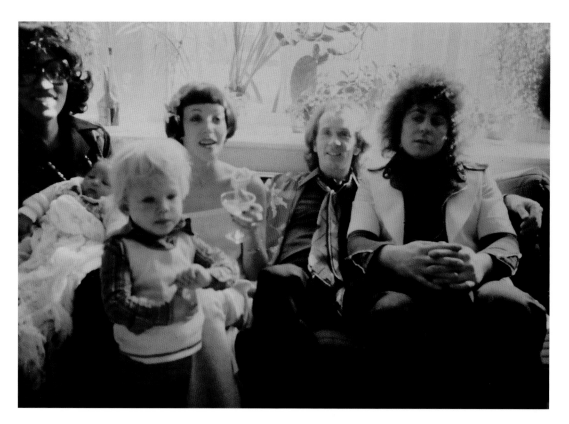

Top: Oh! happy day – Tony makes an honest woman of Nancy, a day shared with their son Felix, Marc Bolan and Marc's girlfriend, Gloria Jones. Bottom left: Nance and Tony were friends and mentors to a crew of rock 'n' roll miscreants. Pink Floyd and friends football team in 1972. Bottom right: Adorable Tony AKA Mr Grumpy.

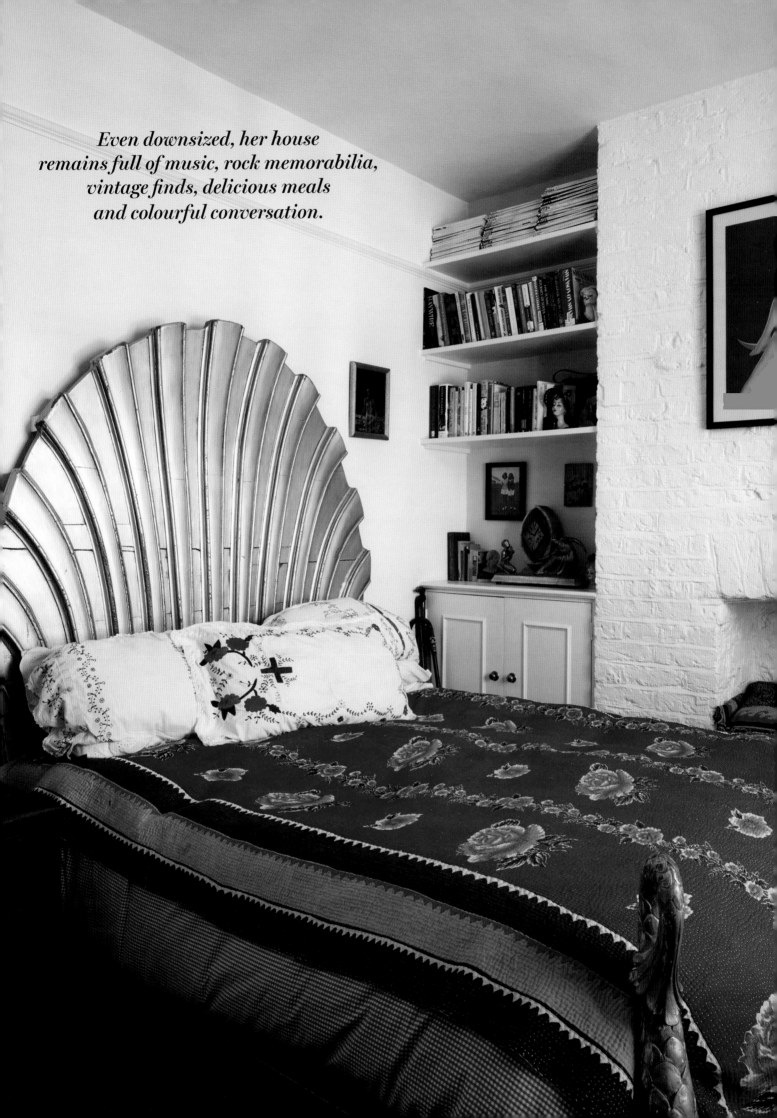

Even downsized, her house
remains full of music, rock memorabilia,
vintage finds, delicious meals
and colourful conversation.

DESMOND MACCARTHY

THESE DAYS, ANYONE WITH AN ENGLISH STATELY HOME IS VYING FOR A FEATURE IN the stylish B&B section of *CondéNast Traveller*. The idiom 'an Englishman's home is his castle', while once conjuring up romantic visions of flouncy-sleeved dandies peering from the parapets to survey their slice of Merry Old England, has now been replaced with 'an Englishman's home is his sink hole!' and the flouncy sleeves are justifiably rolled up to accommodate a pair of rubber gloves and a good deal of 'muck in and muck out' attitude. Desmond MacCarthy is a pioneer of this theory and probably one of the first to put it to the test. These days, an English country gent cannot afford to rest upon his laurels, sending his children off on the Grand European Tour, without first ensuring that his seventeenth-century pile isn't coming to rest gently on his head; thus exists a pressing need to capitalise on one's assets.

Desmond was born at Wiveton Hall. His maternal grandparents bought the house in 1944. They did little to update the property except to repair the roof and do a little painting, and Desmond confesses to have left things much at that until recently when his friend – decorator Annabel Grey – persuaded him to let her beautify some vital rooms. Today he lives in the Hall by himself and Chloe, his widowed hundred-year-old mother, lives in a cottage in the garden. 'Things have changed over the years and now it is considered quite all right to let out wings of your own house. In the old days one was in for a bit of a dig for that!'

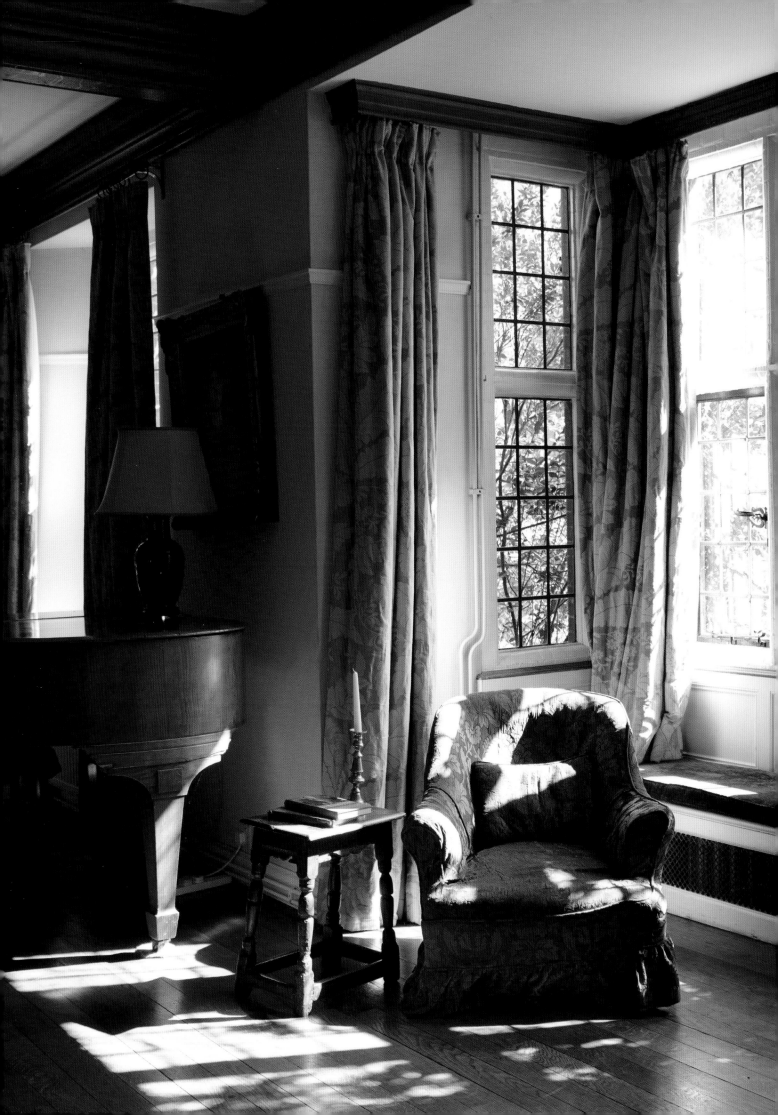

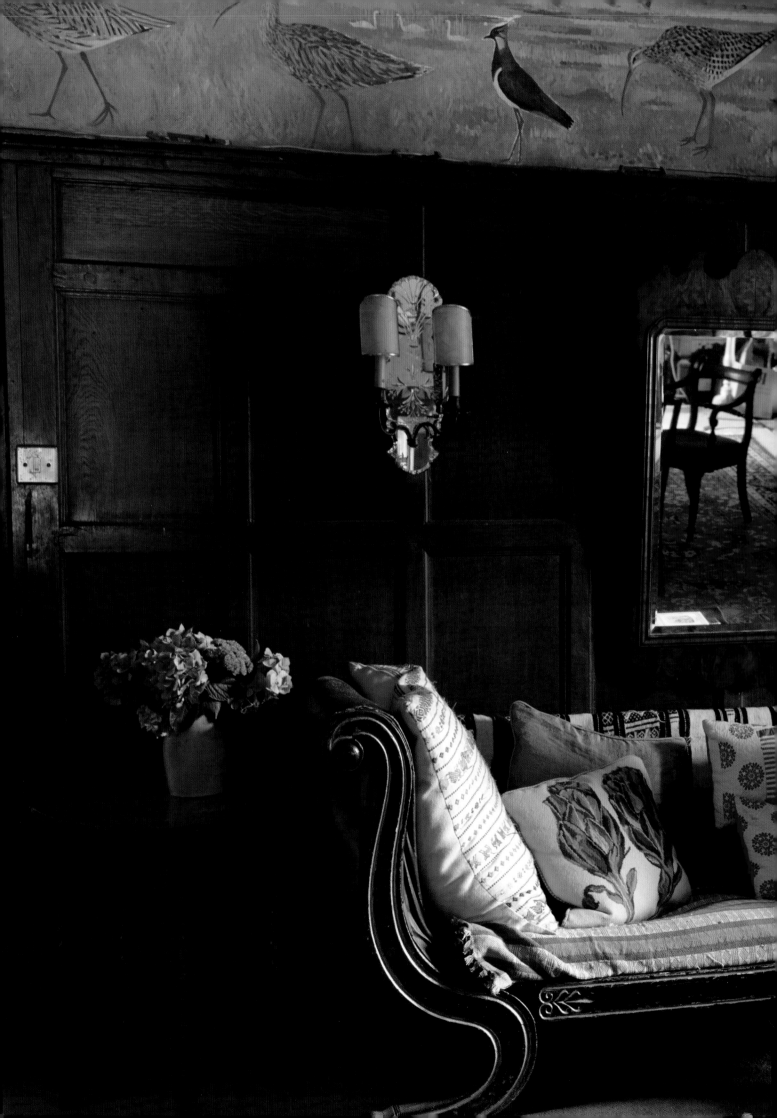

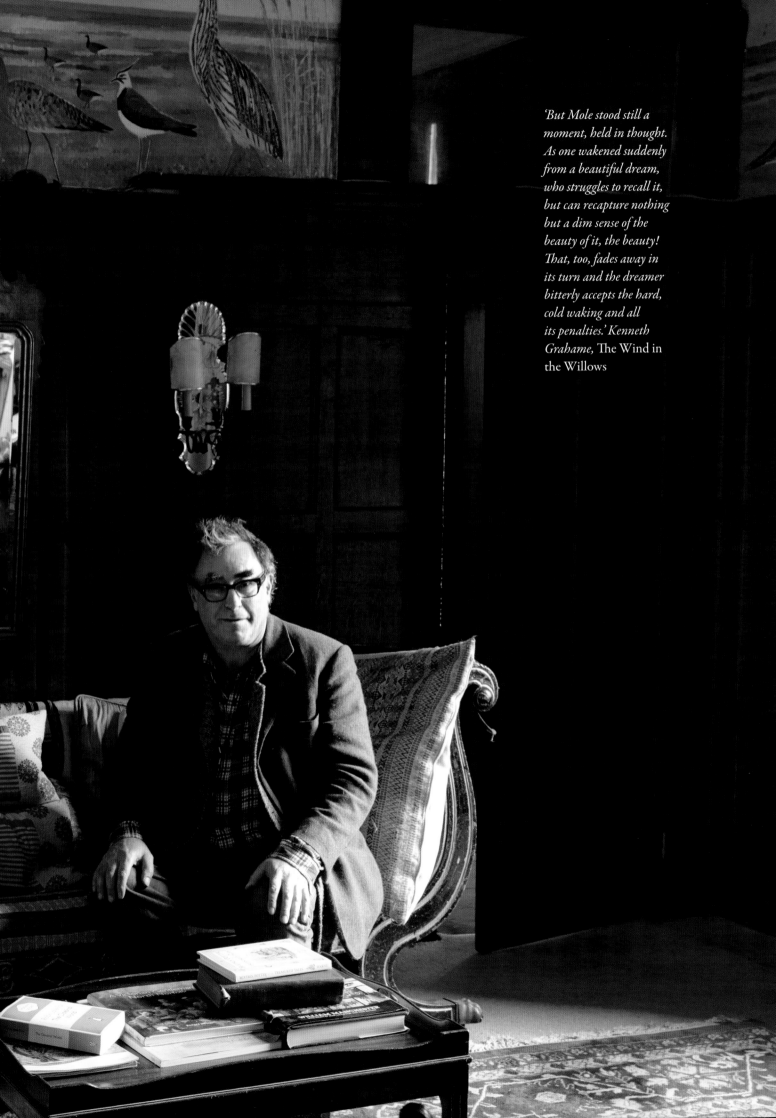

'But Mole stood still a moment, held in thought. As one wakened suddenly from a beautiful dream, who struggles to recall it, but can recapture nothing but a dim sense of the beauty of it, the beauty! That, too, fades away in its turn and the dreamer bitterly accepts the hard, cold waking and all its penalties.' Kenneth Grahame, The Wind in the Willows

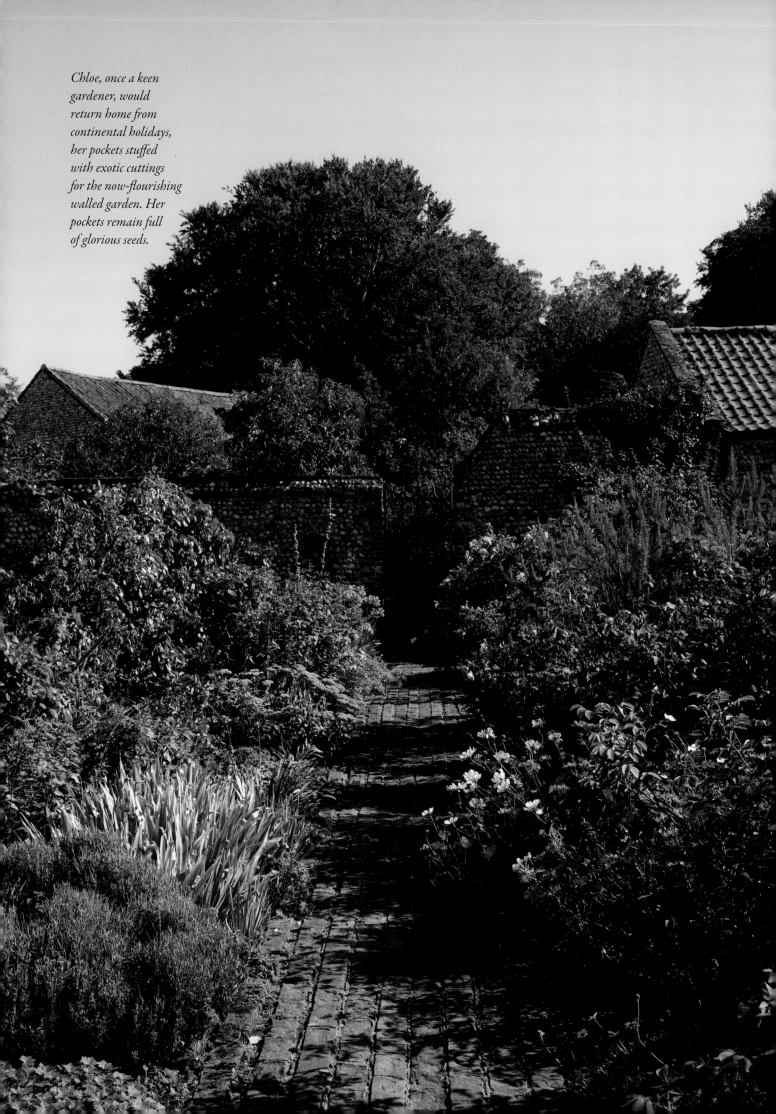

Chloe, once a keen gardener, would return home from continental holidays, her pockets stuffed with exotic cuttings for the now-flourishing walled garden. Her pockets remain full of glorious seeds.

Recently, the Hall has been the subject of a successful TV series based on the assumption that Norfolk breeds eccentrics and oddballs, a reputation founded by doctors who wrote NFN (Normal for Norfolk) on prescriptions to categorise mentally challenged patients! Inbreeding is no longer so prolific, Desmond assures me. He feels it was quite accidental that the series was funny. Since the show, his eyebrows have become the source of much amusement and Chloe is enjoying an inundation of attention from overly enthused fans.

Norfolk is on the way to nowhere. It covers that far eastern part of England that rests in the sea like a huge dowager's bottom. For six weeks a year, the woods are full of bluebells, the fields become an ocean of undulating wheat, and the sea gives up its tastiest creatures to a sudden invasion of avaricious City gourmands. Wiveton becomes a veritable Garden of Eden. During this time, Desmond's tweedy pockets are jingling to the sound of the café's till.

'We had a man here who worked for fifty years. He could do anything from painting the rooms to cutting down the trees to herding the cattle – always making do. But so much has changed now … standards are so much higher. People are so particular about electricity and things! No one wants to see the wiring any more.

'Everyone seems so very impatient these days; everything is so space age. My mechanic can't even get here because the computer has broken in his car. But my Polish helpers are happy to walk to work every morning … we don't consider walking anywhere any more!' Chloe, once a keen gardener, would return home from continental holidays, her pockets stuffed with exotic cuttings for the now-flourishing walled garden. Today she still enjoys a daily walk, hand in hand with her son, to the bustling café that keeps her fed and amused. Since the TV series, both she and her son have become national treasures.

Desmond is bursting with ideas for Wiveton's future, from yoga retreats to concerts, and the beautiful West Wing is pure antiquated luxury. He doesn't feel that it is natural for people to have terribly tidy houses, not when they have children and friends coming for barbecues, plus their dogs and animals. He does like to keep the whole estate as much of a 'lost domain' as possible and that, he says, is why the drive is fairly unmade up. 'This is also a little accidental as there is never enough money available to spruce it all up.

'I am not against change but nothing cataclysmic needs to happen, does it? We have improved the house here and there. Yards of new fabric … terribly expensive isn't it?'

Desmond feels that hard work has to be fun and though he would rather be working in the woods on a daily basis, he is now committed to focusing on the business and feels that he really doesn't have enough woods to keep him completely occupied anyway. 'It is excellent to be paid for having fun, don't you think?'

He picks up a little book as he sweeps through the hall to the West Wing. 'Look, I found this for 10 pence … isn't that remarkable? It is written by my grandmother.' On his mantelpiece sits a tiny painting by Dora Carrington and another by Vanessa Bell; there are artefacts from that Bloomsbury era all over the house. His paternal grandfather, Sir Charles Otto Desmond MacCarthy, was a noted literary critic and a member of the Cambridge Apostles, well known among the British Bloomsbury Group of artists and academics.

Like all true Englishmen, Desmond is not a man to dwell on the hard times. One feels he lives by the motto so profoundly ingrained in his schooling: Play up, play up and play the game! His mind is whirring with pressing, practical issues, then suddenly he is paused like a clockwork mouse; a perfunctory dream sabotages his most urgent matter. Then he is off, back through the dusty halls to pick up where he abandoned his daily duties, out of time and muttering to himself like Alice's white rabbit. Over a herringbone shoulder he tosses a reminder that he will meet me in the café for lunch at 2 pm sharp.

I wander to Chloe's cottage to escort her to lunch. This home is full of ravishing surprises, small details can be found in every room and Desmond's quirkiness is represented in piles of untouched and ancient ephemera – held together by intruding weeds – on random windowsills. This pair are bound together by land and legacy, keeping the home fires burning with a generous helping of duty, respect and civic pride; extending a welcome and warmth way beyond today's expectations. Long may Wiveton remain the discombobulate lost domain.

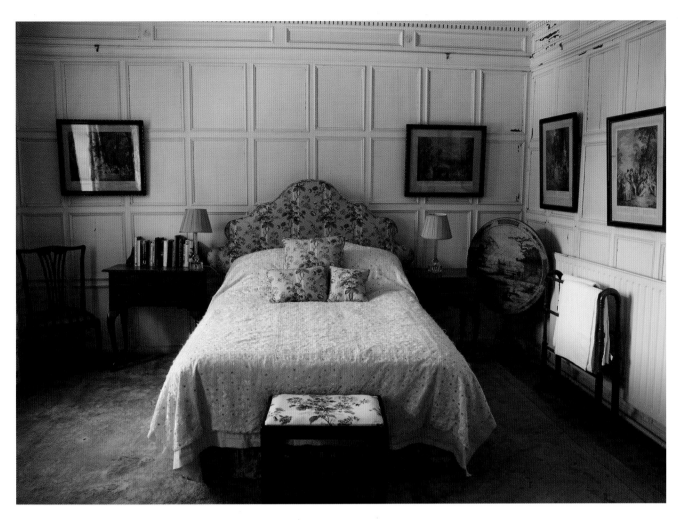

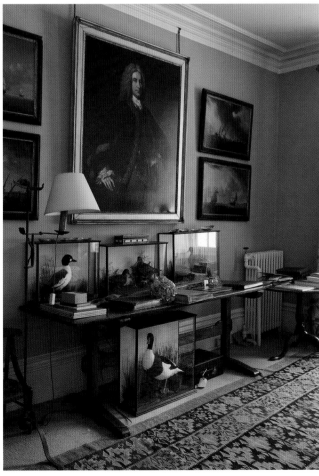

'I really don't think that one has to have a terribly tidy house! And why would you not have an organic house when the farm sells organic produce and the café serves organic food?'

REBECCA PURCELL

HER STYLE IS ECLECTIC AND HER ENTHUSIASM FOR HER WORK AND COLLECTIONS insurmountable. Rebecca cannot help but sparkle as she hunts through her many baskets, drawers and piles of what she refers to as her junk, looking to gather a few unique pieces and form them into a family for my benefit. These pieces are recycled regularly and continue to sneak into photoshoots where Rebecca weaves her spells.

From five years old until twelve, Rebecca gathered forgotten, forlorn items and created little realms of beauty, into which she injected her imagination. She didn't grow up in a perfect home and her childhood was not the happiest, but with her little gang of friends (aptly named The Little Dudes!) she would create tiny kingdoms and each child would talk these up into an exclusive story and thus make magic out of everyday detritus.

From an early career in display, Rebecca knew there was a deep need inside her to gather objects and images together to make a perfect world for herself. She is curious about her emotions and believes that even if happiness had been handed to her at an early age, she would still want to explore the full spectrum of feeling, beauty, joy and pain. Avoiding or blocking pain, she believes, is what we are seeing too much of now, and the collateral damage from this can be devastating. 'I am certain that part of the reason I surround myself with these objects is that they bring me a sense of comfort.' But just as importantly, Rebecca feels the multi-layered, textured complexity of her home energises her and allows her to be highly creative. Sometimes she wonders whether, if

Among Rebecca's passion for collecting tiny things are these miniature chairs. The idea that anything this small should be so painstakingly and accurately produced, speaks of an era when things were less driven by time and motion.

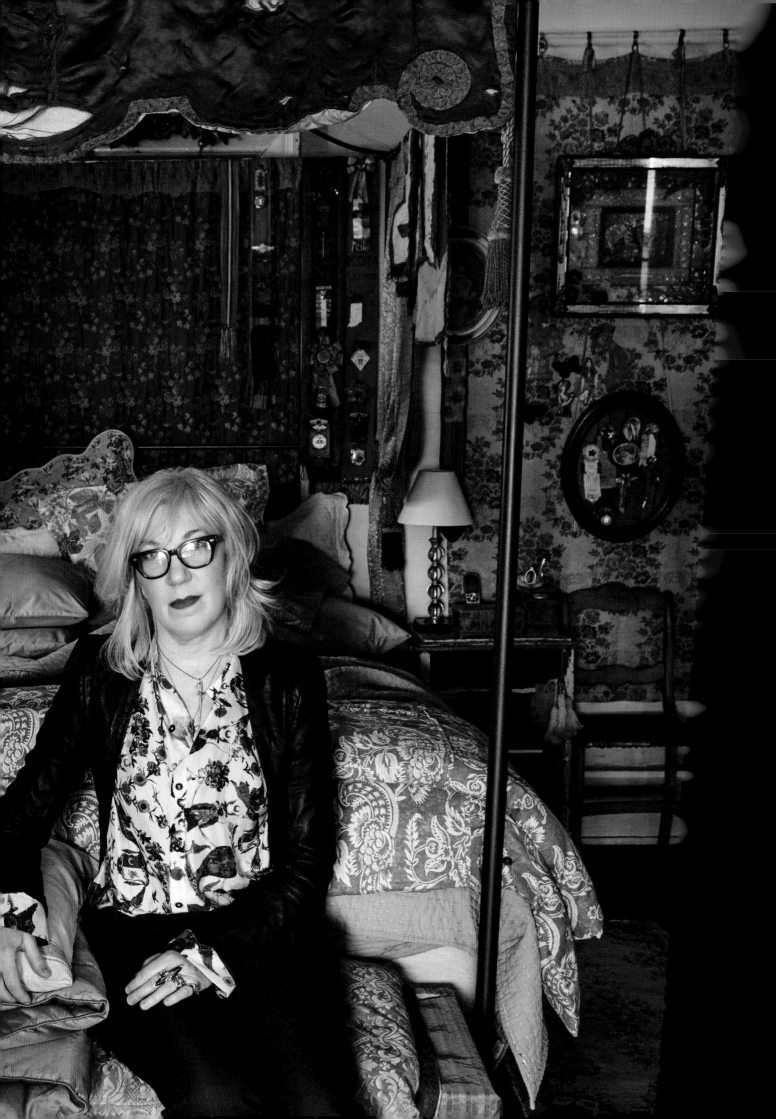

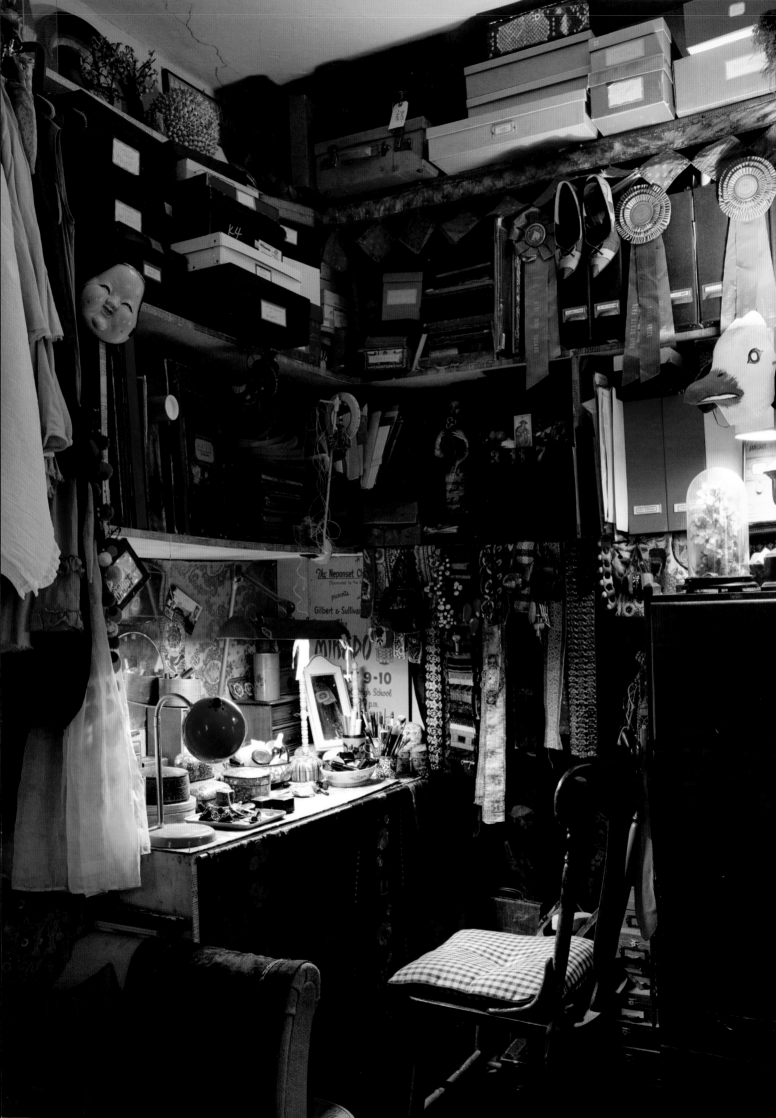

she had been a happy child, she would be mentally healthier and living in a homogenised and minimalist home.

In the early nineties, Rebecca earned the position of Display Director to New York's most exciting conceptual department store: ABC Carpet & Home. This shop was a revelation, an Aladdin's cave of East meets West exotica. There had been nothing like it in the retail arena before. Uncertain of her early role at ABC, proprietor Paulette Cole began to ask Rebecca to create vignettes and room sets using all the eclectic furniture and textiles she was gathering on her worldwide journeys. Over time, Rebecca, put together a team of fifteen people and created the look that spread right across America in just a couple of years. Her themed displays over six retail floors and twenty-seven windows caused a paparazzi meltdown when the stretch limos lined up outside one by one, dispatching a discerning cargo of celebrity clients through the ever-revolving mahogany doors. For this, Rebecca earned high critique for her individual way of combining past and present or, as she puts it: 'Creating in the spaces between things'. Eventually this segued into a freelance career working with the company that was stealing first position for their most romantic approach to visual marketing: Anthropologie.

Rebecca's ideas come from an eternally prolific source. She is able to amalgamate the most unlikely subjects into a comfortable coupling with the potential to evoke a deep familiarity within us, perhaps a feeling of sorrow even; the melancholia that drives us to investigate layers, to discover ourselves through personal memories of everyday items portrayed in her cameos. It is an all-pervasive feeling and links us to a past of which we have no conscious knowledge, a haunting of images, an aesthetic adventure, a looking glass into how we have evolved.

Nowadays, coupled with her styling, Rebecca has expanded this talent into developing her own deck of cards for what she calls 'World Making' through a library of philosophical symbols from Western culture. It's a kind of tarot card pack which she reads as a possible pointer to a personal creative journey, so when you pick a card and read the symbol, Rebecca will help you find an authentic passage into the self. She is workshopping with museums and Jungian libraries to wade through a matrix of esoteric information as a way to articulate symbols through the ages to the present in order to understand the collective unconscious in today's culture.

She has travelled a long way from styling sets that involved rowing her props out to a house on stilts in the middle of a Jamaican bay to bartering with an old Indian street vendor for his dirty bucket and stool, or overseeing her assistant taping scarves to a gathering of little pink pigs. 'I didn't do it myself, but I had to watch and feel bad for her!' Rebecca doesn't actually feel the impulse to get on a plane any time soon. Her time is for herself now and she prefers to divide it with her work in the studio of the apartment she has lived in for twenty-two years, and weekends at her home in the Catskills, New York State, which she shares with her partner Geoffrey. She likes creating little souvenir cards that she can exhibit in local antique shops. It is time, she says, to please the self. Sometimes she thinks she may go minimal, de-clutter her life – prune. Rebecca is confident in her pruning abilities. No good at gardening but pruning and cleaning out the old wood is something she loves to do in the country. A minimal life would have to be textured, she says. 'Many people make their houses resemble hotel rooms these days; for these people there does need to be a bit of jooshing from a stylist or an interior designer. But for me I can't do the client thing.' My guess is that when you have spent more than thirty years learning and practising your craft, there inevitably does come a time when you decide to sacrifice the dollar for integrity and well-being. You have to hope that compromise becomes part of a collective decision to be true to the self. This is the moment when potential genius is born.

I left Rebecca's home feeling a little puzzled but desperately clinging to the tail of her theories, checking I had it all on tape. She was passionate in explaining her modus operandi for an authentic life. Slowly it dawned on me that this belief is the foundation on which Hugh and I have produced this book. It must be the road map to creating a harmonious life for ourselves and others. It must help us have an awareness of our footprint on the Earth, our attitude to change and understanding of human nature. But somewhere the pressing matter of money separates us from instinctive choice. Whoever would have thought that a stylist, known for creating pleasing images, could actually contain the code to contentment in the tiny tips of her ever-busy fingers.

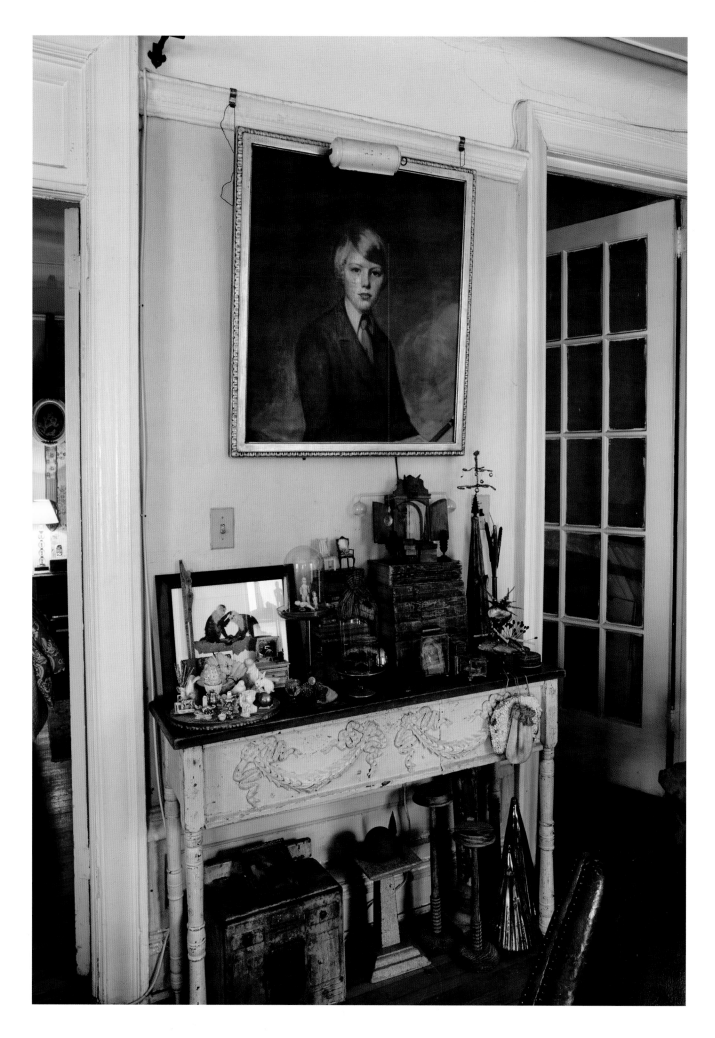

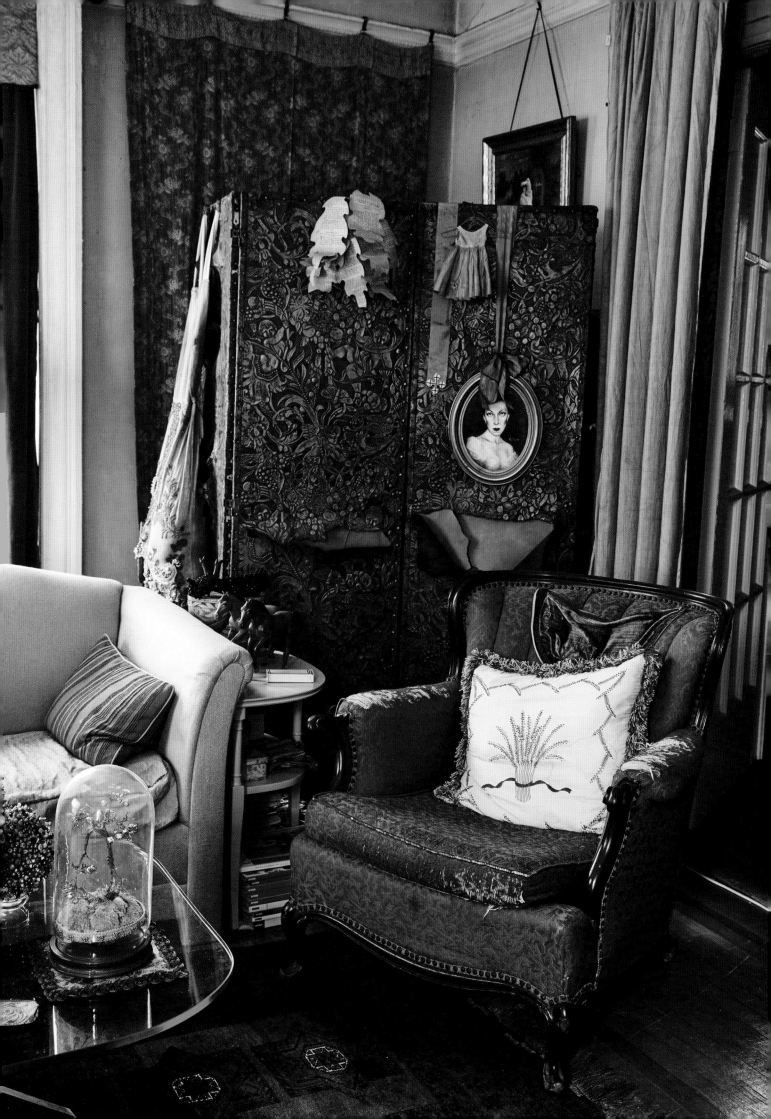

This apartment remains virtually in its original condition from when the building was erected in 1922. Little has changed except for Rebecca adding a coat of paint here and there, over the eight or nine existing layers that were already on the walls. Among her collections of tiny things are the souvenir cards she illustrates for her community.

MELISSA NORTH

Interior Designer / Socialite / Hostess / Bookworm

FOR AS LONG AS I CAN REMEMBER, MELISSA HAS HELD A PLACE AT THE HEAD OF THE most illustrious and literate tables in London. Along with her architect husband, Tchaik Chassay, and two partners, she founded the original Groucho Club in London's Soho and set about the decoration in what, at the time, was an authentic mismatch of shabby Bohemian style. It was 1984, we were cruising into a fashion for big hair and shoulder pads; expense accounts were excessive and our interiors were beginning to reveal an absence of the feminine touch as women set up careers, leaving the gate open to the trend for chrome and steel to subjugate the British love of faded chintz.

Melissa comes from a family ruled by educated, independent free-thinkers and innovators. Indeed Melissa's maternal grandmother was Mary Hamlin, founder of The Hedges Inn in East Hampton, New York, which now houses a museum. She later bought thirteen houses in the immediate vicinity, restoring and furnishing them accurately in keeping with their original period.

No surprise then to find her granddaughter, some six decades later, trawling London's Portobello Road market to find genuine one-off pieces for a club that would gain the reputation for welcoming the literati and the educated, crumpled, Bohos of London. As far as I remember, the only things that matched in the Groucho of that time were the exquisite alabaster pyramid table lamps that Melissa happened to pick up on a trip to

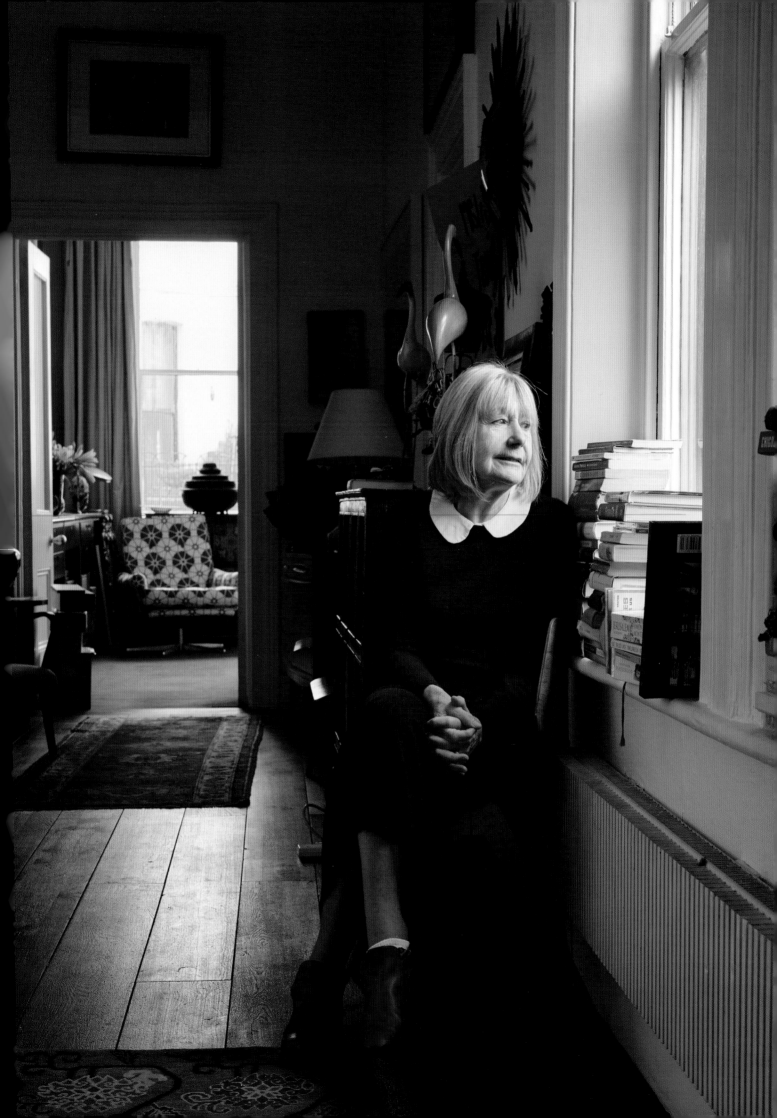

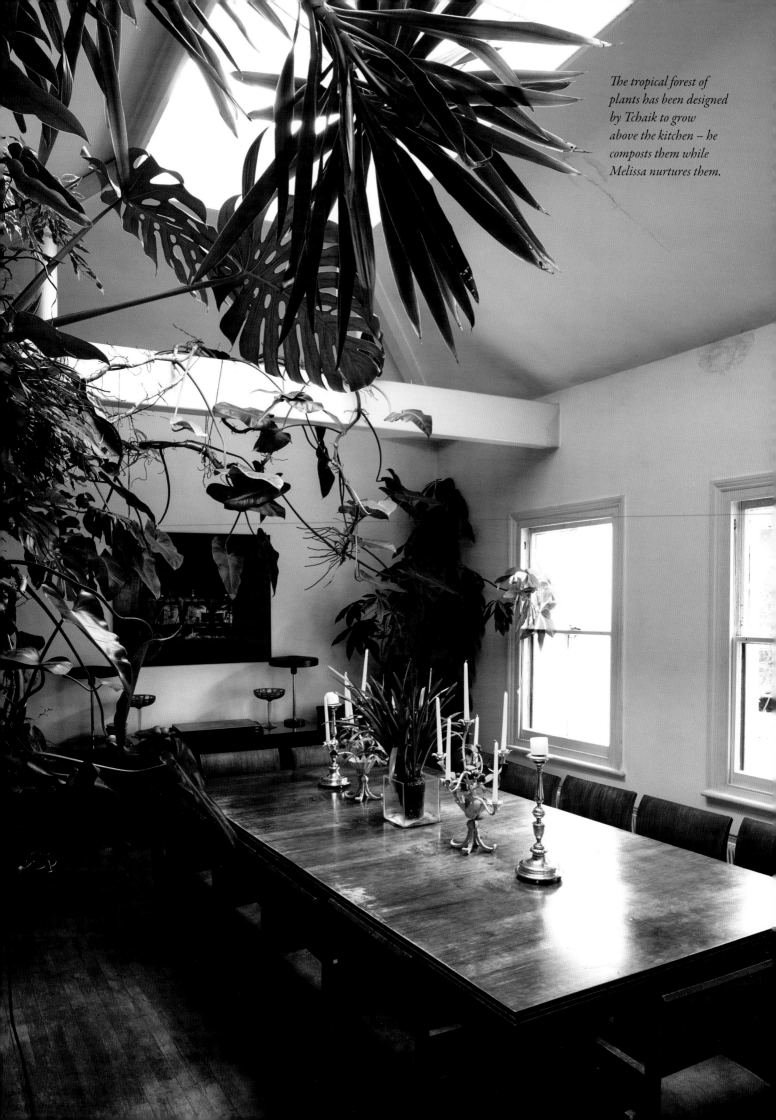

The tropical forest of plants has been designed by Tchaik to grow above the kitchen – he composts them while Melissa nurtures them.

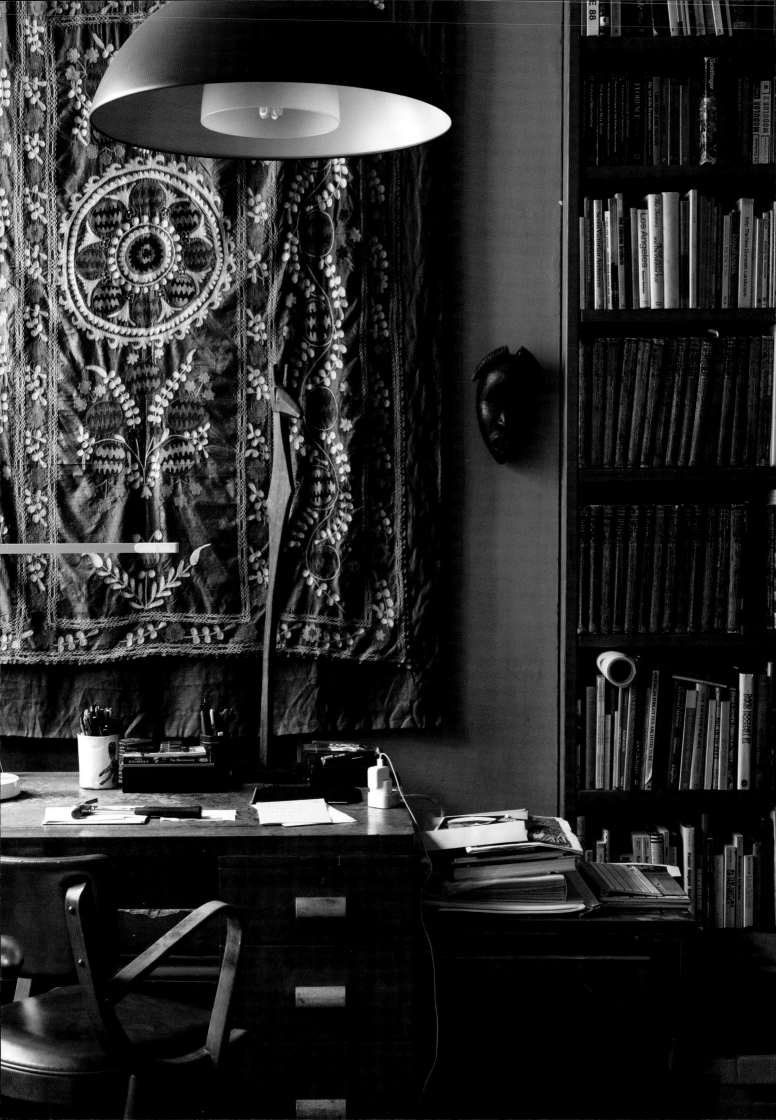

Egypt. Her gift for installing the original is perfected by the number of years in the 1960s that she spent stripping and painting Victorian furniture for the 'junk' shop she shared with her friend Celia Brooke.

When this closed she embarked on a series of adventures travelling the East; setting out on horseback across Afghanistan and eventually returning to the UK with the horses! She has travelled with her possessions packed in grain sacks and sailed the Aegean to the home her sister Mary has kept in Greece for over four decades. Her clients have been her friends – from Paul Simon to David Gilmour – and more recently she was working on the designs for a new house with her dear friend Carrie Fisher. It was on the return journey to LA that Carrie suffered a heart attack and sadly died. Melissa was naturally devastated.

Melissa and Tchaik came by this home after the owner, their friend David Hockney, asked Tchaik to convert two apartments into one by knocking through the adjoining walls, creating long vistas from the grand drawing room to the mews at the rear. The conversion was overseen by David's partner, Peter Schlesinger, and while Tchaik was designing the structure, Peter was arranging the details. For a while, David and Peter lived together in the newly converted, all-white apartment, but then Peter left and David fled to Paris to live for a year. During this interlude he let the apartment to his friend the fashion designer Ossie Clark, who proved to be a less than reliable tenant. On Hockney's return he was furious that Clark had thrown out his magnificent fireplace in order to make room for his own mirrors. He refused to move back into the apartment and, as he had recently bought the entire building, asked Tchaik to build a further studio above the existing space. Melissa remembers the whole house shaking for ten minutes as the roof was lifted off to create a large glass lantern. For a time, David lived in the studio while Tchaik and Melissa moved into the newly vacant flat. But a restless Hockney decided to move back to his old studio and sold the apartment to them for £25,000. 'For the first year we lived with all David's wonderful antique furniture, and then one day, a truck came to pick it all up. Terrible shock!'

'It took forty-two colours to get this shade of green,' Melissa tells me as we walk around the flat. Enthused by the colour she saw at night emanating from the windows of small shops in the Yemen, she waved a sample of a small Qu'ran stand she had acquired in the same colour at her specialist painter, never imagining it would take two weeks and involve layers of every conceivable shade of yellow, pink and green to achieve the final shade.

This house is dominated by the huge Art Deco dining table that has absorbed a fine selection of stories accompanied by the spoils and spills from various other stimulants over many a good meal. Melissa chuckles over the night her greatest friend – 'His Eternal Grumpiness', Nancy's husband Tony Howard – debated into the dawn with a young man somebody had brought to the table who had been largely overlooked. Tony, an avid sports enthusiast, later enlightened the fellowship that John McEnroe had been THE most awe-inspiring guest and fortuitously for Tony, no one, including his hostess, had the faintest idea who he was.

It is from this apartment in Notting Hill that Tchaik and Melissa have brought up their two erudite children, Dixie and Clancy. Motivated and prepared for everything the world might throw at them, they have grown up surrounded by a conglomerate of fascinating and creatively motivated people.

The walls of this home are hung with a variety of nostalgia in photos of the old days: an unfinished painting by Hockney of Tchaik, wearing a Fair Isle jersey his mother knitted; many personal pics of fun in the sun, with friends in the beloved village of Lindos, Rhodes; a colourful pottery collection. Not to be missed are Melissa's many books in piles, both read and unread, hidden from Tchaik behind chairs, under cupboards and occupying most of the windowsills. The entire room is offset by Tina Barney's larger-than-life photograph of Melissa in red. Melissa then and Melissa now. A poignant contrast between the Melissa who had so far to go and the Melissa who sits calmly regaling me with stories of her intriguing travels and experiences. Today perhaps softer and with a deeper perspective than she had as that woman in red. Perhaps some day soon an autobiography will be due. She doesn't read memoirs, possibly because they can be loosely based around factual events and more involved in emotional truths, but an autobiography is focused on fact and detailed chronology, for which she has the sharpest memory, a lightning wit, formidably articulate. A natural raconteur!

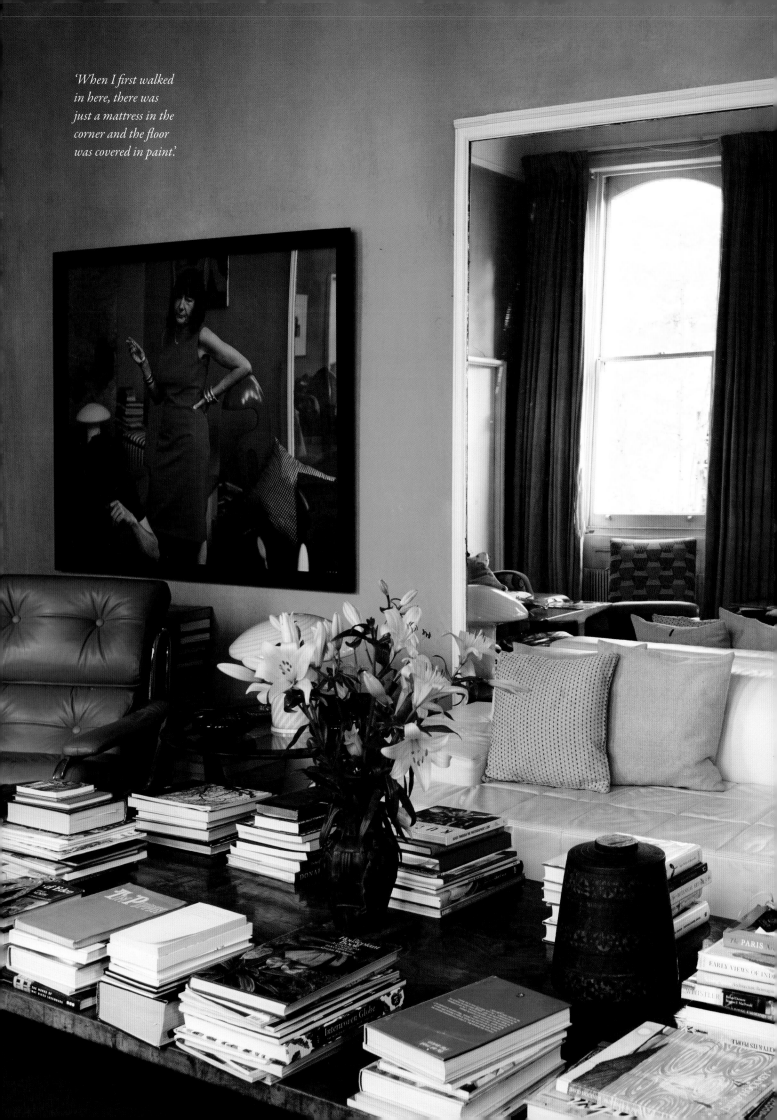

'When I first walked in here, there was just a mattress in the corner and the floor was covered in paint.'

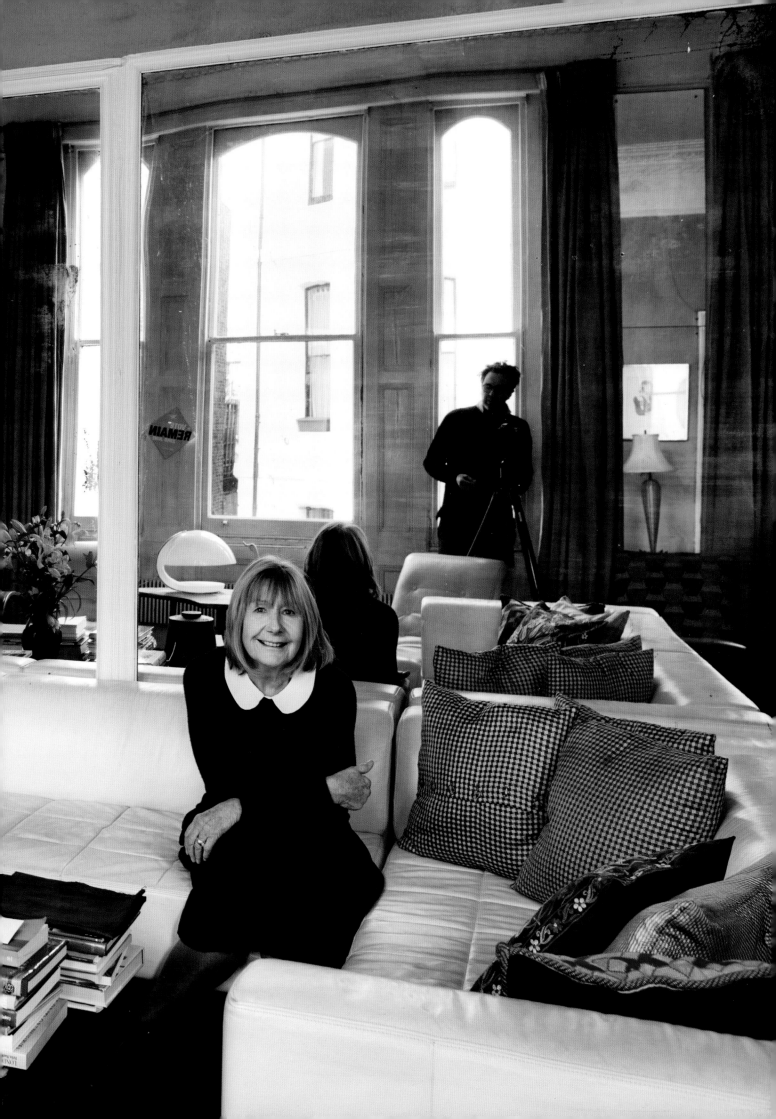

Top: A treasured image of Melissa and her late, great soulmate, Tony Howard. Bottom: In the black and white photograph, His Royal Highness the Duke of Edinburgh inspects the pudenda of a spoof photograph of the naked Marilyn Monroe by artist Alison Jackson. Other precious mementos of a rich past adorn the walls and surfaces.

CHRISTOPHER HOWE

Interior Designer / Furniture Maker / Historian

IN AN ERA IN WHICH INTERIOR DESIGN HAS BEEN REDUCED TO MAKEOVERS AND quick-fix solutions, where MDF has stolen the soul of anything that remotely resembled craftsmanship, patience or endurance, Christopher Howe has resisted the temptation to become an overnight interiors guru and instead he has adamantly stood back, observed and stuck rigidly to his belief that good things take time and effort, and the eventual reward is contained within the beauty and longevity in using traditional skills and methods to build a noteworthy piece of furniture. As such, he is considered a designer of exceptional repute.

Growing up in a fairly large but unremarkable post-War British house, the son of a nuclear physicist stationed at Aldermaston, Berkshire, where he split the atom and invented the silicon chip. 'There wasn't a single piece of antique furniture in our house.' On a civil servant's wage, his father furnished the home, making virtually every piece himself, including a kitchen fashioned from recycled laboratory tops. The youngest of five, Christopher remembers annual family holidays, setting off in a green Zephyr 4 with tents and camping equipment packed neatly on a roof rack. His father had fitted the rack with rubber suction pads and an ingenious pulley system. In this way, returning home, the entire package could be winched up and stuck to the ceiling of the garage ready for the next break. No surprise that inside Christopher beats the heart of the inventor.

Today, while being audibly suppressed by Bertie, his over-effusive mutt, we are listening to Christopher

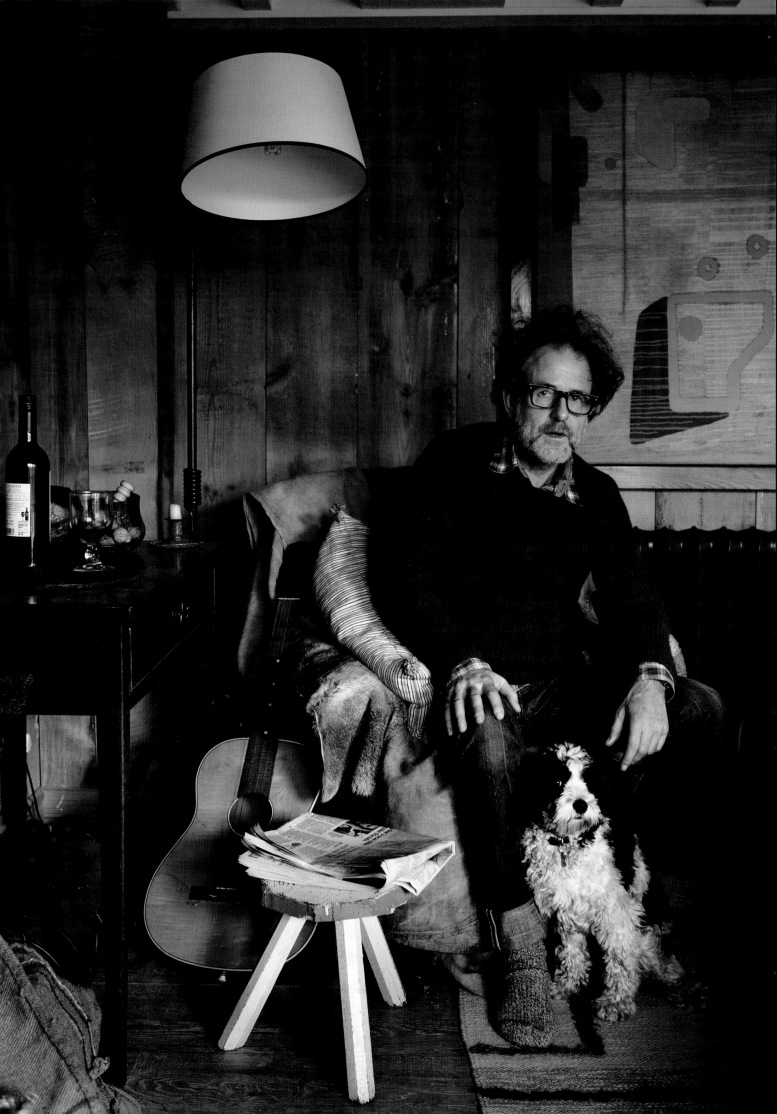

Much of the restoration on the sheep barn was done with architectural salvage, in line with Christopher's belief that the traditional materials and techniques impart the greatest rewards. Where this was not possible things were made by master craftspeople. The gate-and-latch door handle leads to a genuine Thomas Crapper loo.

explain the benefits of spending his weekends out of London, in the converted sheep barn he renovated and shares alternate weekends with a friend. In the middle of a Gloucestershire field, he took on the project with the intention of keeping strictly to his eighteenth- and nineteenth-century design principles, but using a doll's house approach to letting in light and creating the impression that a compact space can be rather grand. Every detail of this beautiful building has been painstakingly thought out and works on a miniature scale as efficiently as the staff quarters at Downton Abbey! From the wood stove that might warm the nether regions of a chilled footman, to the 'gate and latch' handles on the door of the bathroom, which reveals a deluxe wooden throne, where a sufficiently warmed up footman's nether regions might quite comfortably sit with the newspaper. This is Thomas Hardy revisited, and although in its new incarnation it provides all the comforts of modern living, we are acutely aware – by virtue of the entire façade being glass – that nature is just a step away. The deprived sheep are grazing somewhere and Bertie knows where this is – but will anyone listen?

On the promise of a fine pub lunch, Christopher regales us with the fascinating story of how he shifted from being an antiques dealer to becoming a furniture maker. During the Second World War, grand country houses were commandeered for military use for what was expected to be a relatively short period of time. Furniture, paintings and valuable household items were dispatched to the attics and cellars of these edifices in expectation of the happy day when it was deemed safe for them to reappear. No one knew at this point that this would take six years. When life resumed to post-War normality, things that were stored in attics were often abandoned as there were no longer enough willing strong arms to deliver them back to their rightful places.

The outcome of this was that precious things were ignored for decades until the advent of the country house sale in the fifties and sixties. Items unsold in those decades remained hidden in the darkest corners of the attics or outhouses until, desperate for restoration funds, they once again came up for auction.

In one such sale in Norfolk in 1990, Christopher found 54 pieces of an old bed from one of England's stateliest houses, Raynham Hall. He knew it to be complete and had a hunch that it might be an eighteenth-century state bed. Bidding against the well-known interior decorator Christopher Gibbs, the hammer finally went down on a five-figure sum. Christopher had bought himself a royal bed. He now had to find the means to pay for it. Luckily a good friend lent him the money and, with the help of a master restorer, he reassembled the entire thing and restored the carving, to discover that, fully erected, it was over five and a half metres (eighteen feet) high. The urgency now was to have the bed photographed and to move it on in order to repay his debt.

Christopher hired an old bus garage in the East End of London to house the bed. It then took a further two years to have an archaeologist verify and catalogue it, and confirm that it was indeed a state bed, having been made at Raynham Hall for a visit by the Prince of Wales in the early 1700s. As often happened, the Prince altered his plans and never actually slept in it. Eventually the bed was bought by Simon Thurley for the restoration of the apartment of King George II at Hampton Court Palace. It was later discovered to be a rare Angel bed, most often associated with women and royal mistresses, taking its name from the ethereal appearance of the canopy suspended from a single hook in the ceiling. It is now on display in Queen Caroline's private bedroom at Hampton Court, where she would have received her king.

After all the costs, Christopher doesn't think that anyone made any money on the bed but he feels delighted that it is where it is, and he can take his grandchildren to visit whenever he wants to. Since then, with his expert team, he has continued to make and restore historical furniture using the old authentic methods.

One of his regular clients was painter Lucian Freud who collected several dilapidated armchairs. This is Christopher's area of expertise. One old chair deserves another and both might look as if they have seen better days, but don't be fooled. Hours of love have gone into measuring and crafting the solid frame, blood has been spilled hand-stitching the upholstery, weeks spent locating the antique ticking. No one is trying to fool anyone. Christopher Howe is all about integrity; about restoring beautiful things or transforming them into something else. And if Bertie is able to locate those damned sheep, a bountiful amount of wool awaits.

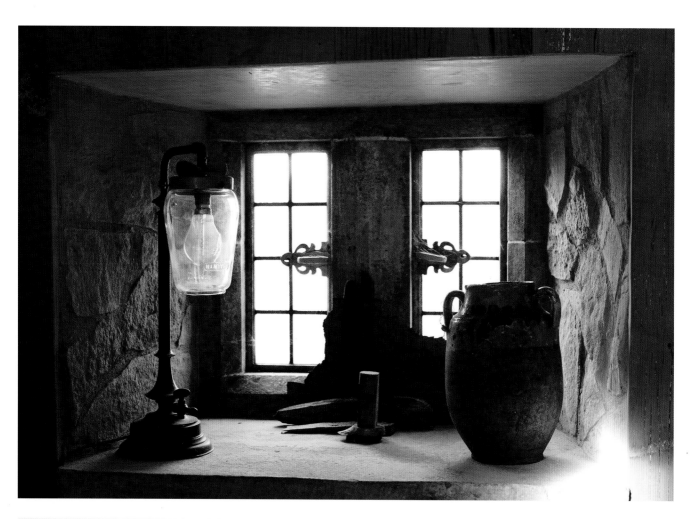

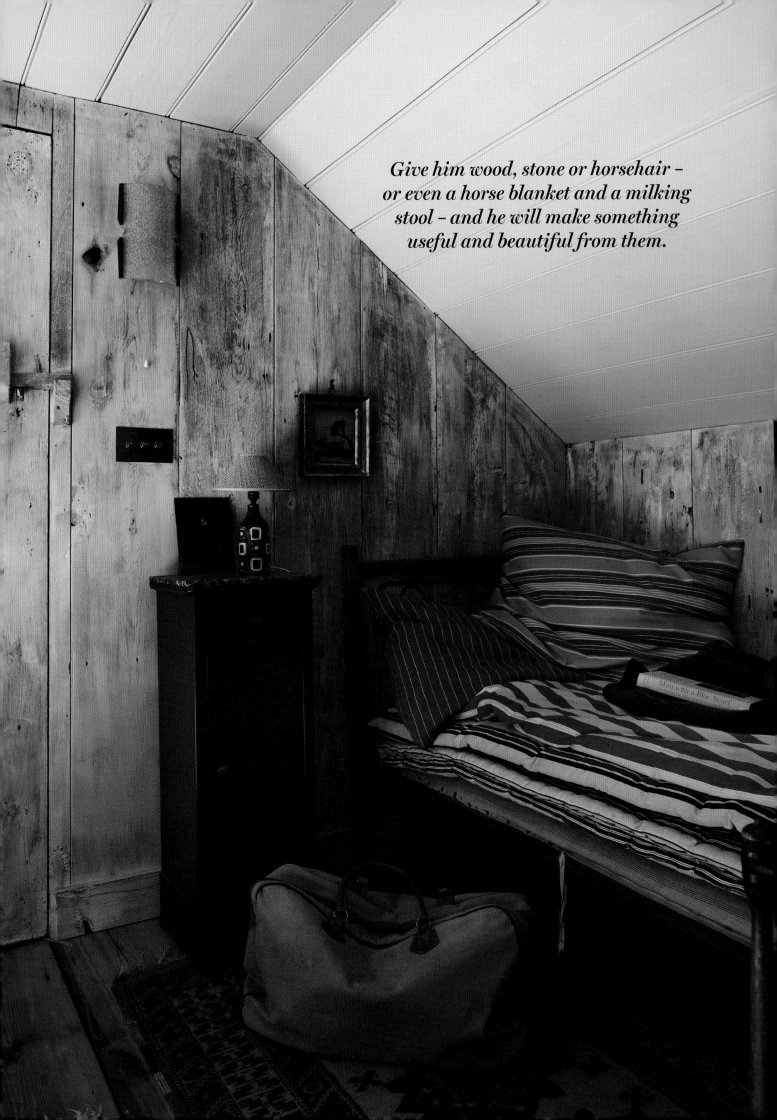

*Give him wood, stone or horsehair –
or even a horse blanket and a milking
stool – and he will make something
useful and beautiful from them.*

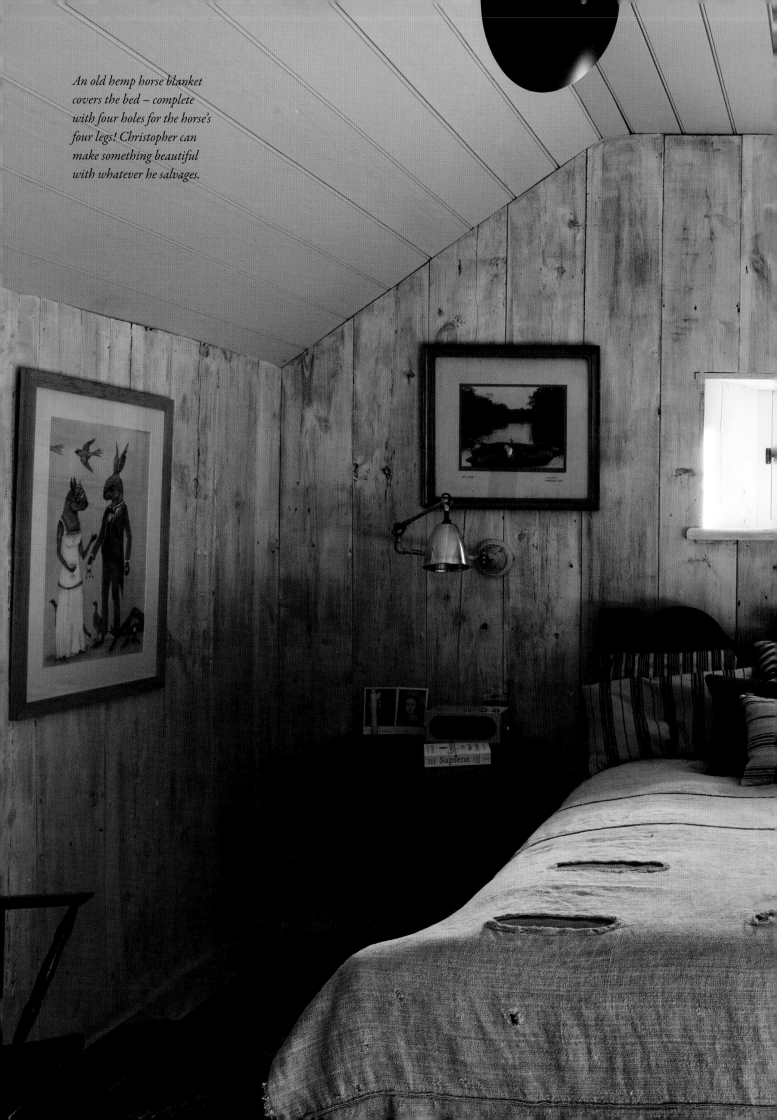

An old hemp horse blanket
covers the bed – complete
with four holes for the horse's
four legs! Christopher can
make something beautiful
with whatever he salvages.

LINDA RODIN

Stylist / Beauty Therapist / Icon

THE WOMEN IN LINDA RODIN'S FAMILY WERE WAY AHEAD OF THEIR TIME. HER grandmother was an avid antiquarian and Linda remembers every drawer in the house being stuffed to the gills with a cornucopia of whacky things. 'She designed silver for George Jensen, the Art Nouveau silversmith, down in her basement and when she died I inherited one ashtray. That was it.'

Any day in New York City, you may see La Rodin alighting from a yellow cab with her face buried in a kiss amongst the soft mop of her powdery grey poodle, Winks. As a successful stylist for more than three decades, there is little she needs to learn about the fashion industry. However, lately she has found that it is no longer necessary to possess an innate elegance to become a stylist. 'A tattoo and a nose ring are more likely to open doors for you in fashion these days!' she laughs.

So what do you do when you are in your late sixties and still have the energy of a forty year old? You hire a lawyer because the little experiments with face oils that you have been working on in your bathroom for the past decade, have been picked up by Estée Lauder and now you have reinvented yourself as the face of Rodin Olio Lusso and are pursued by the beauty industry on a daily basis.

Here is a woman who has never made a plan for anything. Life just happened around her, not all of it rewarding and some of it downright punishing, but she never felt like throwing in the towel.

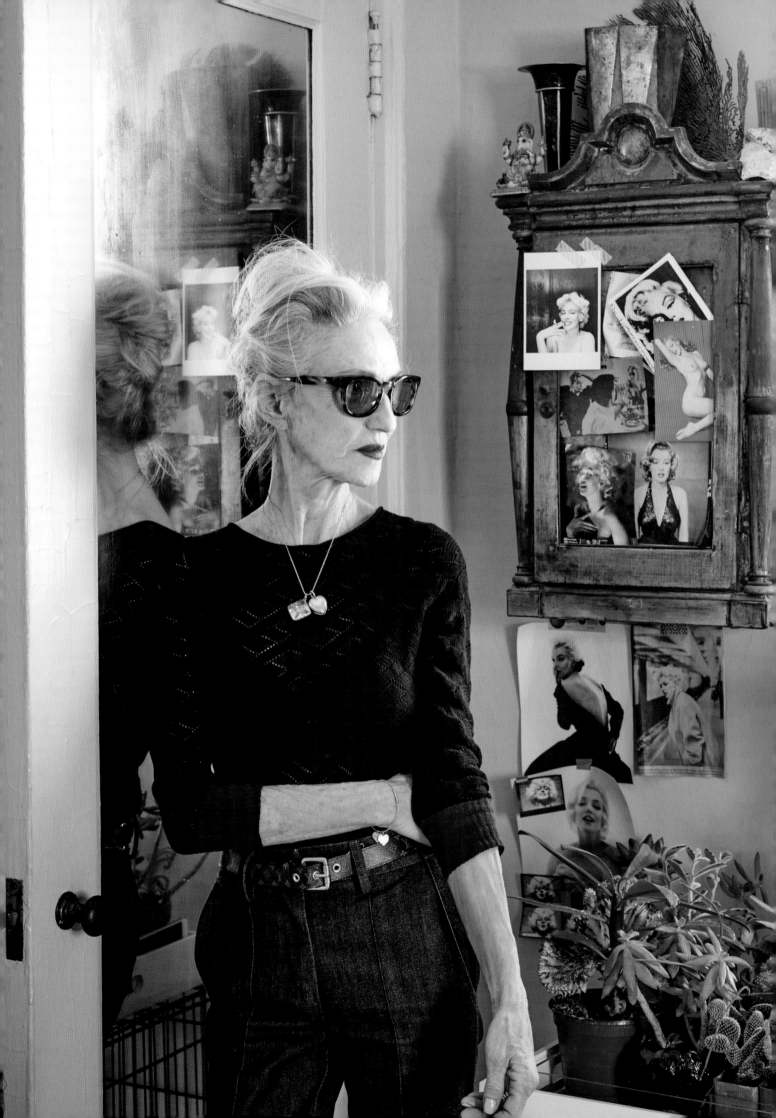

Trinkets and ephemera adorn every available space, each one selected for their beauty, their nostalgia or charm, either a treasured possession over the years or discovered at an unlikely flea market. At home here in their midst, Linda, elegant and upright, Winks at her side awaiting his next spontaneous hug.

'My mother was completely
kooky! She had black
wallpaper in her kitchen
with blue flowers ...
Andy Warhol flowers! But
there was no Andy Warhol
back then. And all I wanted
to be was normal!'

She fell into things. She had to. Her parents died when she was thirty-five years old, she lost a beloved sister and life just became something she had to get on with on her own. She says she never feels lonely and she never wanted to marry. Plenty of boyfriends but – perhaps due to the unstable compass of fate – it became pretty clear that she would live life under her own terms. Because of this, her home for more than thirty years is a place where she needs to feel safe, so at home she surrounds herself with an abundance of sentimental items and every time she opens her front door, her mood is immediately elevated.

Her apartment is in an elegant Art Deco building in Chelsea NY where one waits a while for the descent of a creaky elevator, closes an expandable gate, seals oneself in behind a heavy mahogany door and waits a further while to be deposited outside the entrance to Linda's bijou apartment on the fourth floor. This is an exercise in patience and a reminder of how desperately ungenerous we have become with ourselves about time. This building is old New York and sings of a time when men had polished shoes and overcoats and women walked with pride, invisible books balanced precariously on their heads. Linda Rodin is one such woman.

In the hall, I navigate around an enormous cardboard box and squeeze myself sideways to reach the Rodin doorbell. 'Oh, sorry! That's a toilet,' Linda announces once I am settled with a glass of wine in my hand. 'There is something wrong with my flush and so the janitor brought a new toilet. I asked for a picture of it before they fitted it. The janitor said, 'You crazy, lady, or what?' So I told him to take it away. I want them to replace it with another Art Deco toilet ... so it sits there until they find one.' I instantly make a mental note to go easy on the wine, but she assures me the current loo is still functioning. The janitor is clearly of the belief that a toilet is a toilet; but Linda isn't having any of that.

'I don't want anybody to go picking stuff out for me. How can you let someone else pick your sheets for you, or even your teaspoons. I'm not the President ... I can walk across the road and buy my own garbage bags!'

Her flat, like her grandmother's drawers, is overstuffed with anything from fabrics to seashells. Trinkets and ephemera adorn every available space, and in the middle of it all sits Linda, elegant and upright, Winks at her side awaiting his next spontaneous hug. Every piece in this home is personal to her. She has trawled the New York flea markets for over three decades. Her mother had an antique shop, possibly started with Granny's treasures, and the apple really hasn't fallen far from the tree.

'This apartment can give other people an instantaneous headache, but for me it is home. I have chosen every single thing in it for a reason,' she exclaims. These things are her friends. 'I wake up every morning, look around my bedroom and I am immediately in a good mood. I don't understand how people can live a minimal life. I walk into those houses and I feel lonely. Five-star hotel rooms depress me. I have an acquisitive life!'

Her beauty products are minimal, however: clean-lined and fresh, so people think she lives in a spartan loft. But perhaps when you don't have your immediate family around to tell you stories, you build them as you remember them from when you were small. This she has done with her choices, perhaps some people might find it all way too excessive, but Linda's layers evoke the most elegant period for women. The height of femininity, there is a thoughtfulness and a vulnerability behind her pieces that tells of a time when women held a home together, remembered to dress for dinner, and tears were shed behind closed doors and wiped away with clean embroidered handkerchiefs.

She has an old-fashioned elegance and her omnipresence within this apartment is a wonderful mandala to her ingenious life. The nostalgia of it all is only challenged by her lightning wit and the forthrightness that claims her not as a feminist but as a woman who carries her own unique worth.

She is not into regimes and every day is different in a stylist's world. One day she may be at a photo shoot or in meetings all day, the next she could be dealing with difficult clients or running the length of Fifth Avenue and Madison for that one little piece of adornment that represents her speciality at choices. Equally she could find it under a table, in a damp cardboard box, at a Sunday flea market. Style is not defined by the price tag. Style is grace, the grace to recognise and acquire beauty in the well-trained sweep of an eye.

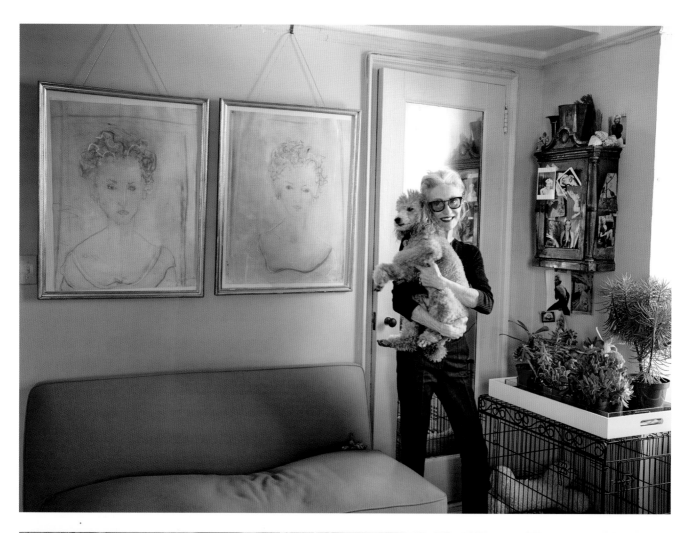

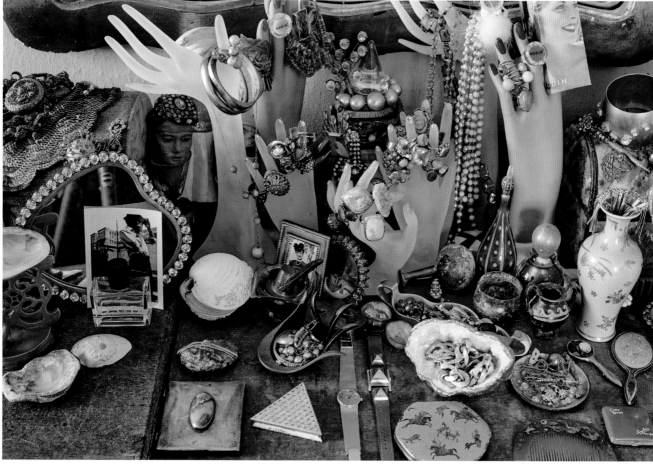

FRANCESCO & GAEL BOGLIONE

Innovators / Restaurateurs / Environmentalists

HIDDEN DOWN A SECRET ALLEY, SOMEWHERE WEST OF RICHMOND'S SPRAWLING deer park, is Petersham Nurseries. This Arcadian oasis is the work of the Bogliones, a visionary couple who were prudent enough to buy a failing nursery next to their home to avoid the land falling into the hands of a property developer. What transpired is a labyrinth of cobbled paths, laid out between charmingly rustic, green houses, passing vegetable and herb gardens, wandering hens and a paradise of peonies, hortensia, jasmines, lilies and other fragrant species that perfume the air with exotic aromas and pull us – oh! so willingly – into a retail space equal to an Indo/French haveli or French château, where we can buy anything from a beautifully formed shovel or a rustic old basket to an intricately carved armoire. Finally, but by no means least, through an extraordinary wide glasshouse, a respite from this eclectic visual overload may be claimed at an old colonial table laid with an array of slow food, seasonal organic dishes all freshly picked, laid or procured from the actual garden or the devoted artisan suppliers.

'We get an absolute kick out of making things as lovely as we can!'

While Francesco gets ready for a business lunch, Gael talks of how she came to London at the age of seventeen, fresh from a modelling career in Sydney, during the late 1970s. Arriving in the wake of the Aussie invasion of designers and artists like Jenny Kee and Martin Sharp, some ten years their junior, she met up with

*In the guest wing, Gael kept the
integrity of the period, stripping
it back to the raw ingredients,
except for the addition of one
ravishing red leather chair.*

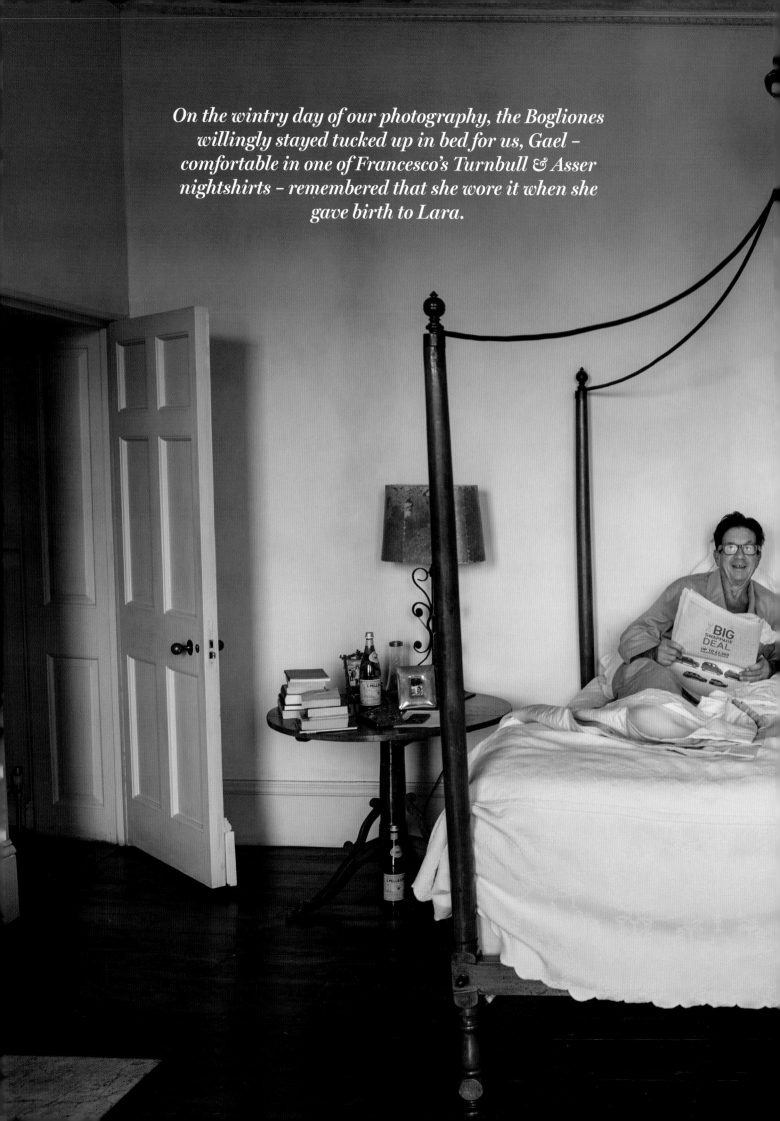

On the wintry day of our photography, the Bogliones willingly stayed tucked up in bed for us, Gael – comfortable in one of Francesco's Turnbull & Asser nightshirts – remembered that she wore it when she gave birth to Lara.

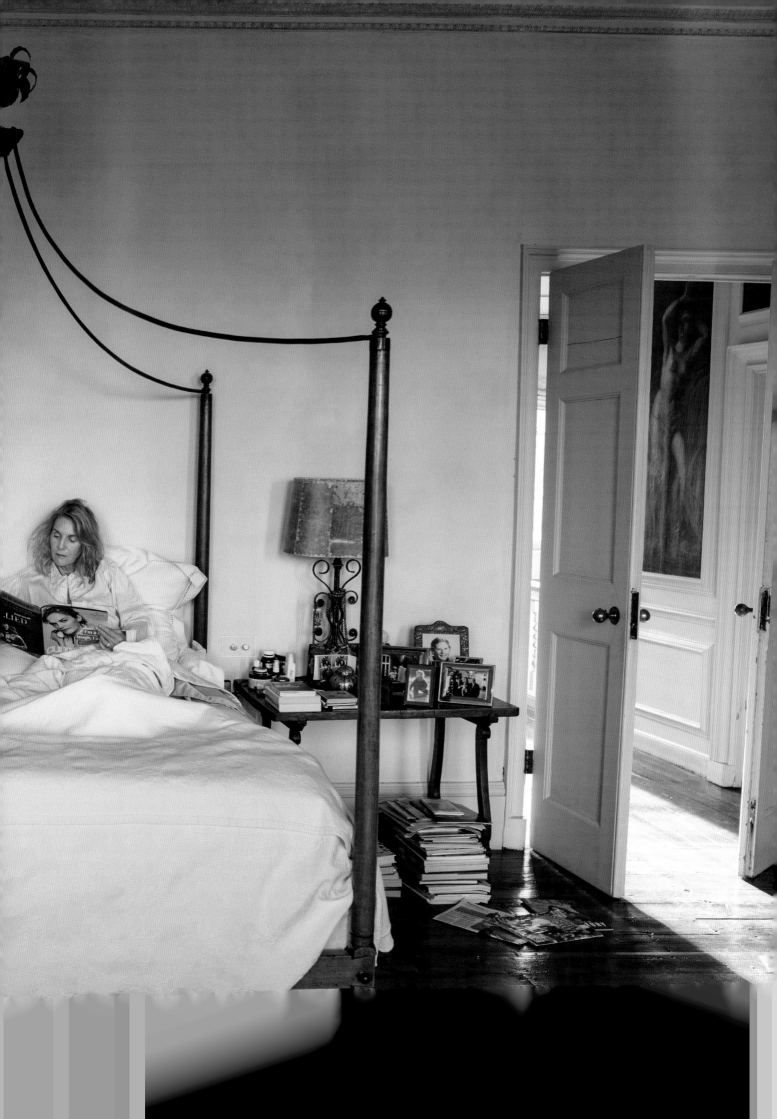

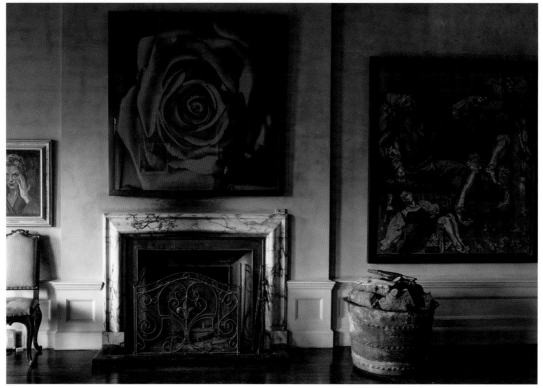

Avid art collectors, Gael and Francesco bought modern, clean-lined, mid-century pieces for the house, as is evident in the stunning Alex Catz painting which sets off the period staircase. It took over five years to finish the project, filling the house with an eclectic mix of items yet retaining its Englishness.

'I am by no means a horticulturist, but we took it on as a challenge!'

her collective country folk and became part of this protective fold. Over the years they have all remained friends and supported each other; a habit refreshingly Antipodean, tight-knit and exceptionally warm. With her genuinely expansive personality, it was only a short matter of time before Gael would attract a hot-blooded lover, and from the moment they met, though neither had a specific plan, they knew they would leap hurdles together for the very long run. 'My father said, "Never marry an Italian!"' But in 1979, marry him she did.

At twenty-seven years old, after living an itinerant life as a hippy in Afghanistan and India buying and selling artefacts, Francesco's father demanded he 'buckle down' and get a proper job in insurance. Eventually, having expanded into offices in Rome, Venice and London, Francesco almost disappeared under the crushing wheel of stress-related health problems; after surgery, his inner hippie resurfaced and the couple, together with their four children, contemplated a less city-based life. At a cricket match in Richmond, with their friends Mick Jagger and Jerry Hall, they were told of a beautiful but dilapidated Queen Anne house for sale just around the corner. Forsaking the match, Francesco went hot-foot to peer over its walls. He was instantly smitten.

In 1998 they sealed the deal on the house and Francesco took off back to India to fill containers with antique colonial furniture and architectural pieces. These, along with Balinese artefacts, decorate the restaurant today. 'We never had a plan for anything but I wanted to keep the Englishness in the house and we began in a simple way and pulled the house together over a period of five years. Francesco keeps me on my toes and annoys me on a daily basis. The oldest part of the house is the guest suite and I really stripped everything back to its purest form there. I wanted to keep it very simple.'

Two years after buying the house, they bought the nursery and most of the family became involved to some degree in building the business. Lara, their eldest daughter, has no intention of working at the end of her parents' garden for the rest of her life and plans to open a Petersham-style business at the old Moss Bros building in London's Covent Garden. Harry will supply the restaurant's vegetables. Ruby, blessed with her mother's exquisite taste, will buy for the retail space, Anna has her own theatrical company and will organise events. The wonderful thing about this is the ethos they have passed on to their children. Gael explains there would be no point to all this without the need to pass it on. The couple have been environmentalists for thirty years and feel proud that their children will continue to uphold the integrity behind their conscientious passion for goodness and sustainability.

Later that morning, Francesco – suited up and looking every bit the international Italian businessman – entered the drawing room in a flourish and began to inspect the floral arrangements. Passing his hands hastily over the various vases like a butterfly seeking nectar, he deftly broke off a couple of small berries and placed them in his buttonhole. Explaining he was in a rush for a meeting he turned and vanished, taking with him all but my own pocket of immediate air out of the room. Gael later tells me he does this whenever he wears a suit.

And there is the nut of the story behind this home and business; tied together by teamwork, ritual, family and the air they have collectively breathed into making art out of living and hard work. Staying true to themselves and their relatively free-falling vision, they have encouraged many artisans and believers along the way to help create a world that will sustain them all and give back through the nurture and care that makes dreams come true.

When I catch my breath, I remember the hippie that is never far beneath the surface of the Boglione skin. Some years ago, when I had my small store in Norfolk, Gael and Francesco came in. It was raining, as I recall, and after thumbing through several ravishing old Indian Kantha quilts they decided on four of the most colourful. Wasting no time Francesco wrapped himself up entirely in all four and stepped out into the greyness of a typical Norfolk day. With a 'see what I have to contend with' shrug, Gael happily followed. Fortunately she never took her father's advice and this couple remain true to their free-spirited ethos, inspiring others with their passion; with no other objective than to choose beauty over adversity, encourage the best from everyone and do everything together.

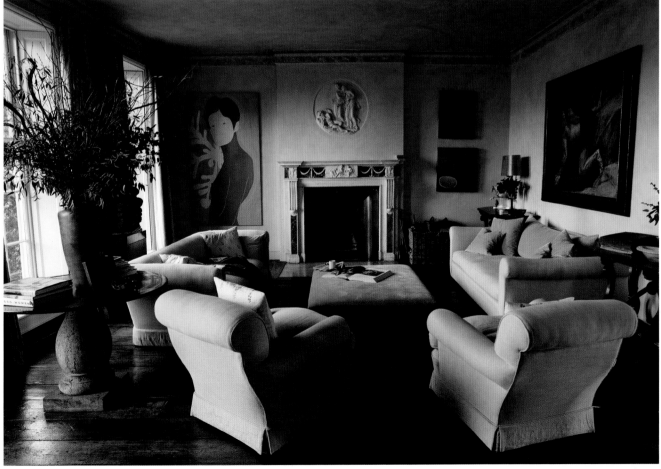

*The promise of canine adventure
exists beyond the confines of the
grand dining room.*

MIV WATTS

Interior Decorator / Stylist / Curator

TEN YEARS AGO I FOLLOWED A GOOD FRIEND TO THE SOUTH OF FRANCE. HE HAD married an elegant French psychologist, they were restoring an old silkworm factory in a less than chic but wickedly authentic French village. I pitched up one weekend with enough clothes to last me a week and began a sweep of what was on the market in the area. This is not always the best way to go about finding a great property in France. A lot of time can be wasted looking at houses that seem perfect on the outside, but inside have been 'modernised' and to restore them would mean a hefty expense, tearing out and re-installing original materials.

I learnt to put my foot down when the agent took me to the twenty-fifth farmhouse with ceramic tiled floors and salmon pink textured walls! A sure indication that this might be the case was often the presence of a few upturned plastic garden chairs on the lawn. There I would stop and politely suggest to the agent that we might be wasting each other's time. Bearing this in mind, I actually shrieked with joy when I found my present house. The bulk of the work had been undertaken by its owner, an irascible English woman with an obsessive need for light.

I visited at least five times and on the fifth time I brought my daughter and we both agreed this was the one. It is a village house, not exactly what I originally wanted, but the house has enormous architectural merit and I have to thank Madame Irascible for her extraordinarily good taste.

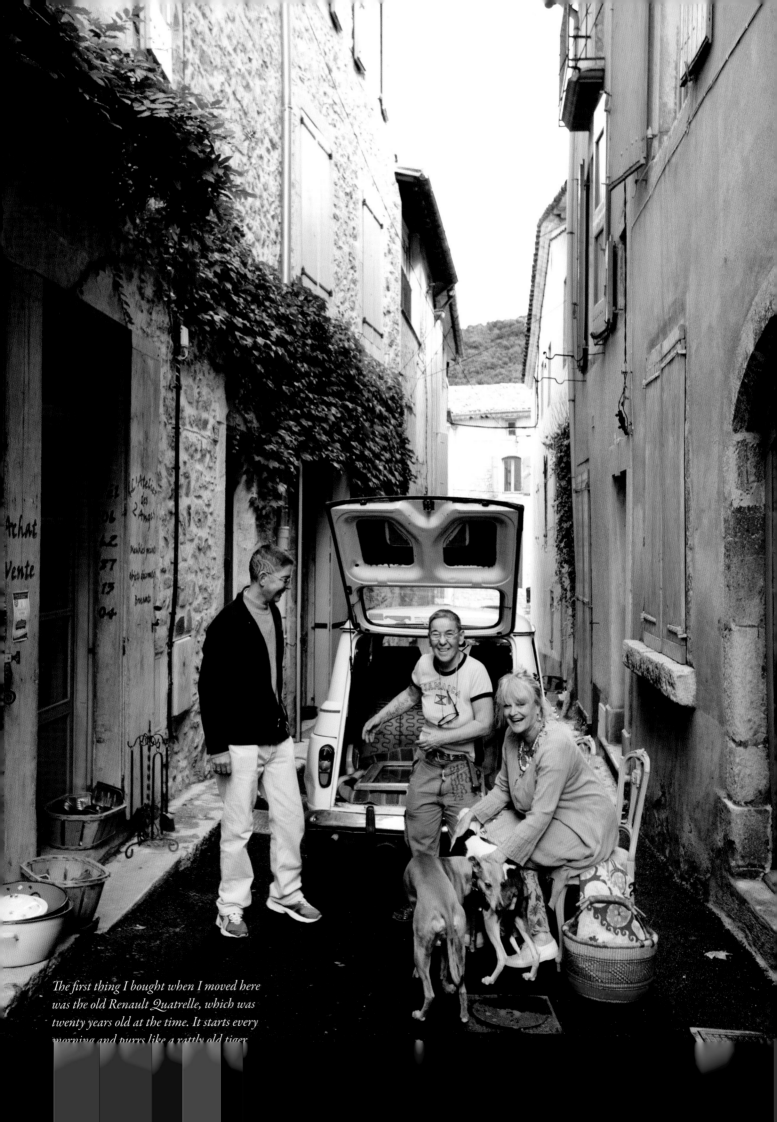

The first thing I bought when I moved here was the old Renault Quatrelle, which was twenty years old at the time. It starts every morning and purrs like a rattly old tiger.

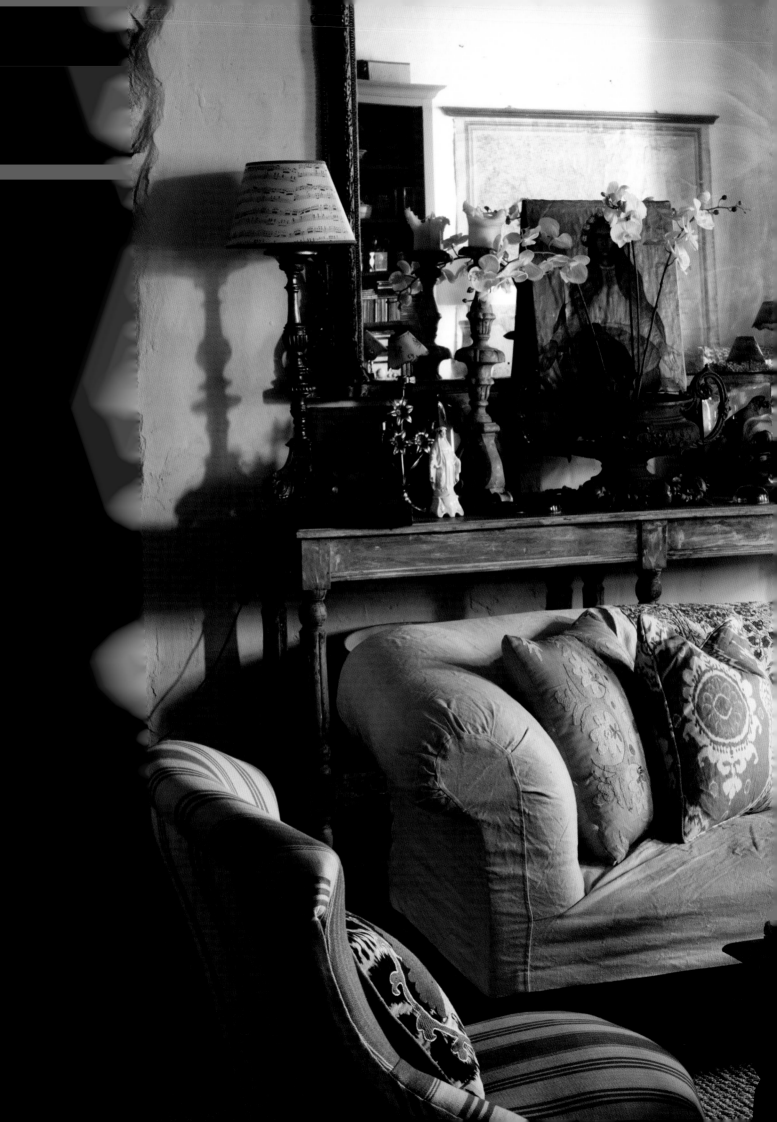

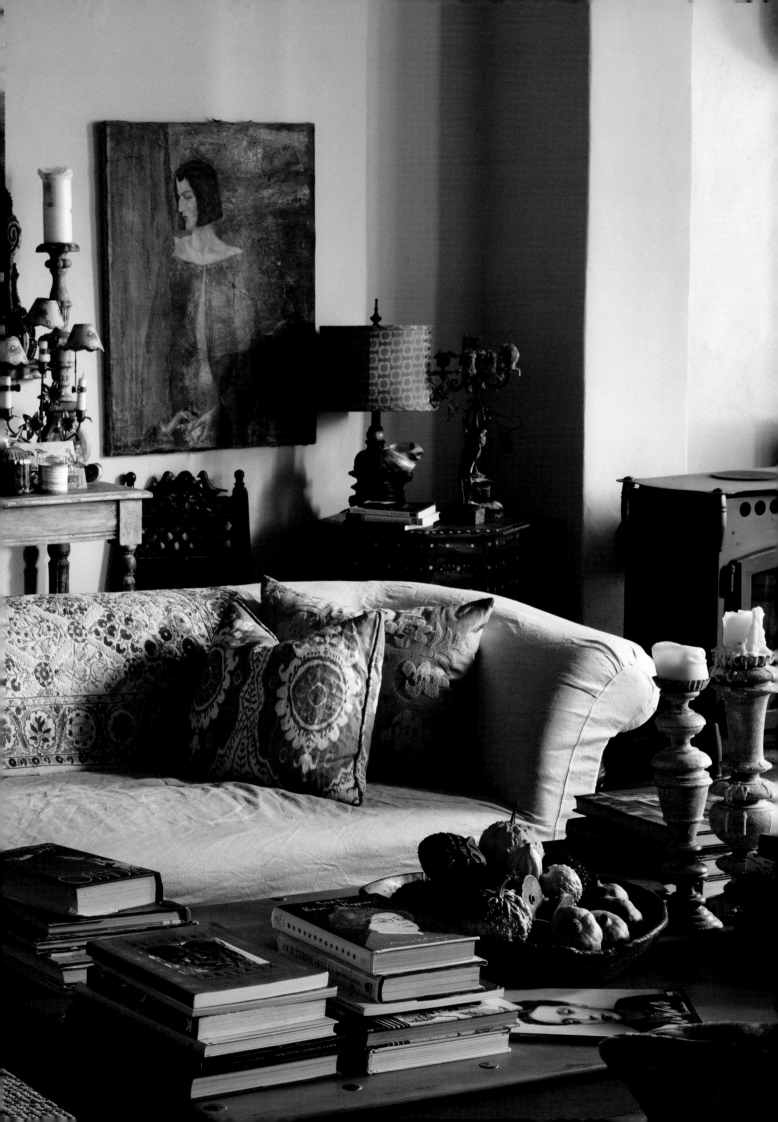

Wonderful light streams into the house. Textiles are a constant part of my life and linens are my particular thing at the moment. I acquired some antique French sheets which make wonderful curtains. The painting of Leda and the Swan (right) was done by students for a theatrical production, Circs, in the 1920s. I bought it for a song.

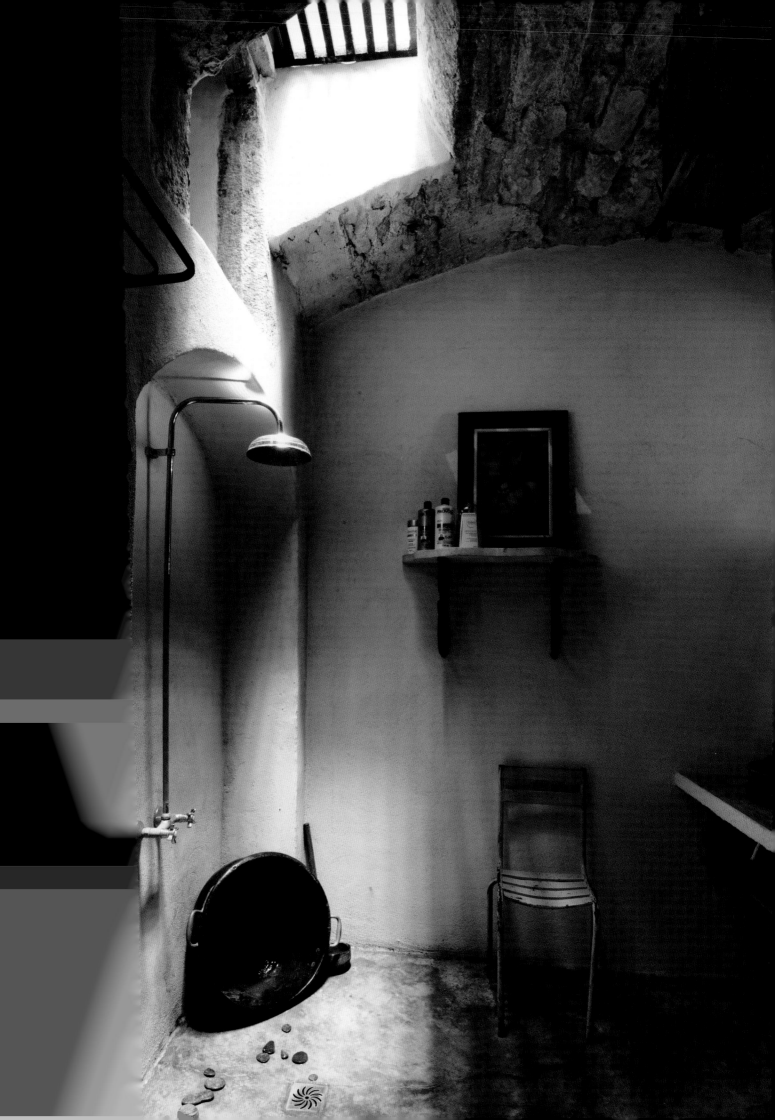

The house has a central glass cupola at the top of a large stone staircase, and Madame had installed extra sources to capture this light. In some cases it could be a tad embarrassing as there were glass panels in the old terracotta tomettes on the first floor, and if one happened to be performing one's morning yoga exercises in the guest bedroom, and the postman arrived and looked up, he might easily have had a better day than he expected.

Anyway now I have occupied this house for a decade, I am in the mind to move because I am a gypsy at heart and need a new satisfying project. The concept of packing up all my possessions weakens the nerve and the more I look for escape alternatives, the more I become attached to this house and all the wonderful objects I have scooped up at many delicious brocante fairs over the decade.

I can remember the location of each and every piece that caught my fleeting eye. Although the better woman within me would like to live a minimal life, the one I am stuck with in reality gets so excited by the shape, history, texture and pattern of things that within a month, any vacant space would be filled with an old commode or linen box. And that raises the question of what to display on top of it.

Of course, I have been a set dresser in my day, and I now enjoy providing comfortable homes for my clients. However, a project can become troublesome, as in the case of the client who would not attend meetings while his wife spent a third of the entire budget on a robotic kitchen that stopped short of doing the school run by a millimetre. Then, rather than ruin a marriage, it was better to blame the designer! That is the moment I retreat over the mountains and back to my cave like a moray eel! There comes a time in one's life when one has to put a cap on indulgence. I have reached that time. Added to this I am of the belief that one does not need technology to produce a good meal! My kitchen is smallish but beautiful. I enjoy using my French coffee percolator. I like packing in the grinds and flattening them down with the back of the spoon. I like hearing it bubble and I enjoy slowly heating the milk in a saucepan. These are my morning rituals. I can open the door to my terrace and begin the day having a meaningful conversation with the orange trees while the scent of the blossom suffuses with the coffee smells. From here I can happily plan my moves. The day I succumb to my home being controlled by an iPhone will be the day I choose to install the Crematorium App and spontaneously combust!

I am not a painter, though I like to dabble and absolutely love the smell of turpentine. I think curating and arranging is similar to painting. I enjoy the consideration in grouping things together – creating families, I guess. Some people come to my house and marvel at its contents. They compare it to a museum, and then I begin to wonder if it might be stuffy or bordering on senility. Does it smell of whippets? Or does it smell of tea and biscuits? Not that I over-indulge in the latter but I am very partial to a whippet or two and they are apt to be draped where they please, from sofa to bed in the most ludicrously discombobulated positions. The bed – the big four-poster – I designed and had made in India. The Fishmonger, reminded by our time on the vaporettos in Venice, breaks into a rendition of 'O sole mio' every morning he wakes up in it. The Fishmonger and I have been together in a haphazard, on again, off again manner for over twenty-three years. I tried to live with him in Norfolk, but ... well, it was Norfolk and he is a fishmonger! I do need a house to wrap itself around me like a comforter. This house has its origins in the fourteenth century with later eighteenth-century additions. I am a custodian of it, that is all. It will be here long after I have left the planet.

I travel a great deal. We have another home in Australia, where the Fishmonger is not involved in his odorous trade, but this house always greets me with a tactile pleasure. The old stone walls retain the traces of past industry. Nearly all the homeowners in this village once were silkworm breeders. The terracotta tiled floors speak to the walls like old familiar friends. The giant wooden beam in the salon tells of a time when bales of silk were lowered onto carts and carried off to the river for washing. Little alcoves dotted here and there had tiny chimneys to keep the chrysalides warm. I place old Indian gods and Buddhas in them now; they are not obvious but I think they quietly protect me. There are many corners in this house for the eye to find pleasure. Pleasure is always in the detail for me, and I enjoy the integrity in well-made pieces. It all needs maintenance, of course, but beauty needs care and caring is part of the ritual of life.

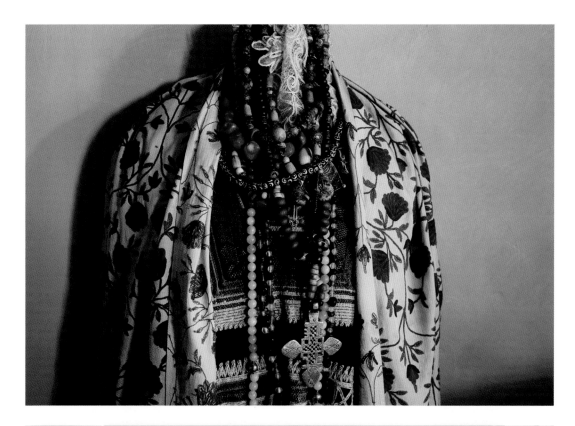

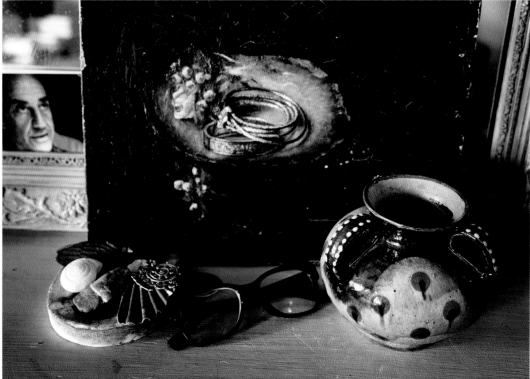

Pottery is another one of my passions. The day I find a piece of Spanish Punter pottery – like this magnificent jug in the signature black and green (right) – I am just over the moon. The craftsmanship in the work of this family pottery in Aragón in northern Spain continues on after five generations.

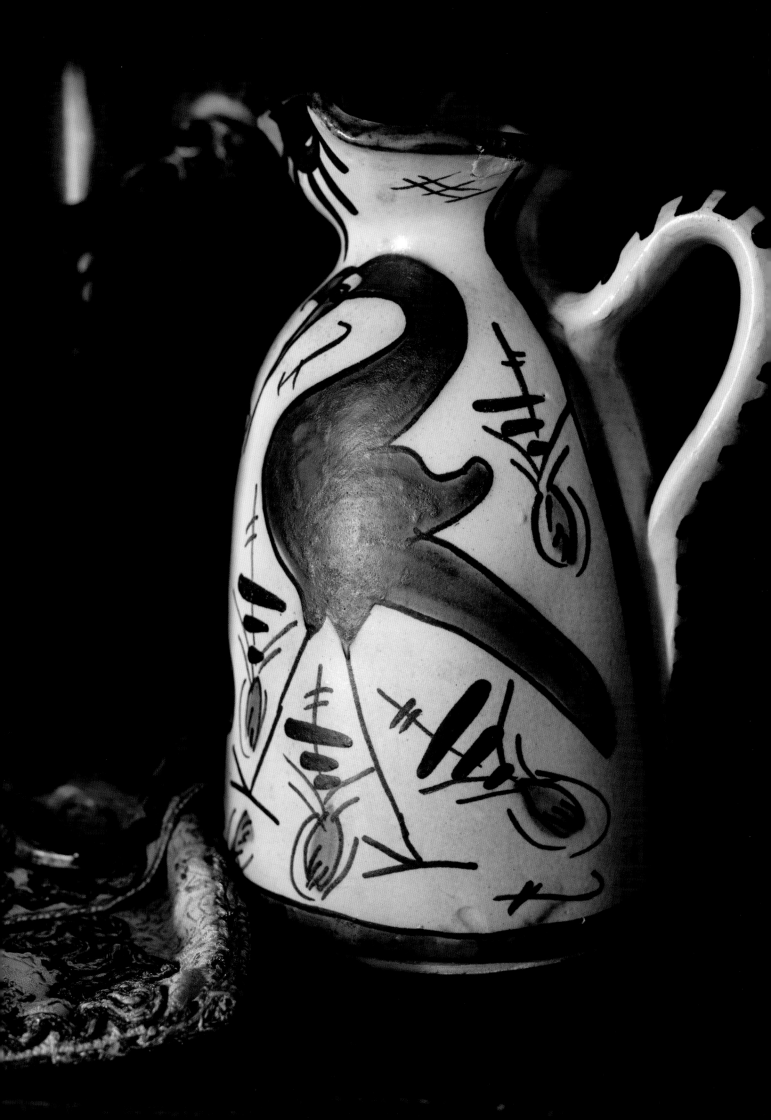

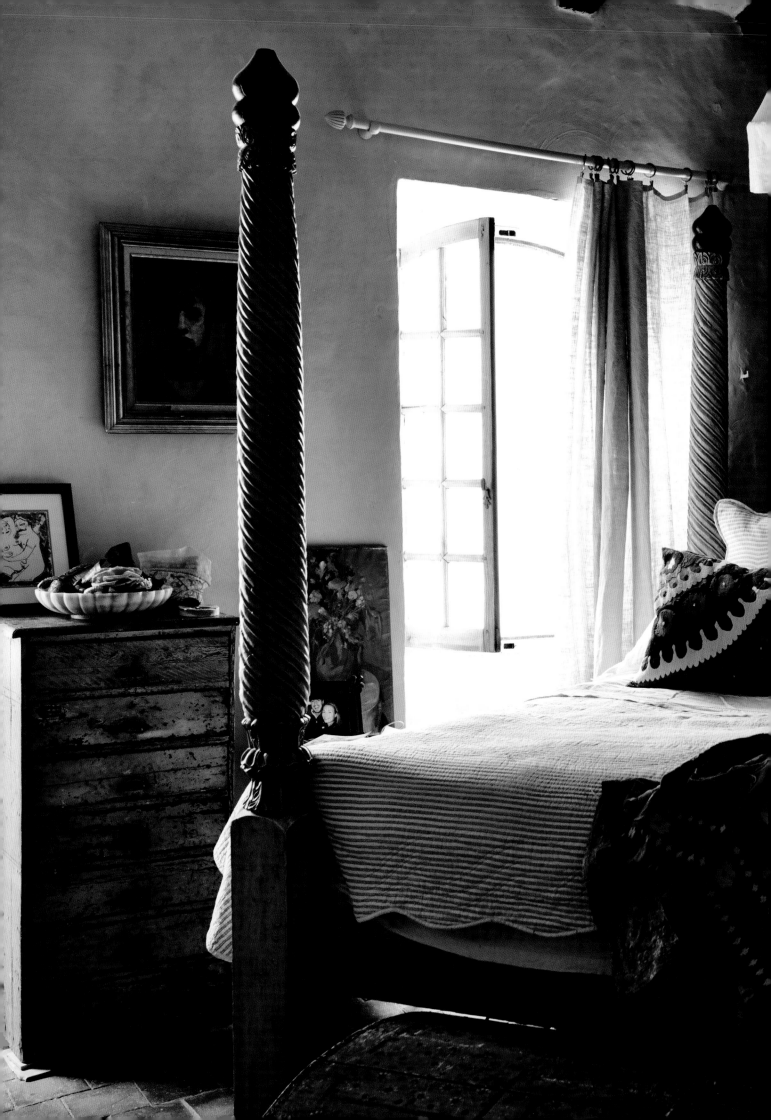

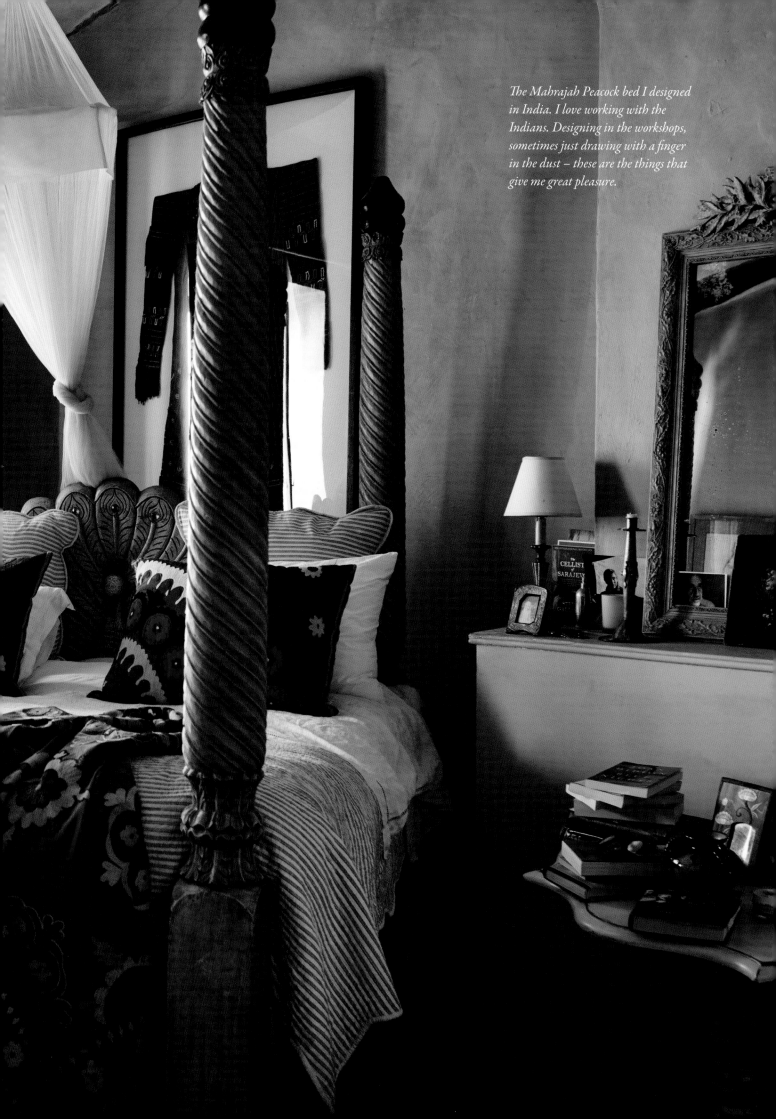

The Mahrajah Peacock bed I designed in India. I love working with the Indians. Designing in the workshops, sometimes just drawing with a finger in the dust – these are the things that give me great pleasure.

ALINE
KOMINSKY-CRUMB

Artist / Writer / Muse

IN A TIGHT-KNIT VILLAGE IN SOUTH-WEST FRANCE, WHERE RIVERS CIRCUMVENT a rocky outcrop of thyme-scented wilderness, where raptors drift high on the warm air currents and herons track a plumb line a scratch above the surface of the water for the purpose of monitoring the fish supplies. Where medieval buildings cling to the side of granite mountains and cobbled paths wind through narrow streets, making tricky turns as they go. With leaden feet and twisted ankles, one finally reaches a summit that supports an ancient château, long in extremis, but worthy of the blood and sprains incurred in the climb simply for the astonishing view.

On first discovering this village, I was reminded of the Robert Altman set created in Malta for the 1980s film *Popeye*. The prop village of Sweethaven was made in wood while this French village is a monument in stone, but the similarity in the clinging cluster of houses is noteworthy. There are other similarities, too – not least in the inhabitants!

Among this charming disorder of buildings sits a higgledy piggledy house of curiosities, with beginnings in the twelfth century, and overlooking the river from which the often-blessed village fountains flow. It is from these sources that Aline Kominsky-Crumb collects the water in beautifully illustrated little bottles and bestows them on her friends as miracle cures for anything from bunions to a belligerent mood. These little

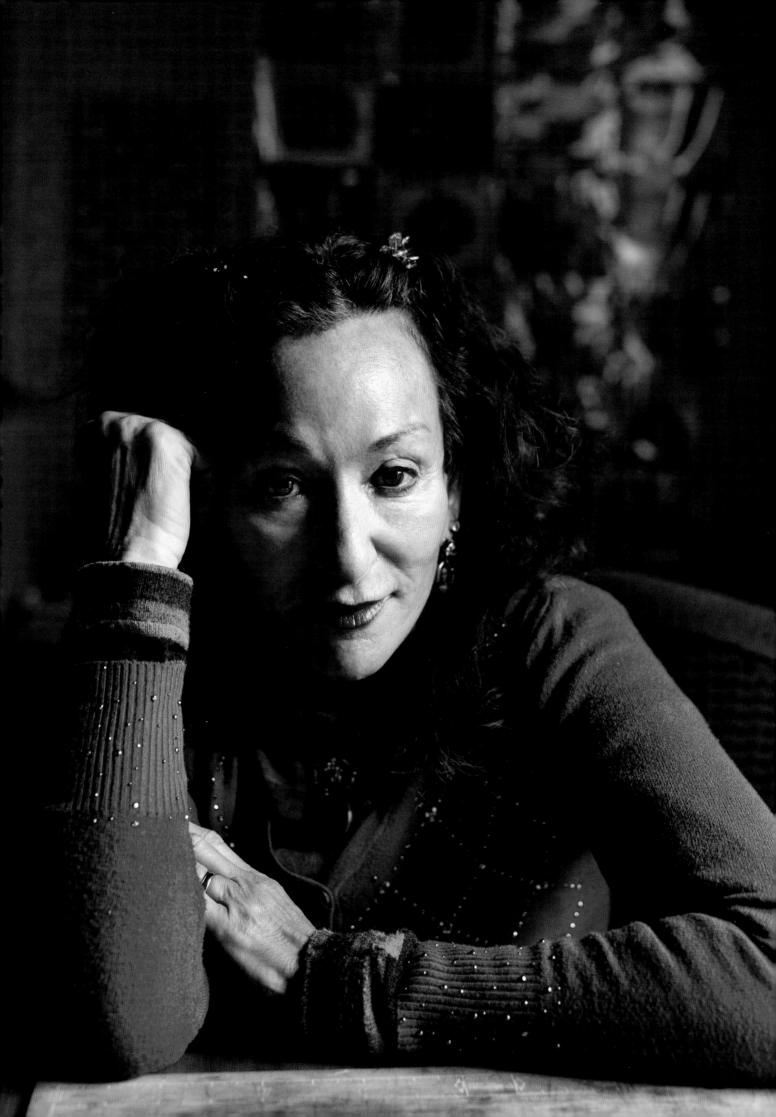

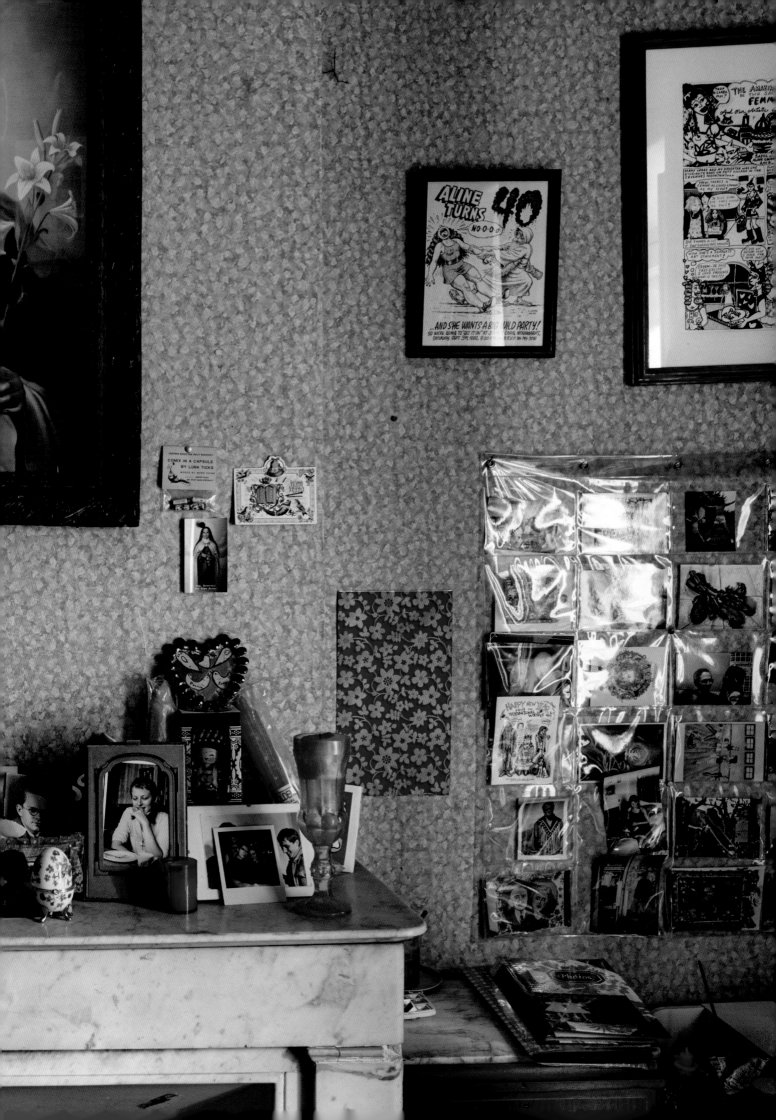

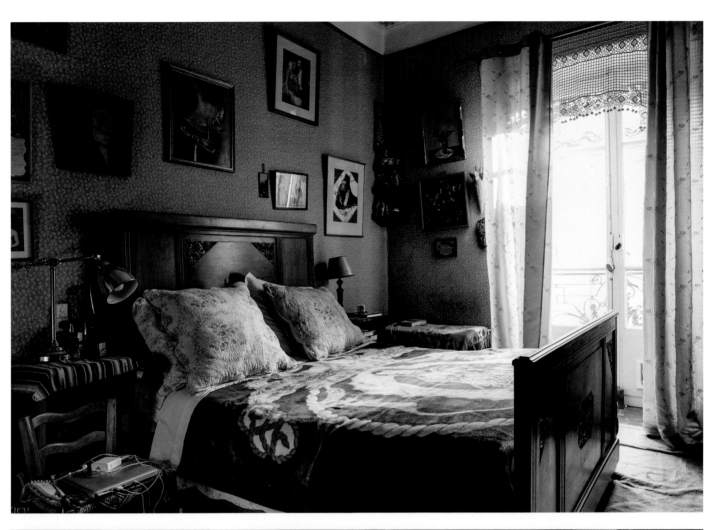
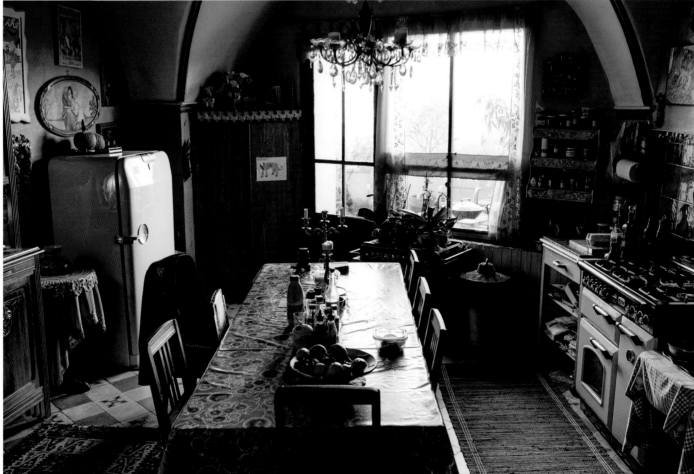

souvenirs might also be found in the nearby gallery along with Les Deux Crumb's extraordinary artwork, from the sixties and seventies until the present day. Included is the work of other local satellite artists who gravitate around the Holy Grail of underground characterisation and circulate in a uniquely bizarre world of comic super heroes and irreverent portrayals of Catholicism and the mind-fuck of mass culture.

This house is tall; tall enough to provide a home for the Zorro impersonator/cartoonist Peter Poplaski living in the upper reaches of the tower with his partner, artist Rika Deryckere, who likes to paint portraits of Aline in varying moods of elation or distress. Aline's brother lives in the lower regions, and in the middle is a warren of dark rooms that hold a cornucopia of mad kitsch. Remnants of a fifties childhood coupled with ecclesiastical ephemera that seem to be the building blocks of a life devoted to observing and exposing the bare-boned ridiculousness of religious idols coupled with an appreciation for the colour and simple gaudiness of trinket art. Aline claims to gravitate towards colour and light, of which there is no shortage on this floor where we talk. 'I continue to have escapist fantasies where I am a mermaid and can swim freely. Perhaps this is due to having spent a great deal of time on my grandfather's boat when I was a child.' Her husband Robert, however, prefers the darker, cosier parts of the house and is currently nowhere to be seen as the last of the cold winter rays pierce the morning through the glazed doors that form a barrier between the kitchen and the terrace. Robert is not one to hang around for moments like this and has probably demured to a loftier position in the house in the company of his music and his books.

Aline doesn't over-analyse everything and I get the feeling that she would like us to believe that her exuberant personality is everything there is to know about her. But just as her home is layered with the souvenirs of her life events, so I suspect there are areas where her emotional guards stand on duty and this makes her forthright personality ever more intriguing. Her happiest childhood memories revolve around the home of her grandparents and great-grandmother, Sophie. As a result, her house remains filled with twenties and thirties furniture that was in place when they bought it; she associates these things with the warmth and protection she received from the elders in her family.

Aline doesn't believe it is possible to take a house and turn it into a home overnight; she has faith that our personal style evolves over time and that every place we have ever lived has had an emotional impact on us so that they become a Rolodex of emotional information and we make our choices from these experiences. Her home has become a shrine to her contemporary artwork over the years. The grotesquely embellished Barbies and her vibrant paintings of psycho dolls mainly depict what she calls the evilness and treachery in plastic toys that reflect all the hypocrisy of fake innocence and lost childhood for the purpose of big business. She feels these items are just a means for people who want power to control us. These are long-standing beliefs Aline shares with her husband and her daughter, Sophie, also a cartoonist and a mother. 'I think as you get older you have the liberty to be yourself. I don't care if I'm considered cool or uncool. I am free of that and that is the advantage of getting older, I think.'

Along with her painting and illustrating, Aline is a strong leader in the local community. She plays a huge part in this small French village, teaching yoga and pilates three times a week, keeping the gallery functioning with recitals, exhibitions and performances at which Robert often plays bluegrass on his ukulele and all the inhabitants gather for a bit of a knees up and a confab about their coming collaborations. In all this, where did she find the time to write her tome *Need More Love*? (I admit to having borrowed from this extensively.) Her time is precious but she still manages to give parties, serve imaginative meals and be a doting grandmother while filling the role of eternal muse to a sometimes irascible but genius husband. Truthfully she is a phenomenal artist in her own right, not only in her drawings and cartoons, but in her wit and intelligence and her extraordinary ability to tell an amusing story. Along with this she is generous to a fault with her friends. Both Aline and Robert are very much loved in these parts and we wait with anticipation for the fledgling Crumb to do her thing ... 'Il faut un village pour élever un enfant'.

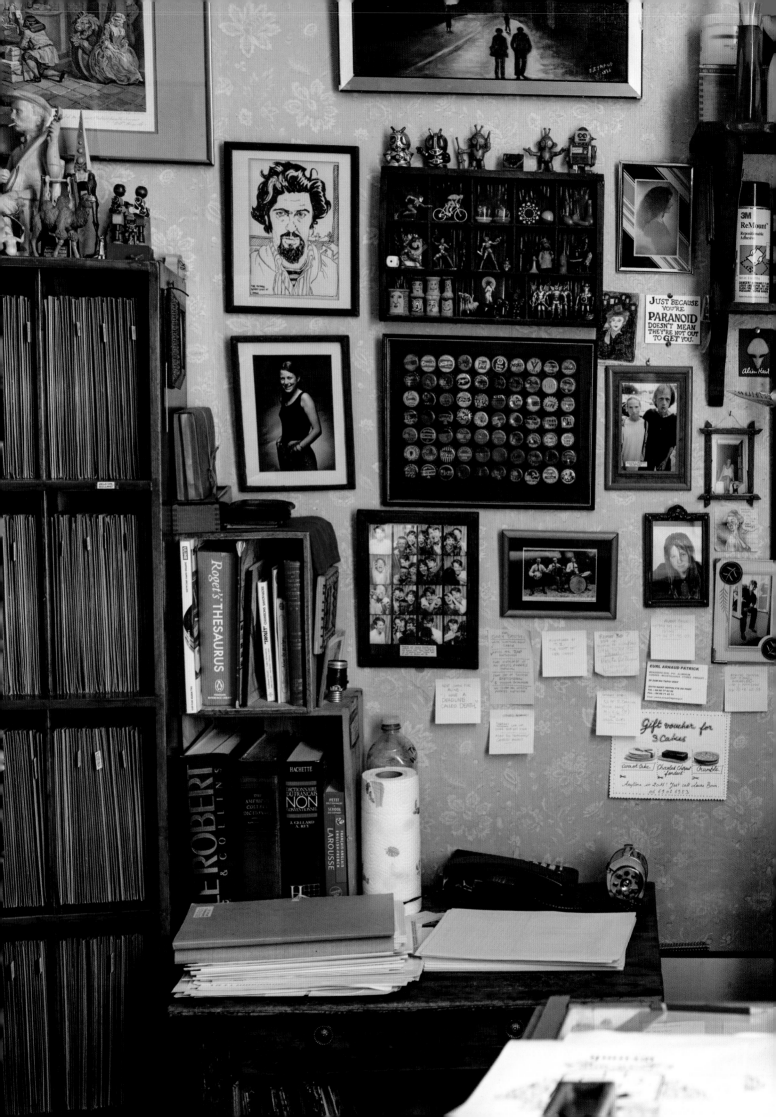

JUST BECAUSE
YOU'RE
PARANOID
DOESN'T MEAN
THEY'RE NOT OUT
TO GET YOU.

Roget's THESAURUS

LE ROBERT & COLLINS

HACHETTE
DICTIONNAIRE
DU FRANÇAIS
NON
CONVENTIONNEL

LAROUSSE

Gift voucher for
3 Cakes

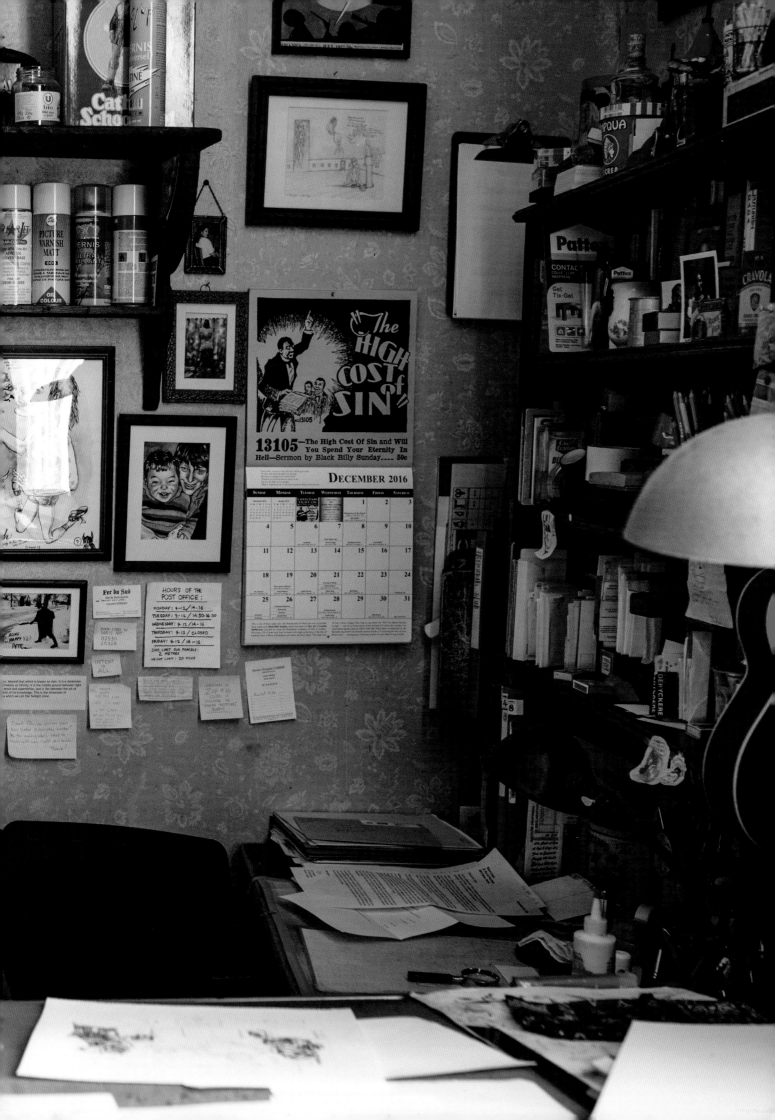

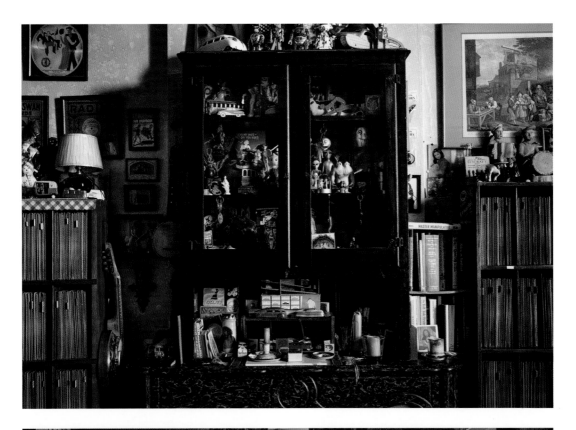

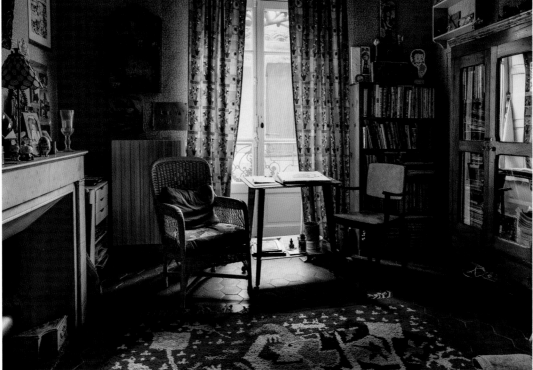

Seventy-eight-year-old Madamoiselle Rigal was scrubbing the doorstep when, twenty-five years ago, they came to see the house next door. Eventually they bought it from Mamam-Madame Rigal, her ninety-eight-year-old mother. Aline has brightened some of the colours but little has been done structurally to alter the layout.

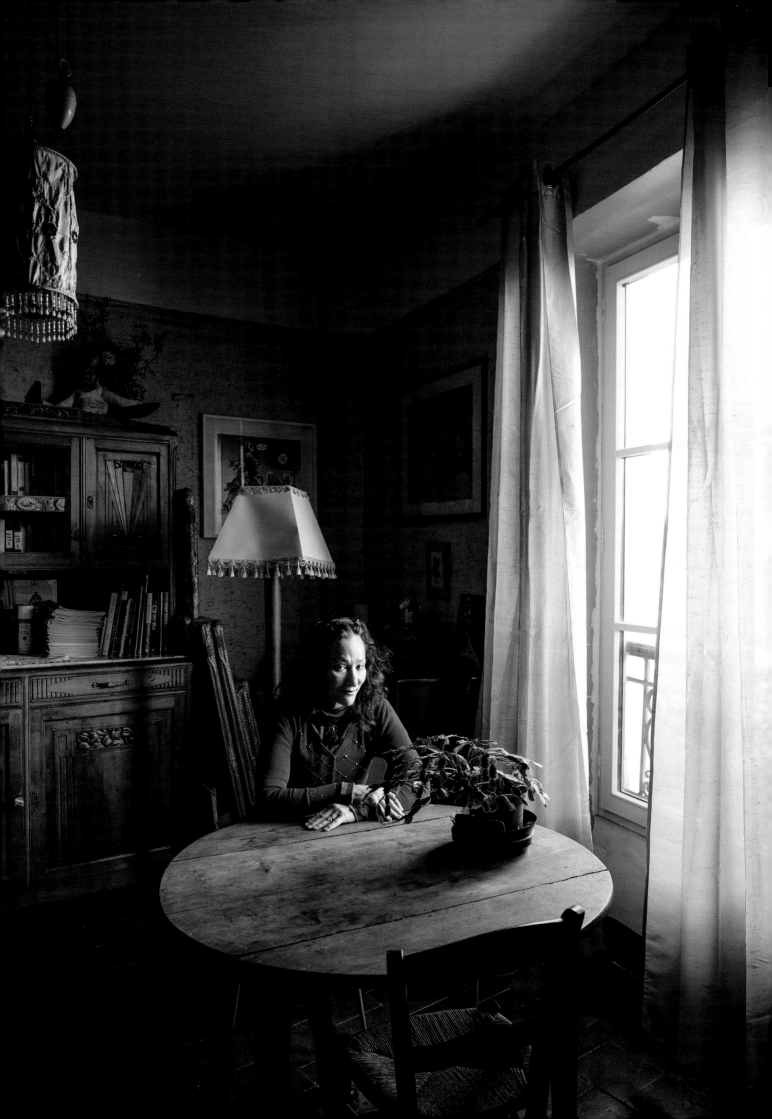

PERNILLE WAGER

Jewellery Designer

SHE IS MORE THAN MODERATELY AWE-INSPIRING. A STATUESQUE EX-MODEL, ROBED to the ankles like an ethnic princess; like an animated Adel Rootstein mannequin, she glides around her Hudson New York loft, elegantly arranging a myriad of sparkling baubles.

She hangs her necklaces on a black madonna and she fills quaint little dishes with beads and bracelets. She says she is a silver girl but my eye is collecting turquoise, rubies and sapphires and a teensy bit of gold. I know what she means, though. Silver girls are more earthy. Silver girls often like to find their jewels in far-flung places, down darkened alleyways where peacocks call behind mossy walls, where dusky gentlemen unfold embroidered, velvet pouches, and marcasite earrings glitter their way into the remains of the day. 'I have saved the special things for you, Memsahib!' Silver girls rattle a little when they lift their laden arms in expressions of surprise and pleasure and in their mind's eye they are already visualising the gown they will match with these shimmering droplets.

Pernille's wardrobe is designed for such exotic moments. She loves a kaftan for casual wear, and keeps dozens of ballgowns billowing about from the rail in her dressing room. Alexander, her husband, would prefer it if she wore jeans and a T-shirt occasionally, but if she dresses down she would rather wear 1940s jodhpurs and a fitted jacket and perhaps something silver and exotic on the lapel. It is a dichotomous situation because this

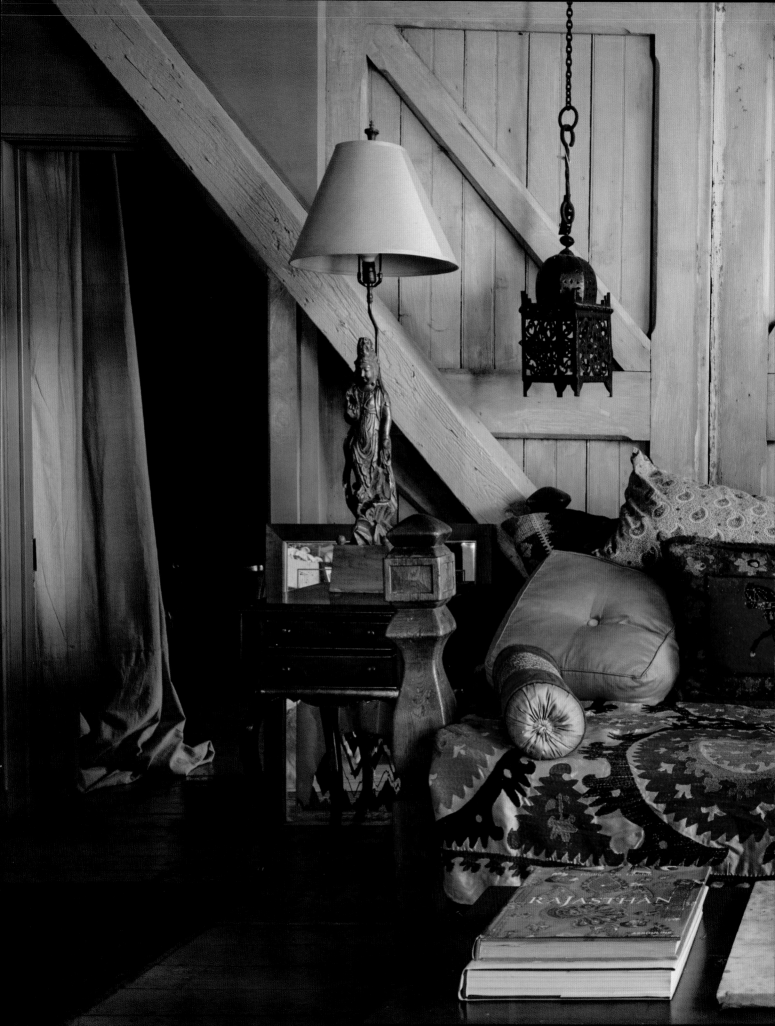

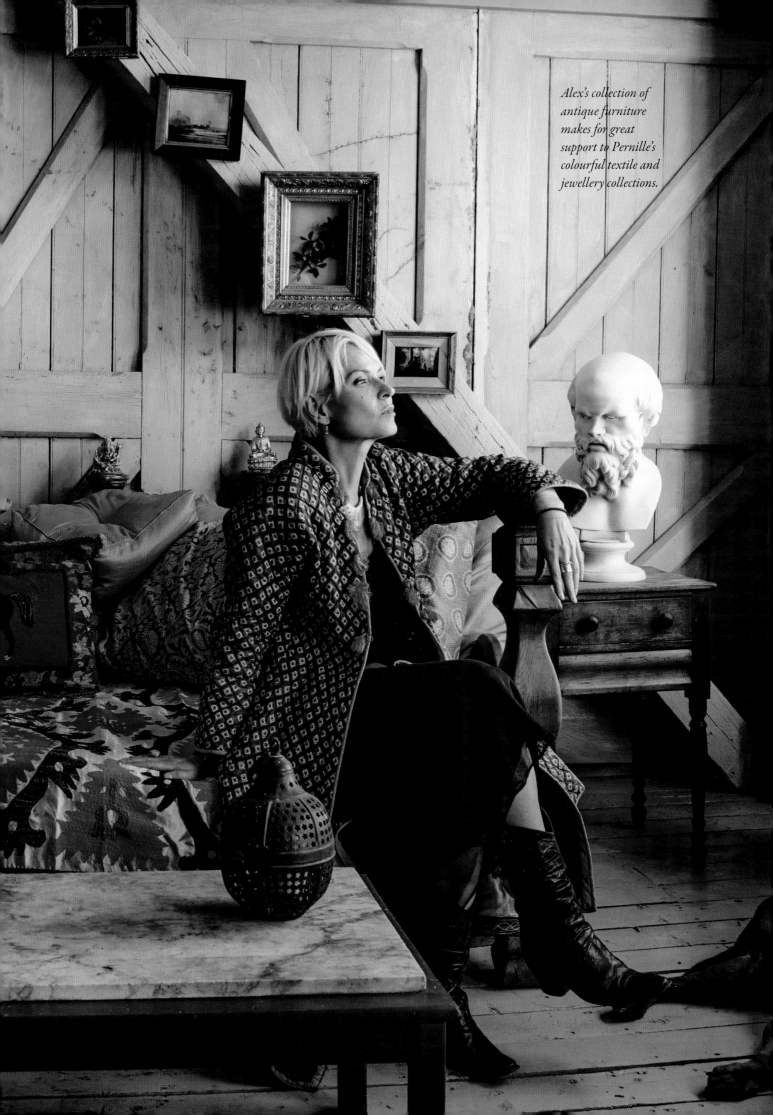

Alex's collection of antique furniture makes for great support to Pernille's colourful textile and jewellery collections.

'With rings on her fingers and bells on her toes, she shall have music wherever she goes!'

silver girl originates from Denmark where everything is pale blue and soft grey, but here, in this loft, we have an eclectic mix of India, Spain, Mexico, a smidgen of China and some very British hunter's trophies! 'Alex collects the antique dead things; I am more of a textile person and I love India.' For years she has been buying the stones for her Jewels from Jaipur so I am surprised when she tells me she has never actually been to the sub-continent. 'I really want to go, but it is a big thing for me. I have heard about the impact India has on people. I have enormous expectations and I am really frightened of being disappointed.'

Her background influences, of course, are primarily cool country, but she modelled in Australia for seven months in the 1980s and the travel bug has always been too much of an irritant to be ignored. You can't live and work in Australia without being hit by the diversity of colour, so shrugging off the pastels, she dived into the full spectrum. She built a huge wholesale business, burnt out, then decided she would design and make only the things she loved herself.

In the distant past, her father had an advertising agency and was often working out of Egypt. This was where she became mesmerised by the treasures of the East. But mainly it was the contents of her mother's jewellery box that started her dreaming; imagining the stories of these mysterious baubles in the palm of her innocent hand. And finally, inspiration came from her mother's haute couture collection. Today she rotates these gowns on a couple of masked shop dummies, elegantly posed in shady corners, but her sister finds them spooky so today they are relegated to the further recesses of the costume department. This is a good thing because they frighten the pants off me!

'I am determined to go to India next year in February,' Pernille exclaims. At this point we are interrupted by the sound of a pneumatic drill. A new studio for the jewellery business is currently under construction. I am encouraged to leave it there for I have not been party to such ear-shattering decibels since I was backstage for The Who gig at the Isle of Wight festival in 1970.

However, Pernille was true to her word and left her Hudson loft for India in February, as planned. We met again in April 2017.

'India was phenomenal. The week after I came back I wanted to turn around and fly right out again. What a country ... the people are so sweet and so beautiful; they are humble, spiritual, hospitable and so generous! India changes you – in immediately noticeable ways and in subtle ways that appear later.'

Of course, India didn't let her down, and now she is newly regenerated in her magpie addiction. In India, pointing her camera lens at everything; she felt she was part of a *National Geographic* shoot. It was impossible to take a bad shot. She has returned with huge plans for another arm to her current business. It will be an exotic collection of eclectic textiles and they will probably need another loft to house it all. The travel bug will not subside and she will continue to wear her stunning kaftans and gowns to glamorous New York events in conjunction with creating ravishing new jewellery designs with all the materials she purchased on this last trip to India.

Somewhere, she says, she has been so busy that she forgot to have children, but she always remembers to travel with her little talisman buddha to keep her safe. Then there is Alex, the businessman and loving husband, who also enjoys a bit of travel, perhaps on a more luxurious level than Pernille, the silver girl, exploring those dusty, Delhi passages. 'I am the weirdest of material girls. I don't care about a Bang and Olufsen sound system or an expensive car. I do care about all this stuff around me, though. I really, really care about it!'

One feels, post India, that 'this stuff' may expand relatively soon – but thank goodness the studio should be ready any day now.

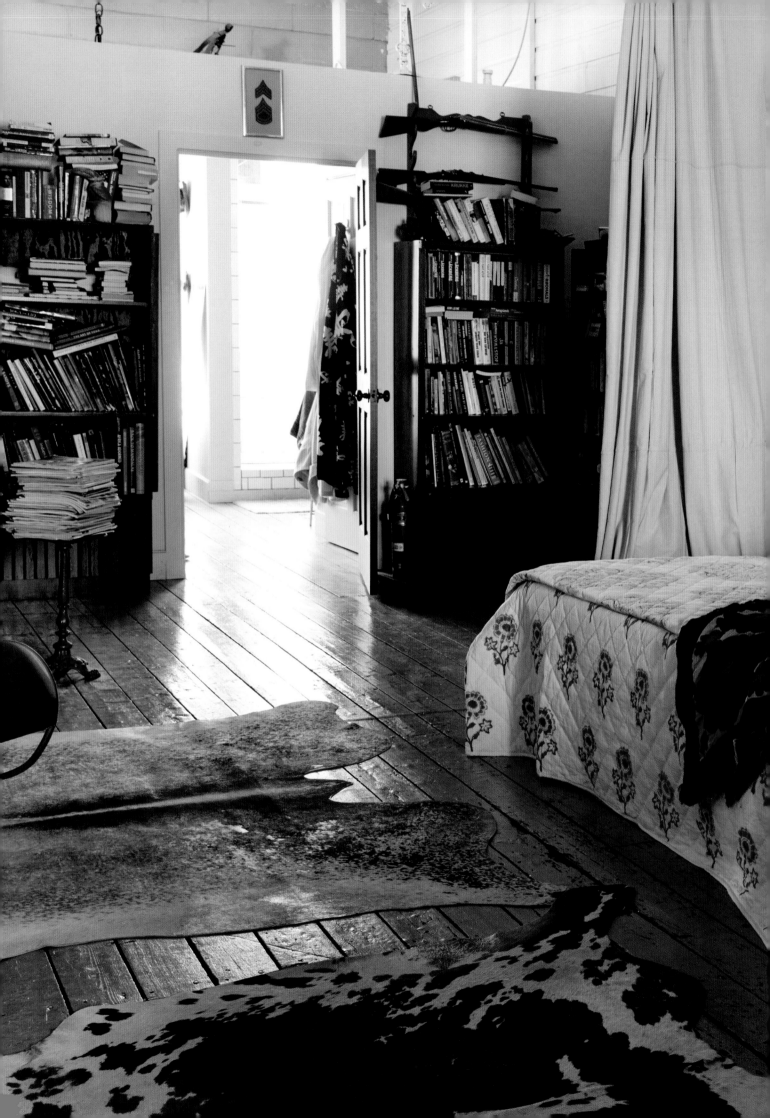

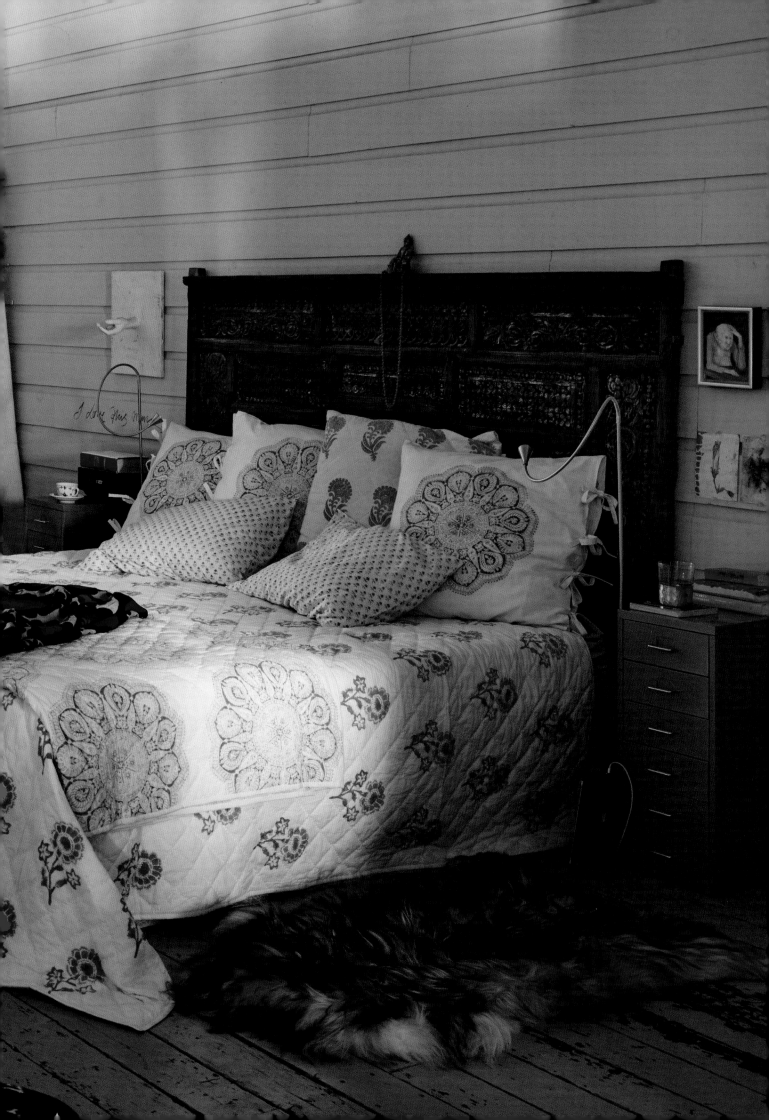

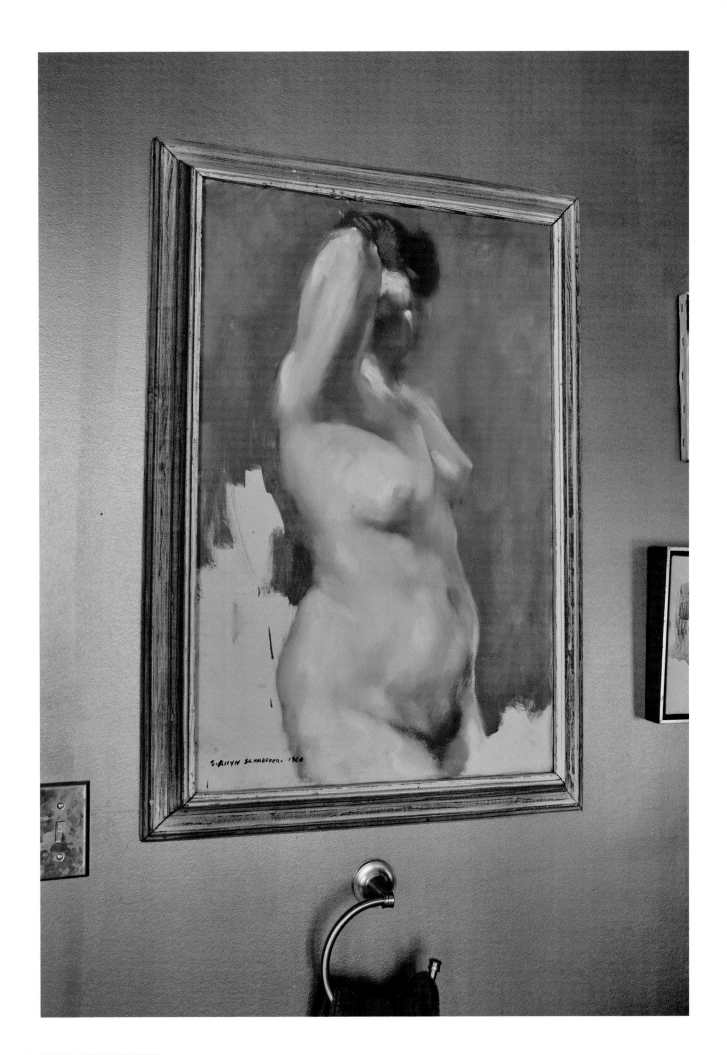

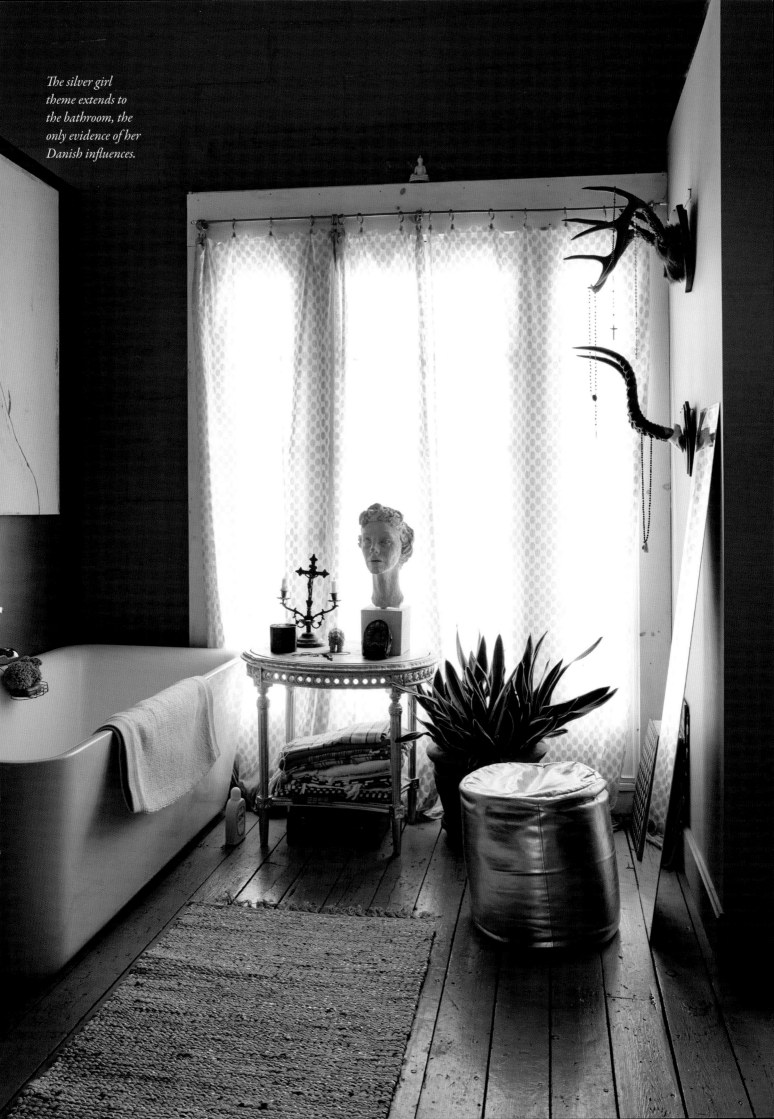

The silver girl theme extends to the bathroom, the only evidence of her Danish influences.

PATRICE FOREST

Publisher / Luminary

IN 1997, PATRICE FOREST BOUGHT FIFTEEN THOUSAND FEET OF NINETEENTH-century warehouse hidden in a discreet mews on the Left Bank near the centre of Paris. Above the door, the inscription from the original builder, owner and printer, Emile Dufrenoy, remains indefinitely, as it is written in the deeds that a new proprietor to the building should keep this name above the entrance for ever. Fittingly and with correct deference, Patrice has named his business 'Idem', the Latin meaning 'The Same'.

The space itself is as intriguing and magical as the mastery and rarity of the work it produces. Once you have located the whereabouts of the building down a hidden, cobbled mews off the Rue de Montparnasse, and you have stepped over the threshold, then euphoria eclipses any prior notion you may have held about the art of lithography. This immediate rush is a reaction to the thundering heartbeat of immense machines, the smell of the paint, the penetrating light from an enormous glazed roof, coupled with a small battalion of expert printers, wafting vast sheets of paper and rolling buckets of thick, oily ink onto slabs of gravestone proportions; in an instant you are aware that magic is done here. You have entered the hallowed halls of pure creation. This is the real thing.

For over a century, these fascinating presses have printed the work of some of the twentieth century's most revered artists. From Chagall, Matisse, Picasso, Braque and Miro to more present-day masters, among

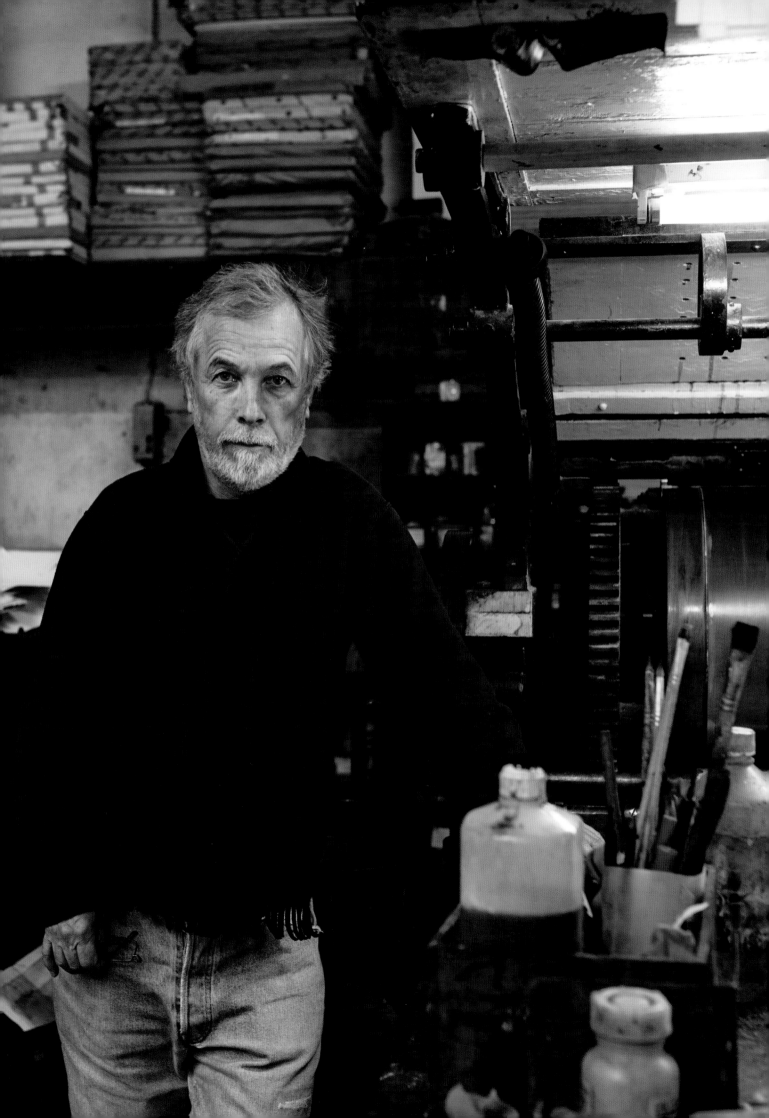

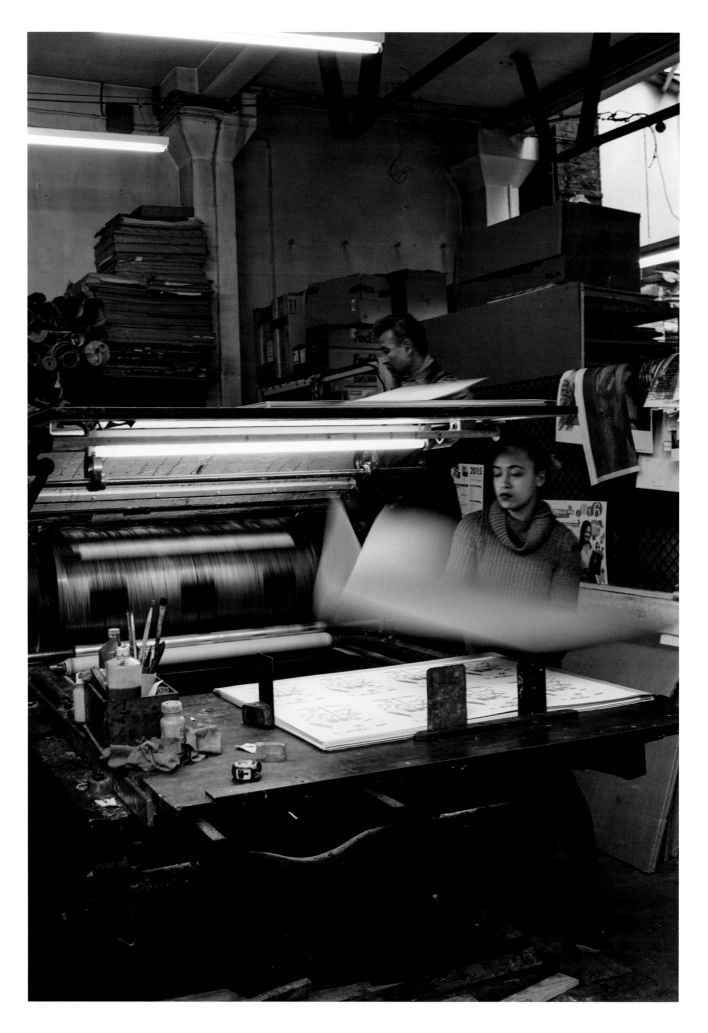

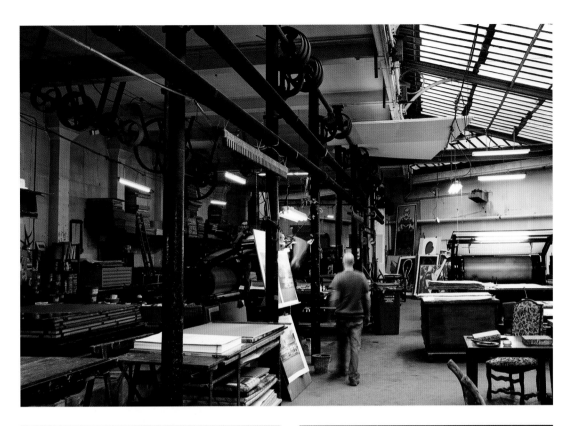

Sharing the vision, American film-maker and producer David Lynch is also uniquely comfortable among the ranks of presses. A talented musician, painter and photographer, David has made a second home among the stones at Idem, printing some of his evocative, often monochrome, architectural images (left).

'I aspired to see with my own eyes what I had heard of from so far away: this revolution of the eye, this rotation of colours that could not be seen in my town. The sun of Art then shone only on Paris.' – MARC CHAGALL

them Ed Koren, Paul McCarthy, JR and David Lynch. The presses originally belonged to the Mourlot Brothers who moved into this building in 1976, having previously used them in two other locations in Paris: one being the famous Imprimerie Bataille at 18 Rue Chabrol. It was here that the flatbed presses did their most prolific work under the auspices of Fernand Mourlot.

After the move to Montparnasse, Fernand's son Jaques Mourlot ran the studio until Patrice took it over in 1997. Recently, and keeping with the integrity of the business, Patrice installed the largest of all presses – aptly named 'Moby Dick'. Having previously worked with this machine in Paris, he found it again in 1987 sitting redundant in a building due for demolition in the south of France. He bought it and had it transported back to Paris, where it now prints limited-edition billboard and cinema posters.

As a publisher of many years, Patrice sees Idem as a home of dreams. 'Artists come in here and lose themselves. They dream big dreams. It is a cave for creativity. They come here to work, and it is like they have come through a long tunnel into a space where they can completely express themselves here on these stones.' The presses are indeed magnetic, perhaps due to the value they hold in spirit. What young artist would not feel privileged to be working alongside the ghosts of their heroes. These machines breathe incentive, they encourage the best from both the printers and the artists. 'People are awed by the whole thing. I have seen some tears shed over the sheer wonder of it all!'

Ten years ago, surrealist film-maker David Lynch was introduced to Idem by Hervé Chandès from the Fondation Cartier. Patrice explains that David's eyes were already open; he immediately saw the dream. David says that he found a paradise and a new world of lithography opened up to him. Since then he has continued to work at Idem, producing a huge body of exclusive work.

The day Hugh and I arrive to take photos, David is working in his own space that Patrice keeps specially for him. Helping him out is a young novice printer, and to her he explains the benefits of meditation. 'It is a place you visit with stillness where everything melts away,' he says. 'You can turn your anger and frustration with the world into peace, and from that you can create without limit.'

His words seem to float and wind themselves around these shiny wheels of industry. Such form of discussion is not out of place because, to those who work here, Idem is a temple of inspiration. The mixture of mediums and textures, the application of artwork to stone, the ink, the paper, the roller and the songs in the presses are a mantra, a form of meditation in themselves. Lynch says the stones could be moved to another location but the result would never be the same. (It is a mercurial feeling and I am unable to precisely locate what it is; enough to express it here.)

But at the centre of all this is Patrice, an incredibly devoted, humble man; a man with the seeds of dreams in his pocket, quietly scattering them among his younger printers, filling their slumbering hours with intent, encouraging his artists with singular devotion. Everyone here is made to feel important.

He is quite self-deprecating about his own role and believes that every small creation is the antechamber to another, bigger step. It is very clear that Patrice is pivotal to the magnetism and success of this studio. He really is the absolute Shaman in his temple to lithography.

LUKE SCIBERRAS

Artist / Dreamer / Lone Wolf

AS AN ONLY CHILD OF DIVORCED IMMIGRANT PARENTS, LUKE SCIBERRAS LEARNT to fly on the wings of the wilderness at an early age; Australia can give anyone plenty of space to be at one with nature, but to be brought up in the parched glory of this vast landscape can strip a solitary child of any dream that he might have of holding a significant place in the bone-hard reality of the outside world. However, for the hope that is snatched with one hand, the other fills a void with the gift of infinite imagination. The Australian outback is built on folklore and legend. Whether it be the stories of the Aboriginal songlines or the enchanting fairytales of May Gibbs, a nation's children will always understand the power of nature and find valuable companions in its wildlife and landscape. For Luke, growing up in the suburbs of western Sydney, bushland walks would have installed in him a vision of the mythological Rainbow Serpent, travelling the sky, seeking another watering hole, and the dust trail of the Dirawong (Goanna), seeking to banish the serpent forever. This is the mythology that carved a landscape and, according to the Aboriginal Elders, it is from the ensuing battle between these two animals that the rivers and mountains were created. These are the stories of giants and, for a time in our childhood, we play with these myths and they become dreams that we cling to in the half light on waking. But the moment we have thought of a single scheduled task for the day, they have dissolved into the unconscious and there they remain until an unscheduled quantum leap allows us a second insight.

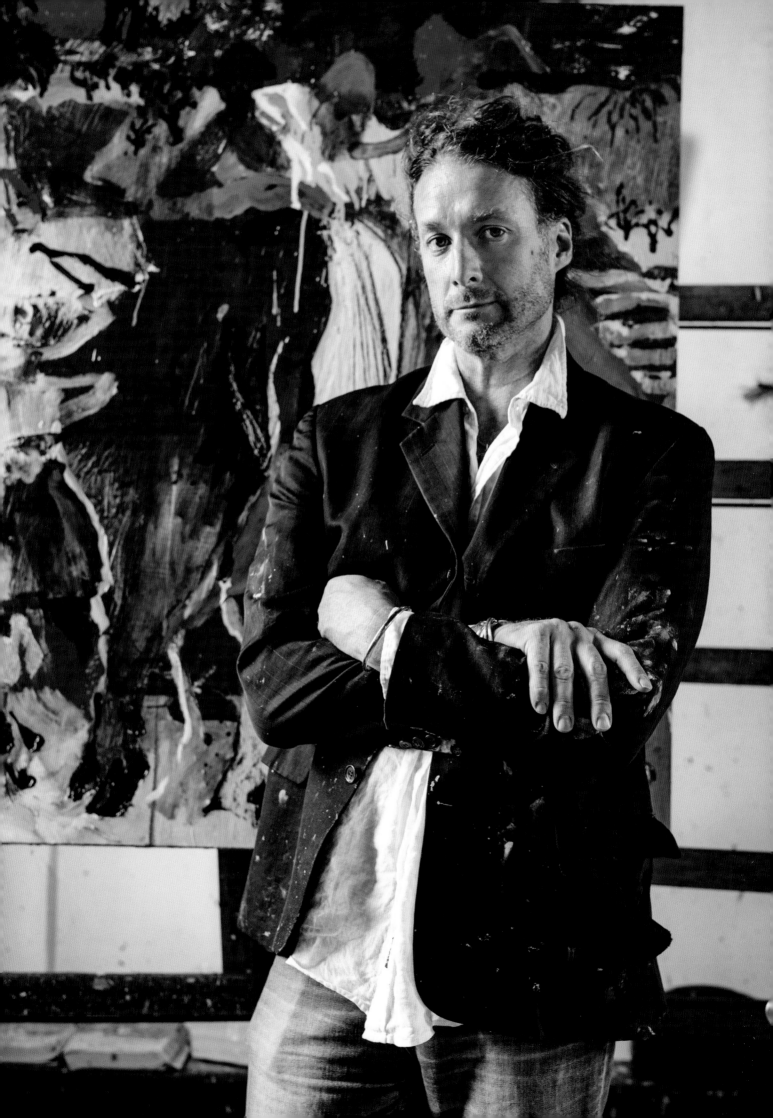

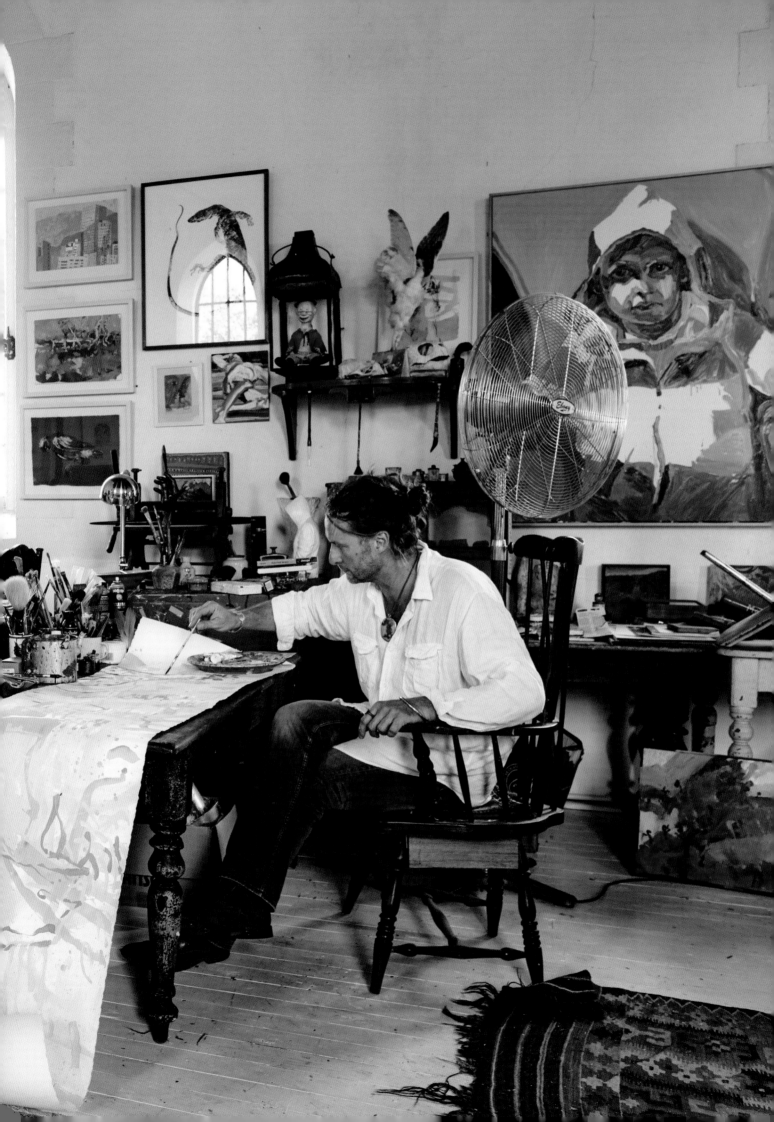

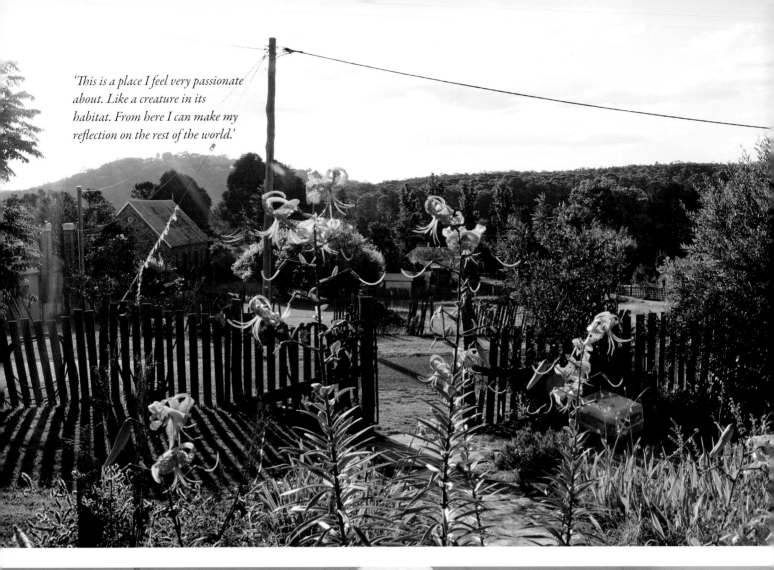

'This is a place I feel very passionate about. Like a creature in its habitat. From here I can make my reflection on the rest of the world.'

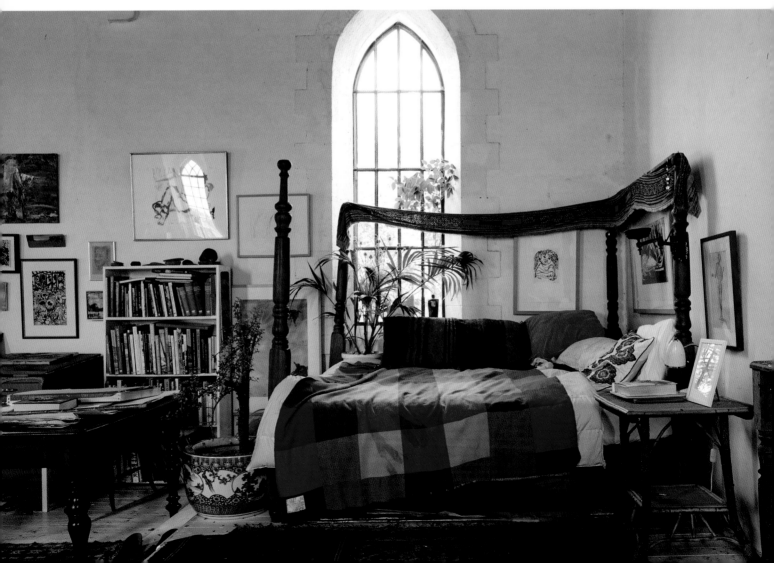

Hill End was founded in the 1860s as a Goldrush town. At the the town's peak there was estimated to be a population of eight thousand inhabitants but by the end of the Goldrush it had dwindled to a mere seven hundred. It was discovered again in the late 1940s by artists Russell Drysdale and Donald Friend and soon became an inspirational escape for many of Australia's enlightened painters, from Arthur Boyd and Margaret Olley to Brett Whiteley and Ben Quilty. Here, under the auspice of painterly protection in a deconsecrated Methodist chapel, is the studio and home of Luke Scriberras.

For most of his youth in Sydney, he had courted and successfully enjoyed the company and homes of his artist heroes. The time spent with these living legends he regards as a scholarship to his own artistic endeavours. 'It was important to me to associate with as many different artists as I could.' So living with the great Martin Sharp and Peter Kingsford, attending parties at Wendy Whiteley's Lavender Bay home, sharing canvas time with the artist and friend Elisabeth Cummings and generally learning his trade through his huge admiration for the sixties and seventies artists, writers and poets founding a culture that would steer Australia out of a post-war lethargy into an apex of confrontational change. In 1997 Luke moved with his wife and fellow painter Gria Shead to Hill End. Through the generosity of Archibald prize winner Tim Storrier, one of his many mentors, who stumped up the funds, the couple acquired an old wattle cottage and lived together, sharing a battered open studio for thirteen years. These days Luke lives alone in a deconsecrated chapel he acquired to replace the breezy open studio. He keeps a lower profile now, away from the tough lifestyle required to impress a bunch of old arty reprobates.

But let's not forget about that quantum leap. It came one night in October 2012 in the form of a heartache at two in the morning. He was thirty-seven years old, a good friend had died, his marriage had unravelled, and now he knew he was in serious trouble. He stumbled through the night to the home of an old drinking buddy who, worse for the night's intake, piled him into the car and drove the notoriously dangerous, kangaroo-littered roads to Bathurst Base hospital. The pain was screwing his heart like a wrung-out flannel and visions of imminent heart surgery sent him into an almost out-of-body experience where he thought that he might be able to observe the end of his life from a bird's-eye view! After a series of tests, he was told he had heartburn and his recently sobered neighbour berated him all the way home. Some time later, when Sciberras had resumed painting, a nurse from the hospital appeared at the chapel door with the results of further tests. 'Something is very wrong with your heart. You need to get your pyjamas and come with me,' he explained. Luke now began to panic and walked very slowly to the waiting car. He discovered he had myocarditis, an inflammation of the heart muscle. He was told by his doctor: 'Your heart is like an empty football; it can no longer pump effectively.'

For the next three months, Luke lay low at Hill End, the familiar small corner of the Earth that held everything he was worth. The local community supported his recovery and eventually he began to fiddle with his brushes again. Taking long walks into the Australian bush, his renewed passion for nature coupled with a precious awareness of the fragility of life, he exclaims: 'To be completely immersed in the remotest landscape is a thrill all on its own. To walk free and feel the pulse, history and nature of a place is what I now love to carry back to my studio. It is during these months of working in a meditative state that I can revisit the landscape and the child-like dream state, and through visual energy comes a piece of work that represents the essence of who I truly am.'

Today Luke Sciberras is considered to be one of the most significant emerging landscape artists of his generation. He travels extensively through Europe and the East, gathering images that inspire his brush and keep him from encountering the cabin fever of a small-village life. Last count, Hill End had but eighty residents. But Luke has learnt that what the heart wants, the heart wants. He is astute enough to know that Earth and heart share the same vital energy and he is only too aware that his gift to the Art world and to himself is knowing that what the Earth gives it can take away in a second, so it is best to make a friend of both. This is only too evident in his work.

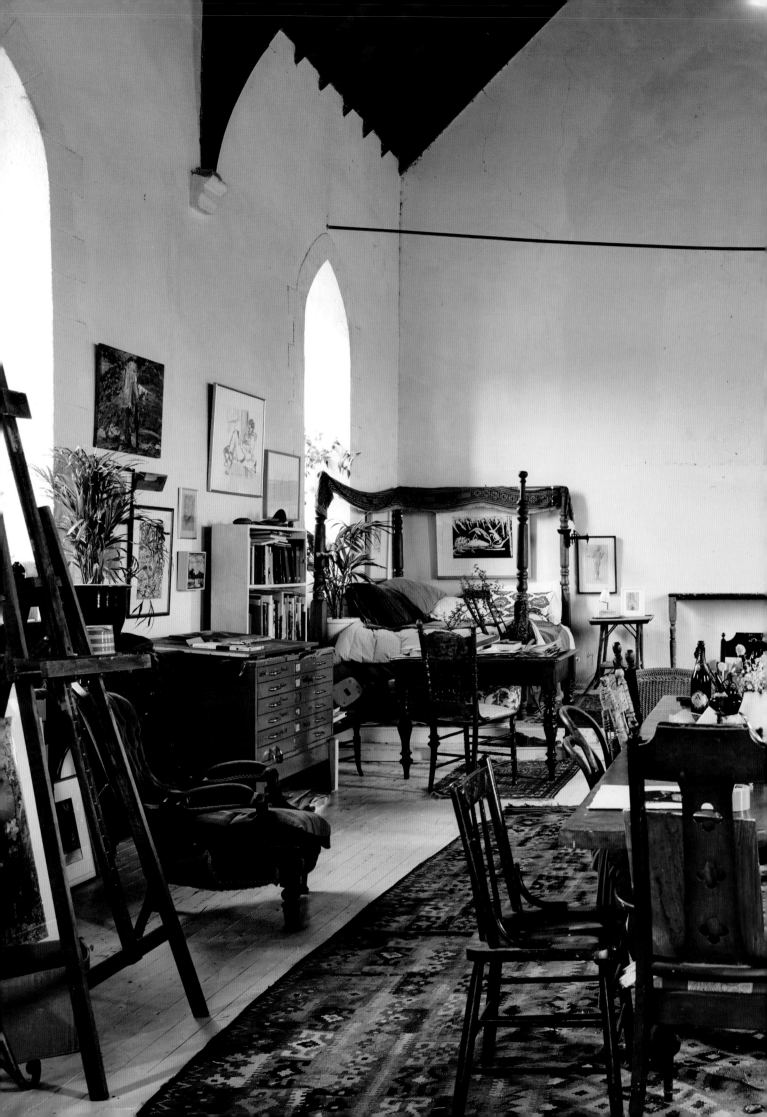

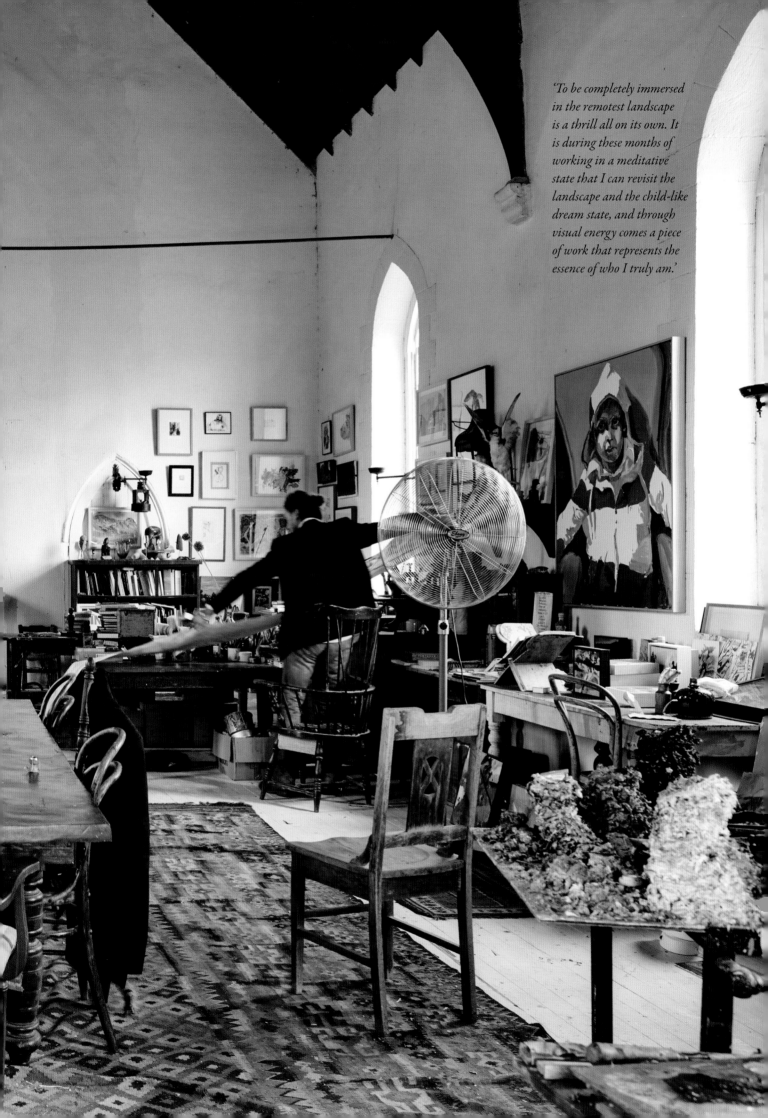

'To be completely immersed in the remotest landscape is a thrill all on its own. It is during these months of working in a meditative state that I can revisit the landscape and the child-like dream state, and through visual energy comes a piece of work that represents the essence of who I truly am.'

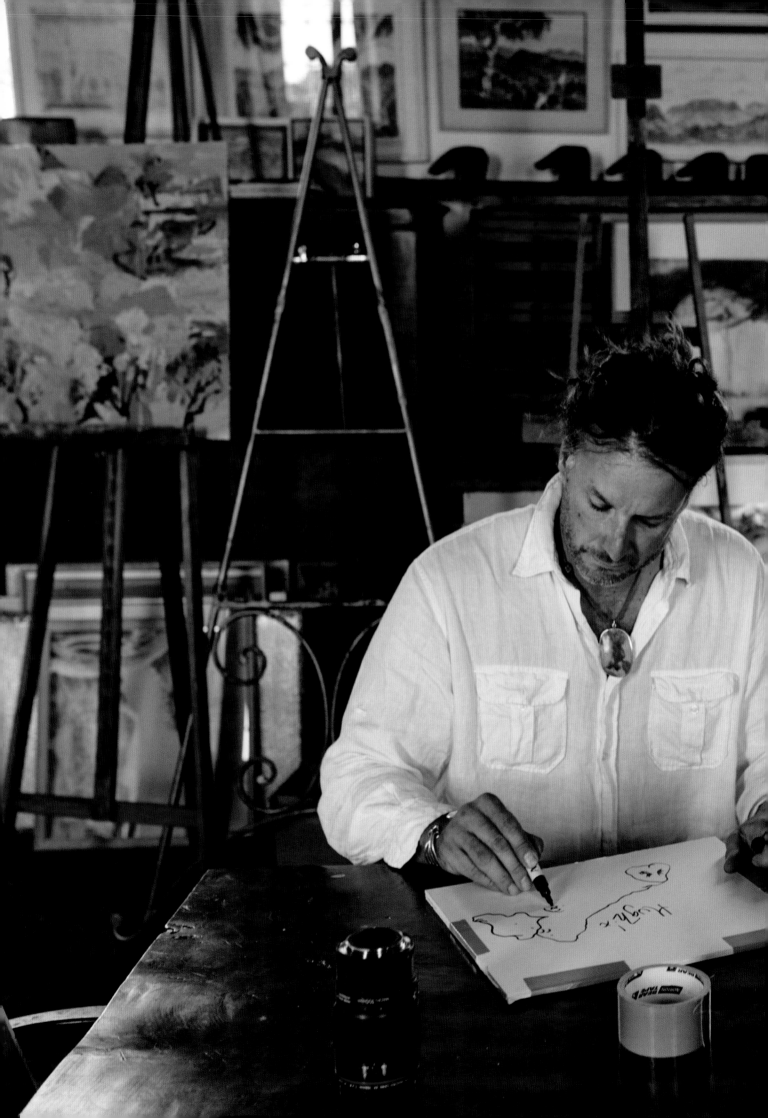

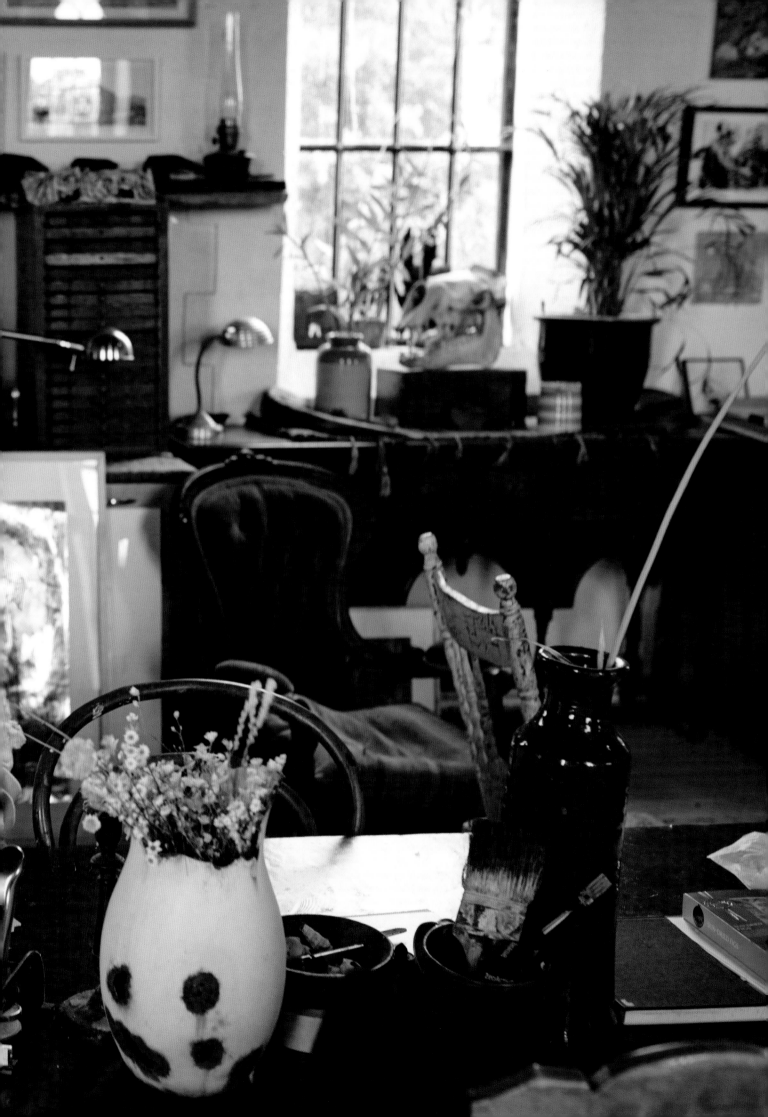

JUNO GEMES
& ROBERT ADAMSON

Activist / Photographer
Poet / Publisher

DRIVING NORTH FROM SYDNEY HARBOUR, ABOUT ONE HOUR FROM THE CITY, there is a sign off the highway that announces Mooney Mooney. Not much happens here except a rather wonderful fish café near the lazy meanderings of the Hawkesbury River. You may notice the twisted expressions in the tortured mangroves that lace the shoreline or, if you should arrive in the dark, you could be struck by the shimmering path across the river towards the reflected moon. You will hear the rattle and bumps of the outboards as they gently hit the wharves and, if you are quietly intuitive, you might think you are in ancient Indigenous territory and the Dreamtime is very, very close. You would not be wrong. This is poet country and hidden amongst the tangled foliage is the home of Juno Gemes and Robert Adamson.

Robert Adamson is one of Australia's leading contemporary poets; he has over twenty volumes to his name. The poet now stands at the window, his rescue fledgling perched on his finger, watching the river. They both just watch. Come evening, Robert will attend flight school with the wild bird he has named Spinoza and suspected was a cuckoo, but later discovered to be a Satin Bowerbird. 'Spin' does not yet have her tail feathers, so practice is necessary for the day she takes flight back to her flock, who now sit patiently in the nearby branches.

Juno is upstairs in her studio processing her most recent portraits for an exhibition she is currently hanging at FireWorks Gallery in Brisbane. Recently they both returned from Chicago where they were part of a touring

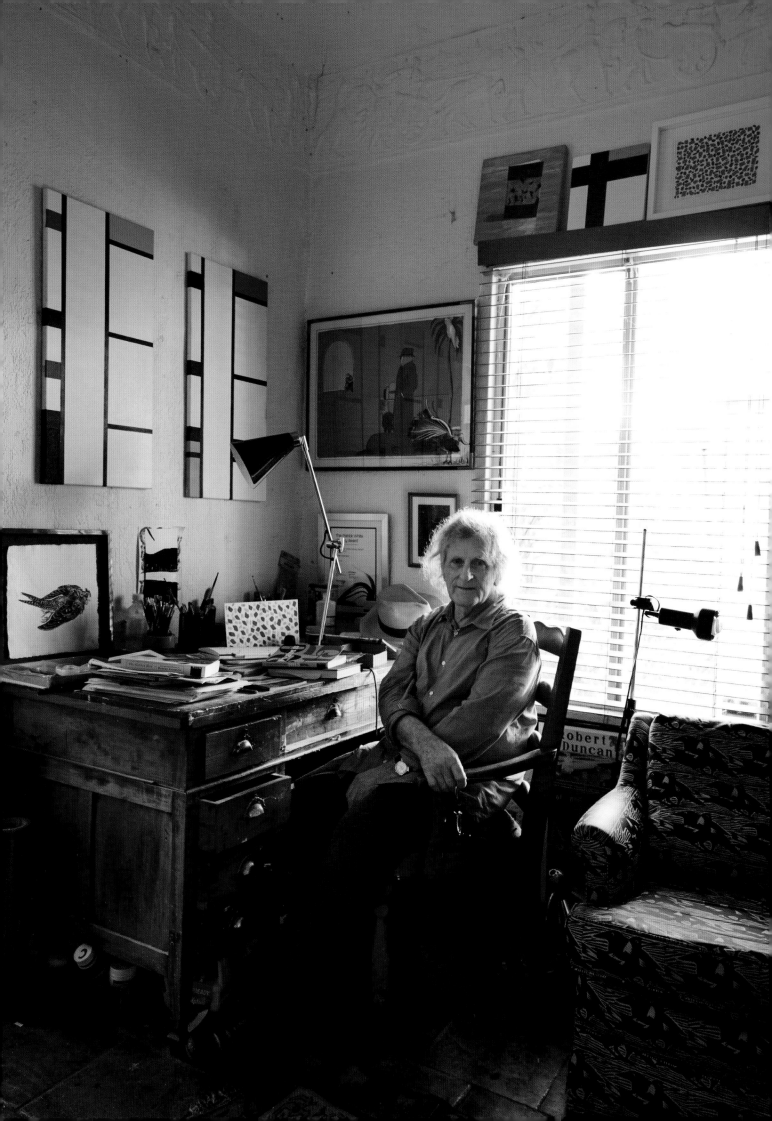

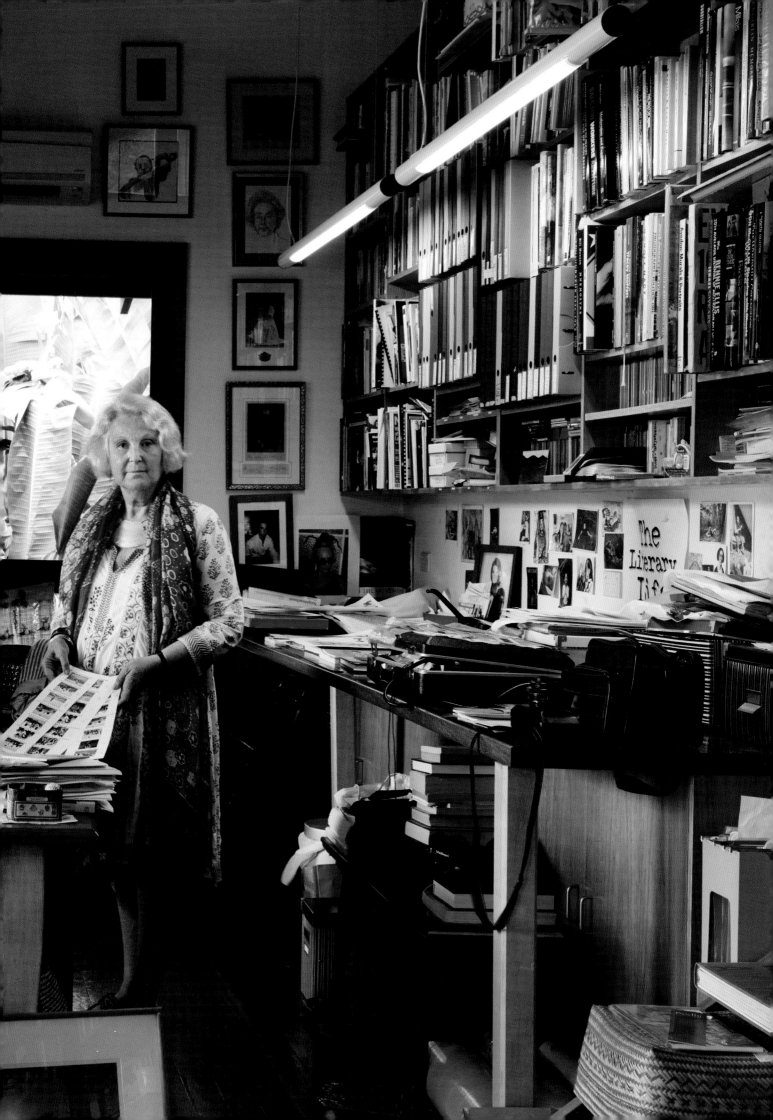

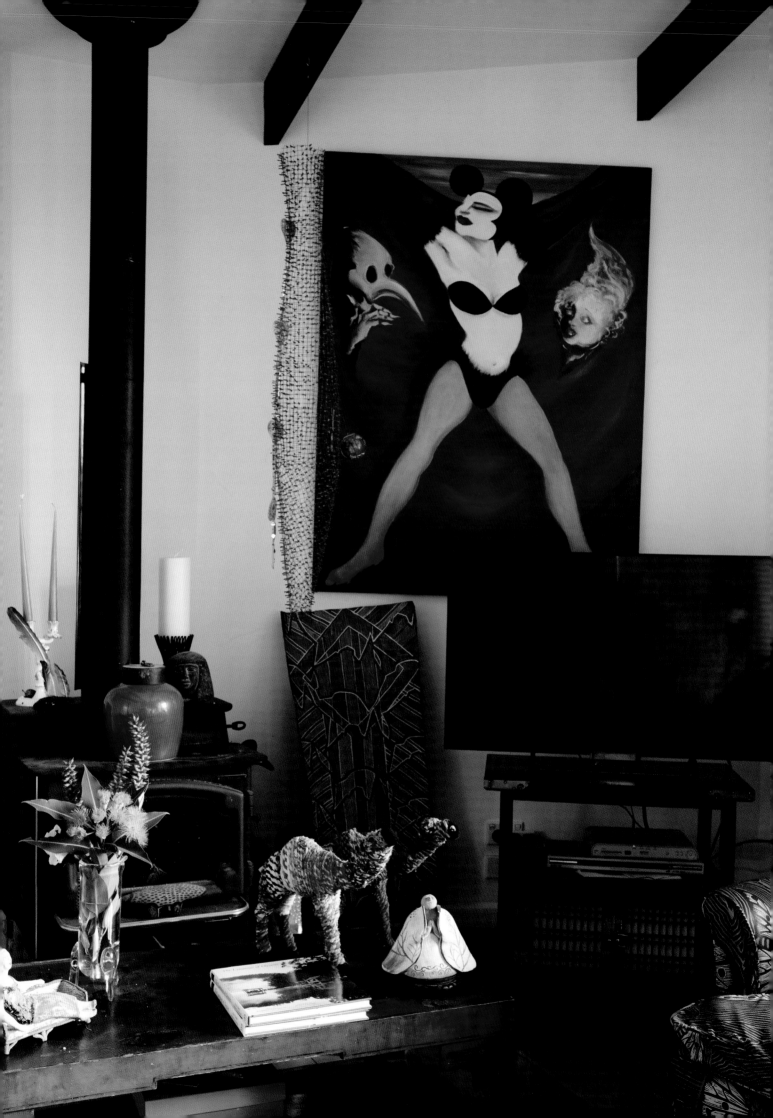

Pieces of Indigenous Australian art stand beside an eclectic mix of art, photography and poetry. Juno took up the camera as the most powerful weapon she could find in her battle to shed light on the holistic culture of the central Australian tribes that were then invisible to the mainstream.

'I have always kept company with poets.
Poets have always been my friends.' - JUNO

seminar for the University. Juno describes herself as a Magyar gypsy, who spent her wild years in the company of creative giants – the likes of designer Jean Michel, and poets Heathcote Williams, Michael Horowitz and Allen Ginsberg.

Juno's parents moved to Australia after the Second World War, in 1949. In the late 1960s, then in her vanishing teens and believing that Australia was telling itself fairy tales about its own heritage, Juno went looking for something radical to roughen up her edges. She found London's UFO club and went on to work happenings and festivals throughout Europe, flying home to Sydney on a regular basis. From there, artist Martin Sharp invited Juno to join the Yellow House, a contemporary temple for art and self-expression.

But while at a festival in Aylesbury, back in the UK, she experienced a life-changing dream. In it, Juno met an Aboriginal Elder who sat before her in the red earth and patted the ground three times. In the plane on the way back from London she was suddenly surrounded by a rainbow as the aircraft banked over the Simpson Desert. Reuniting with her old friend and film-maker Mick Glasheen, she immediately became involved with a documentary he was making on the sacred site of Uluru in central Australia. Juno knew then that her dream was a call for action. She had to find the custodians of this Indigenous nation, who were desperately trying to uphold a holistic culture that was entirely invisible to mainstream Australia. Juno knew this was what she had come back to do and determined that it was photography that would make the most lasting and powerful impact on the media. She headed back to Europe and took an old bus to Venice to study with American photographer and theosophist, Lissette Model, who also tutored Diane Arbus.

'It politicised me. I woke up, and then Adamson appeared before me with the words: "I want to be with you for the long run!"'

Bob was surrounded by young poets visiting his studio at all hours of the day and night with whiskey and wine, and Juno decided she did not want to be a gatekeeper. So one day she made the journey to Mooney Mooney to visit the area where Bob spent the best part of his childhood. On the advice of her father, she heard of a house coming up for auction and within twenty minutes it was done: Juno has bought them a home.

'It was Bob's spiritual home. The place where he was most at peace. I began to love it too.'

The house is a warren of higgledy piggledy rooms all bursting with books, projects pending, projects finished, and projects yet to be begun. In the middle of all this are soft places to fling oneself and stroke a Siamese cat, of which there are two constantly rubbing at one's ankles. On the kitchen table are a dozen golden Christmas cakes that Bob has baked for his friends while Juno has been down in the city dealing with some family business. 'I used to be a pastry chef,' Bob tells me.

So here they are today sharing the long run together, their respective wild days behind them. Juno is taking portraits of the Dalai Llama and continuing her work with the custodians of Indigenous tribes. 'Australia has seen the light at last,' she says. 'Things are changing, we are more aware, we see the beauty in these extraordinary people.' Bob continues to publish his poems and tell stories of the bird life and the mysteries of the languid Hawkesbury. They meet in the kitchen each day for coffee and discuss their individual projects, then return to their studios. Every two hours a thought is shattered by the squawks of Spinoza demanding an urgent feed but, come the evening when all is still, they will walk to the end of the wharf together and row out for a little moonlight fishing, the ballads of the Dreamtime washing gently in their wake.

Robert Adamson – Garden Poem – For Juno

Sunlight scatters wild bees across a blanket
of flowering lavender. The garden

grows, visibly, in one morning –
native grasses push up, tough and lovely

as your angel's trumpets. At midday
the weather, with bushfire breath, walks about

talking to itself. A paper wasp zooms
above smooth river pebbles. In the trees

possums lie flat on leafy branches to cool off,
the cats notice, then fall back to sleep.

This day has taken our lives to arrive.
Afternoon swings open, although

the mechanics of the sun require
the moon's white oil. Daylight fades to twilight

streaking bottlebrush flowers with shade;
a breeze clatters in the green bamboo and shakes

its lank hair. At dinnertime, the French doors present us
with a slice of night, shining clear –

a Naples-yellow moon outlines the ridges
of the mountains – all this, neatly laid out

on the dining room table
across patches of moonlight.

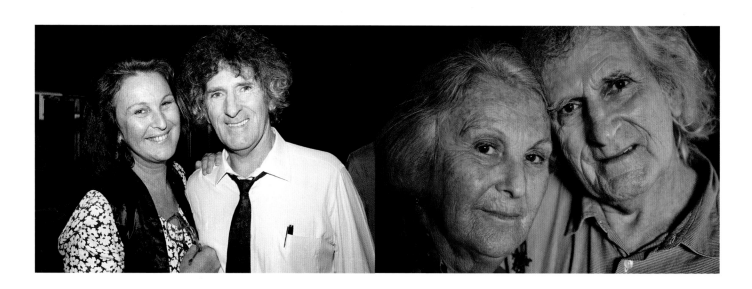

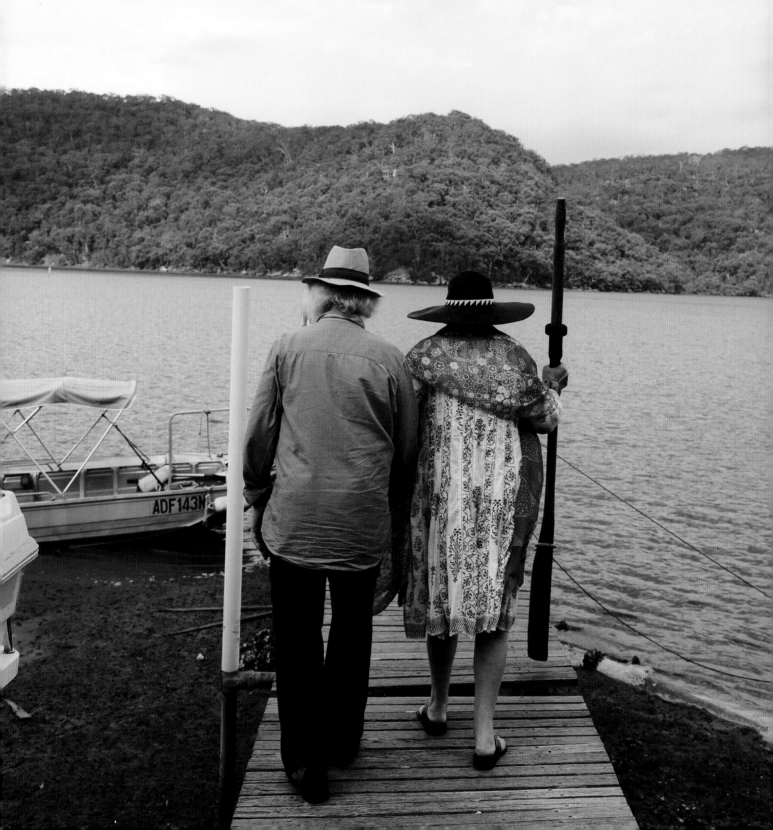

*'Adamson appeared before me with the words,
"I want to be with you for the long run!".'*

MARTIN SHARP

Artist / Cartoonist / Free-thinker / Mentor / Gentleman

ON 1 DECEMBER 2013, AFTER A LONG BATTLE WITH EMPHYSEMA, AUSTRALIA'S MOST formative and dearly loved artist and founder of the sixties counter-culture, Martin Sharp, died at his home, Wirian, a rambling mansion in Sydney's elegant Bellevue Hill. He was seventy-five. Those who knew him well would later attend a memorial service steeped in nostalgia and laced with personal stories of over forty years of prolific work and mentorship. Others who only knew him on the Western side of the planet would be catapulted back to the late sixties and the birth of Britain's satirical, irreverent rag – *Oz* – that rumbled at our very foundations, lampooning all that was authoritarian and mocking all that was dreary, featureless and dull.

Oz was first published in 1967 after Sharp and his partner in crime, Richard Neville, escaping convictions for obscenity in Australia, trekked across Asia together and arrived on British shores, separately but with the shared intention to shake things up a bit. But finding Swinging London more liberating than the Sydney of its day, they both revelled in the hedonistic optimism of the Summer of Love and Martin, retaining his eye for irony, moved from satirist to art – literate work, producing the layered, psychedelic, pop art covers that catapulted the magazine into the forefront of London's alternative, underground culture. From here he would collaborate with his friend, photographer Robert Whitaker, cutting up and collaging his images of The Beatles, creating covers for Bob Dylan, posters of Jimi Hendrix and designing album covers for musicians of the day.

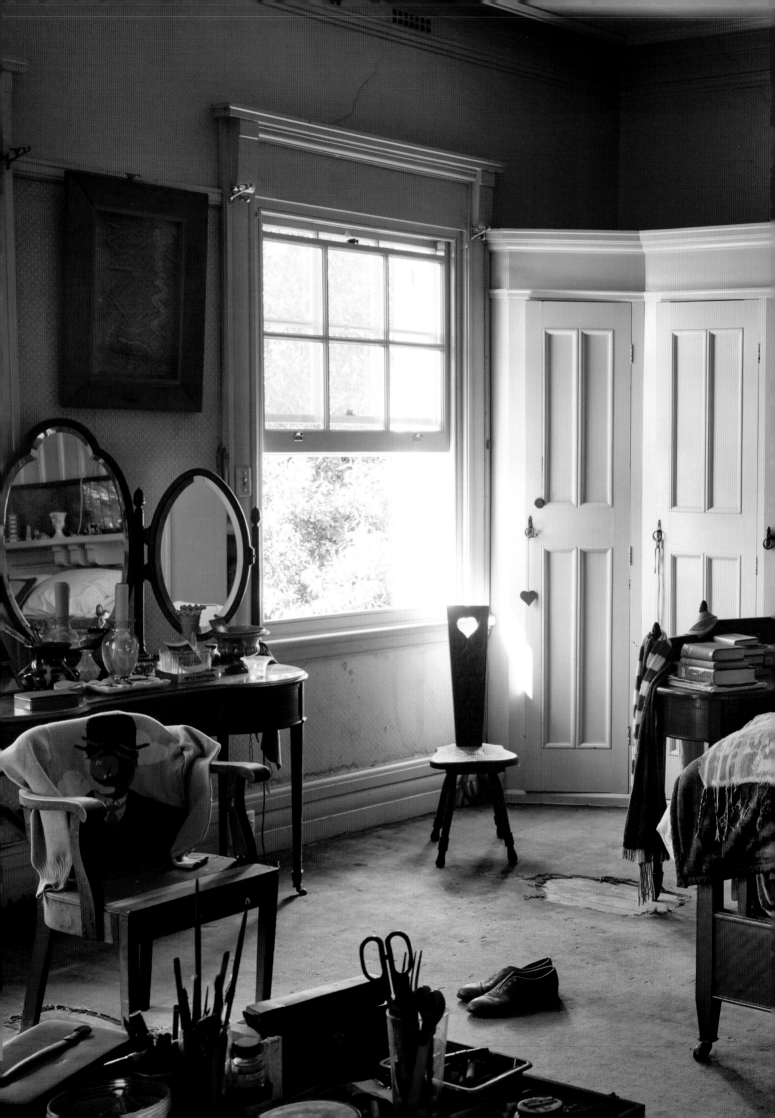

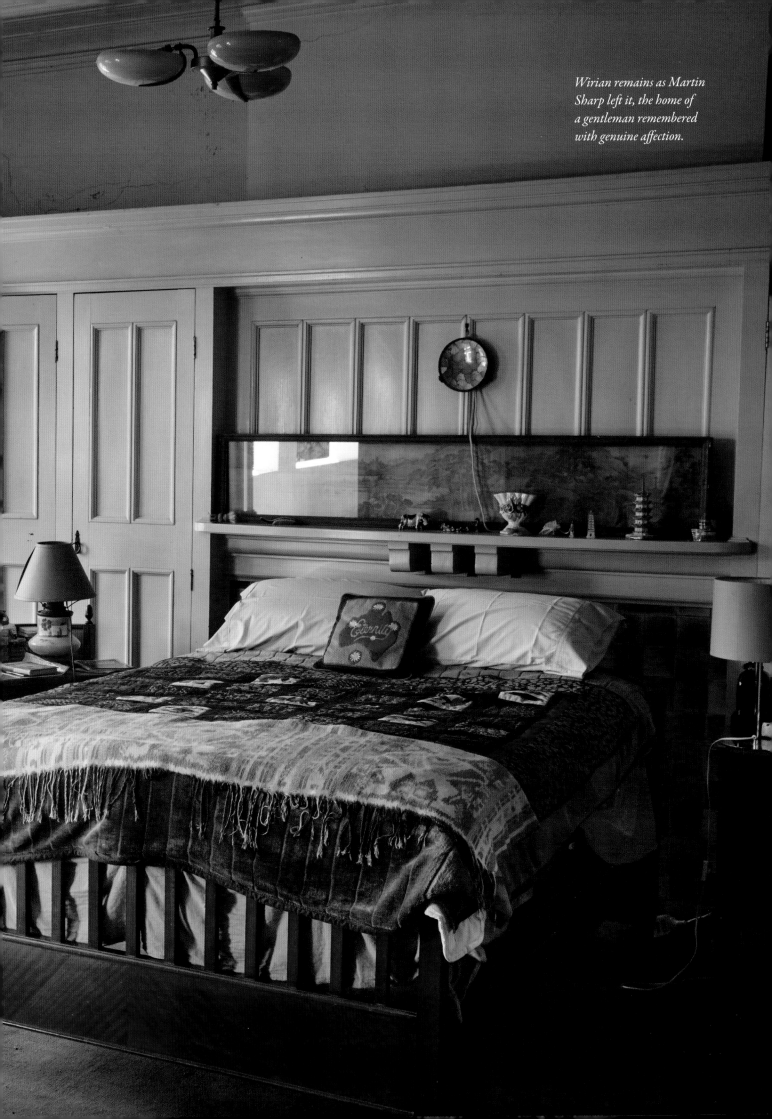

Wirian remains as Martin Sharp left it, the home of a gentleman remembered with genuine affection.

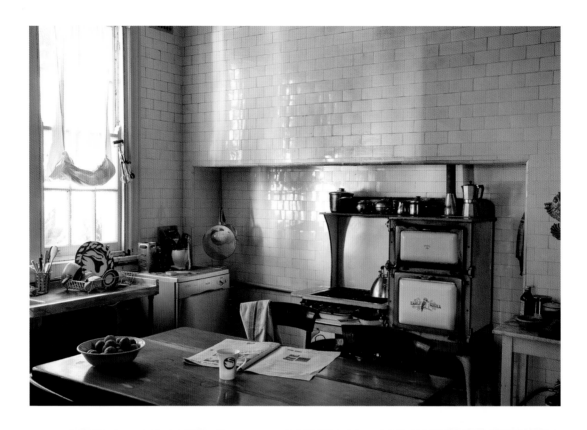

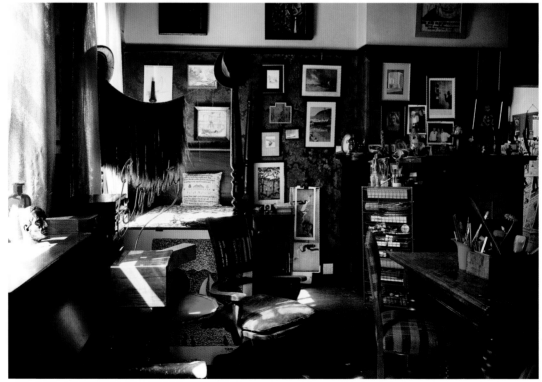

In crucible form, Martin Sharp's home, Wirian, is one of the rare and remaining places where countless people learnt to use their eyes, because everything we see has meaning. The house was originally the home of his grandparents, and it is now kept as it was when Martin lived and worked there.

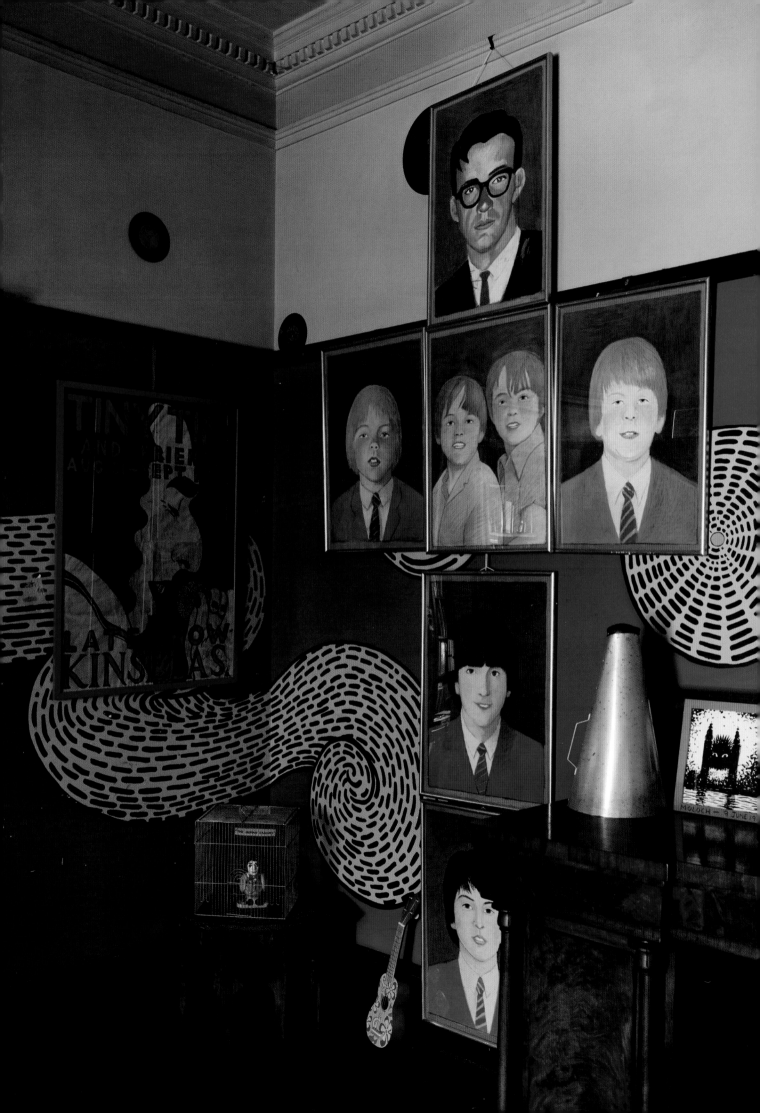

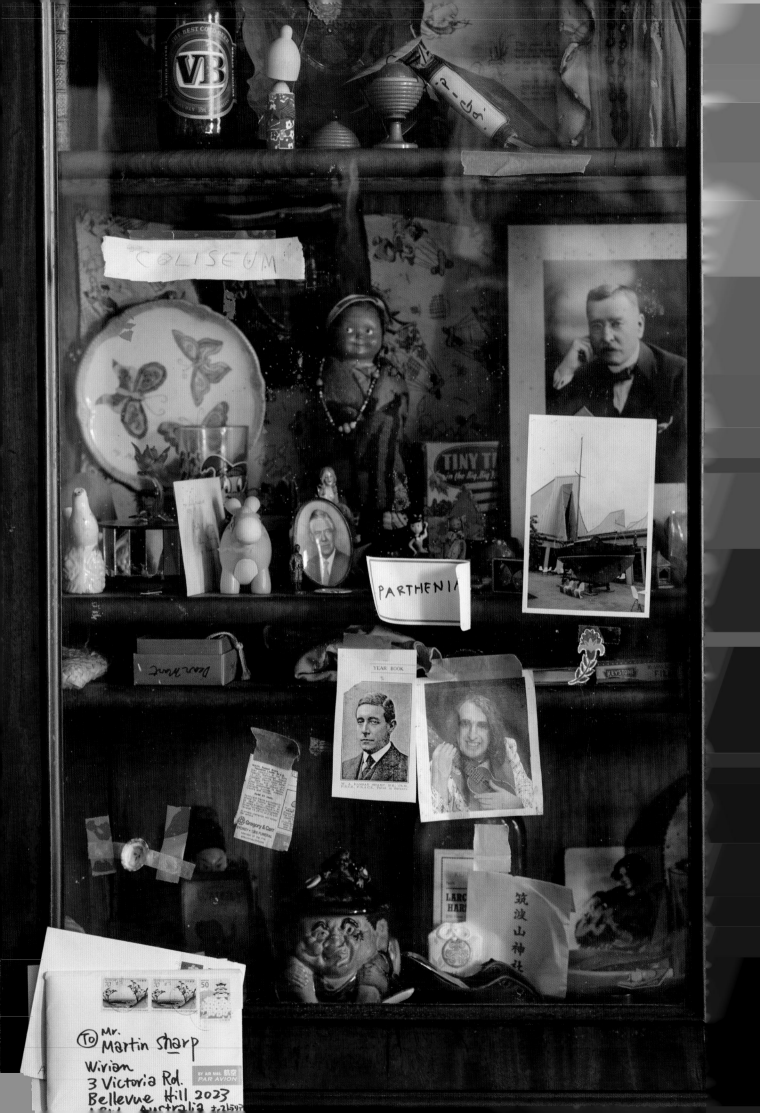

Throughout his life, Sharp was captivated by the music scene. In time, Robert Whitaker found him a studio in the disreputable Chelsea Pheasantry and soon after, Sharp met Eric Clapton at Mayfair's Speakeasy club and, with Australian film director Philippe Mora, they all moved in together. From here Martin would collaborate on many projects with other musicians and film makers, among them the sets of the film *Performance* directed by a young Nick Roeg and starring Mick Jagger as a jaded rockstar.

In late 1969, Martin Sharp returned to Australia and set up his acclaimed Yellow House. Inspired by his love for Van Gogh, it was a permanent artists' multimedia collective in MacLeay Street, Sydney. Here he invited other young artists to exhibit and be part of an intensely curious series of happenings and exhibitions.

'He took me to Wirian to see if there was anything he could use to decorate the Belgian Bourgeois Interior, remembers Bruce Goold, 'where he intended to create a display using the Magritte lithographs he had brought back from Paris. He led me up a narrow staircase to the servants' quarters and unlocked a creaky door to reveal an Edwardian collection of Alibaba treasures, abandoned furniture, a marble column and a Lalique head, which Martin stuffed with pink roses and mounted on the plinth. He was an intuitive and eccentric decorator and it was a great honour to be part of his life.'

For the last thirty years of his life, Martin Sharp lived the life of a recluse in Wirian. Never marrying or having children, he would paint obsessively, sometimes the same subject over and over again. Many of his friends would arrive and stay for anything from a night up to a year, watching Martin paint while the music blared. Juno exclaims: 'Australia is yet to acknowledge the contribution he made to the international counter-culture and to the world.'

Luke Sciberras says: 'Living at Wirian was one of the most nourishing and frightening periods of my life. Martin was a truly eccentric and brilliant man. His intellect and eye saw into and beyond his surroundings. Above and beyond the groundbreaking works he made in the sixties, Martin's work seems to straddle so many lives, and Wirian was and is one of the great crystallisations of those meaningful lives and works.'

In the 1970s Sharp was asked to oversee the renovation of Sydney's iconic fun fair, Luna Park, restoring the enormous laughing face at the entrance. But in 1979 the park was blighted by an arson attack on the Ghost Train, which claimed seven lives including a father and his two sons. Sharp was devastated and for many years after burdened himself with conspiracy theories attaining to malpractice behind the fire.

Around this time, he became intrigued with the eccentric falsetto balladeer Tiny Tim. No one can explain why this happened but it was to occupy his thoughts for the last remaining decades of his life. Some say it was down to a large chillum of best Nepalese temple hash that he had imbibed before being introduced to Tiny Tim's music at the Albert Hall in London by Eric Clapton. It was this and the tragedy at Luna Park that overtook all other interests in his art and his life. He spent the final years documenting and trying to inform people of Tiny Tim's greatness.

Whatever it was that took him on a diverted path away from the understanding of his closest friends, they remember him with unrestrained affection. Juno considers him 'a true Maverick Soul'. His work, like his life, cannot be compartmentalised. An artist for all seasons, all situations, a painter, a poster-maker, a cartoonist, print-maker and film-maker. I loved watching him draw at the great table in his study at Wirian. On one of my final visits he thanked me for introducing him to the Aboriginal people in my life, something I shall never forget.'

For Hugh and me, this has been a jewel of a discovery, not least in our surprise at finding a connection to Martin through many of our contributors, for it is said that when something is done on true instinct, it heralds divine intervention which, in retrospect, has been at work from the outset. Martin Sharp is the kind of mentor who gives inspiration to so many and a uniquely gentle soul. We are grateful to have gained permission to photograph Wirian. I live in the hope that Australia will preserve its illustrious past and treat it as a memorable example not only of its period, but also as the home of one of the most innovative, enlightened Maverick spirits that Australia's free world is supposedly founded upon.

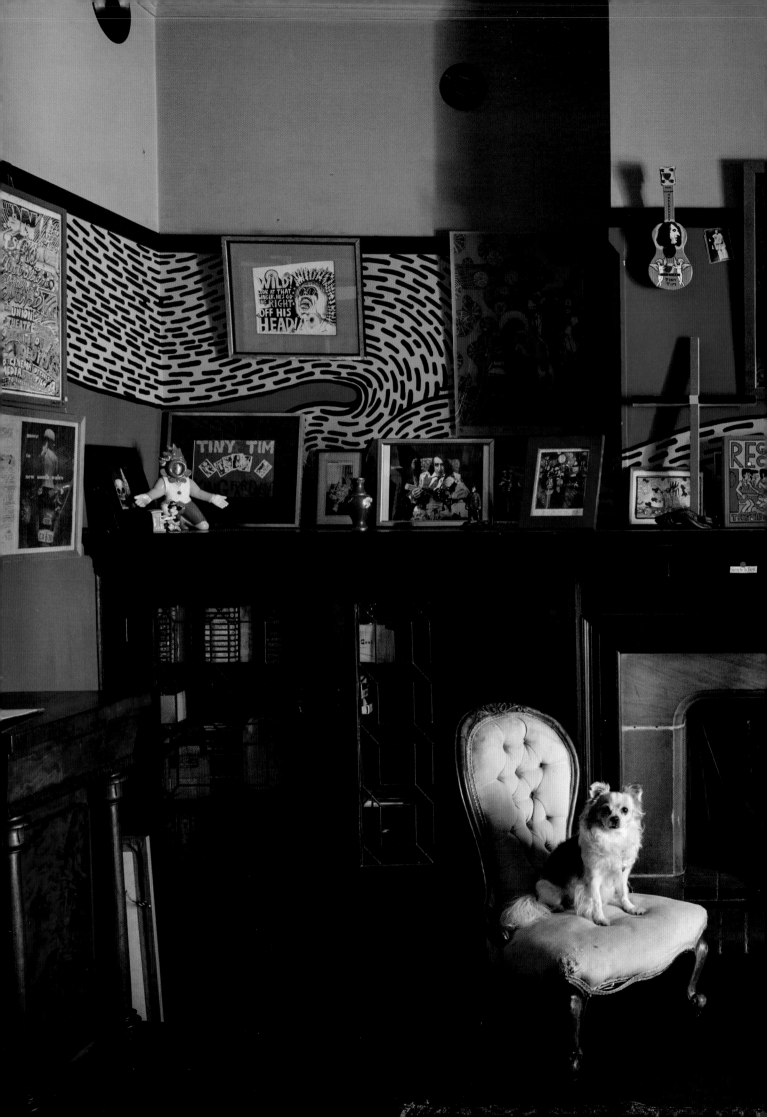

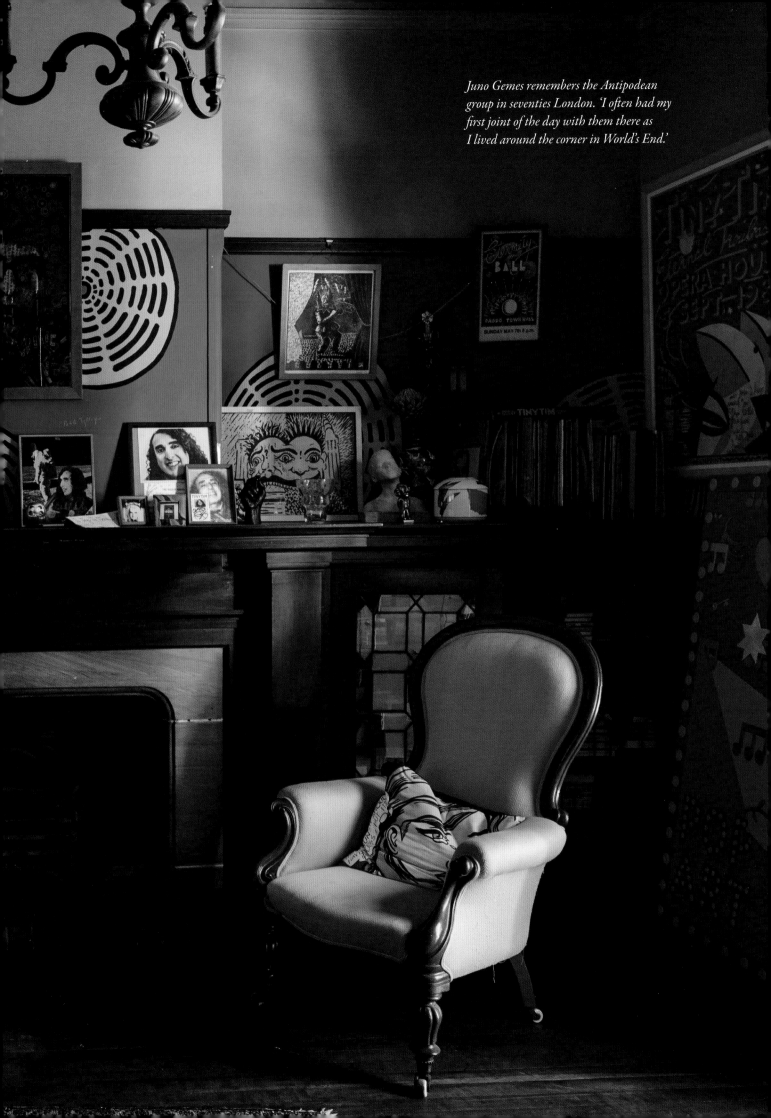

Juno Gemes remembers the Antipodean group in seventies London. 'I often had my first joint of the day with them there as I lived around the corner in World's End.'

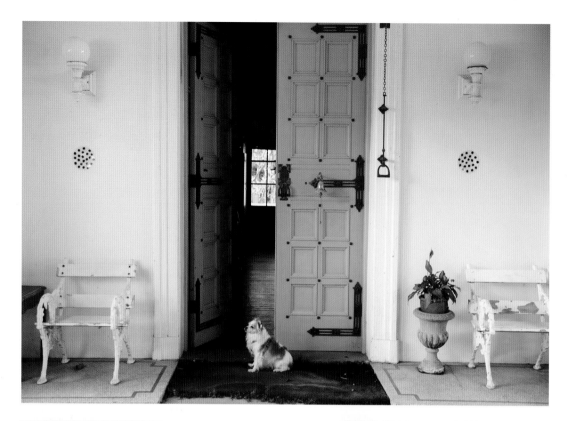

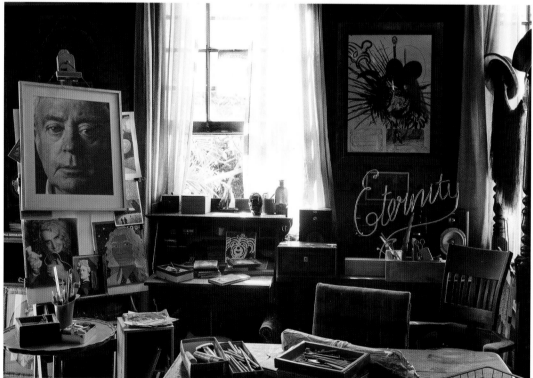

'Once Martin had become obsessed with Tiny Tim he could paint very little else,' remembers his friend Marianne Faithfull. Gael Boglione remembers the time when 'Martin rang and asked me to bring my modelling portfolio to Wirian. I thought it was for a casting but Tiny Tim just looked at it for a long time. It was kind of creepy.'

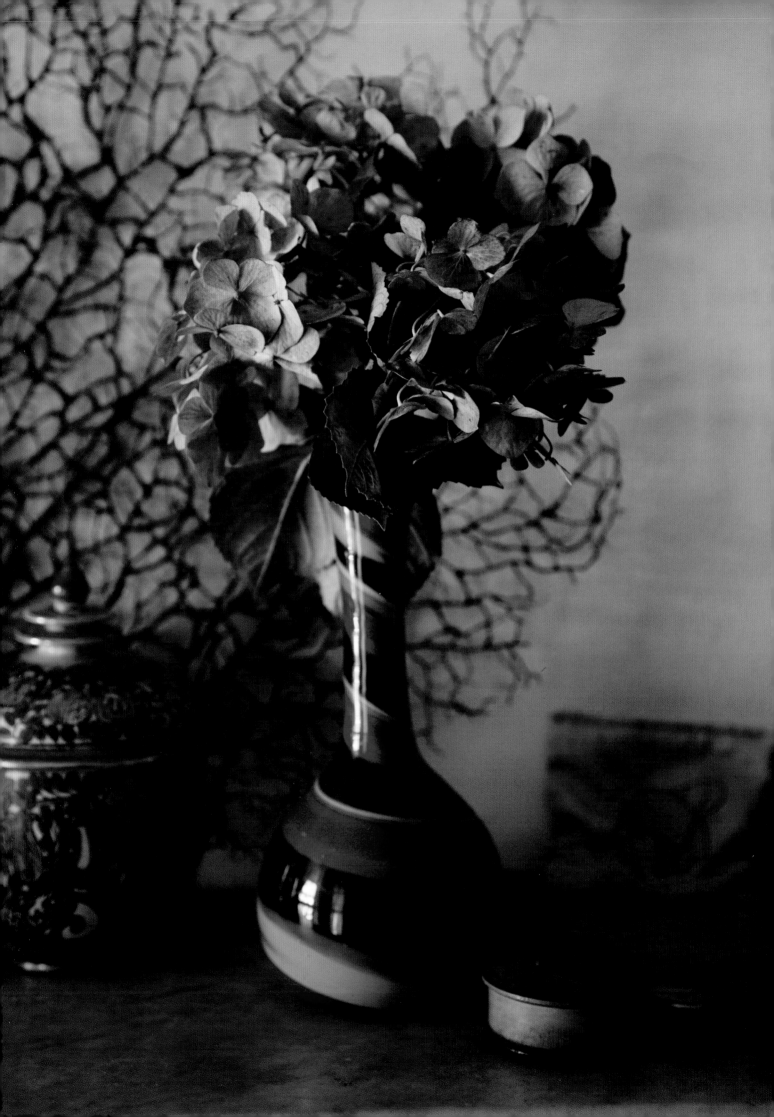

This book is a collaboration between interior decorator and home stylist, Miv Watts, and photographer, Hugh Stewart.

MIV WATTS is a true bohemian. Beginning her early career as a window dresser for Burberry London, she met and married Peter Watts; sound engineer for Pink Floyd, in the late sixties. Having two children in quick succession – Ben (photographer) and Naomi (actress) – she threw herself into homemaking while her husband was touring. Peter died tragically in 1976 and Miv put her many skills to work as a stylist and set decorator. She worked with directors Nick Roeg, Steven Hopkins, Russell Mulcahy and David Mallet on *MTV.* Moving to Australia in the 1980s, Miv worked consistently with feature films on location in the Far East. She returned to the UK in the early 90s, and designed, among other things, two UK Boutique Hotels out of India, where she worked with local craftspeople to design furniture, textiles and hand-painted wallpaper. Her passion for the beautifully crafted, unusual, and unique is equal to her love of colour, travel and Indigenous people. Her work has been featured in the *Telegraph, Independent, The Sunday Times, Condé Nast Travel, Guardian, Tatler, Harpers & Queen, Country Life, The Lady, Vogue* and *The Financial Times.* Miv has recently refurbished two large town houses in the South of France. She has homes in the south of France and Byron Bay, Australia. *www.mivwatts.com*

HUGH STEWART is truly a world-class photographer who has a love of the lived-in environment. He documents interiors, architecture, people and the way they live with a realism and warmth that makes the 'cookie-cutter' houses and inhabitants of slick magazines seem somewhat predictable and dull. He is a visual storyteller where the ordinary becomes something enigmatic. He captures personality. And his way with natural light makes his images beautiful and engaging. Hugh lives in Sydney with his wife and three children but continues to work between Australia, the US and Europe. He has worked for *I-D, The Face,* British, Australian, French and American *Vogue, Condé Nast Traveller, Travel and Leisure, Vanity Fair* and has photographed two Chanel No.5 Campaigns. He has photographed, amongst others, Johnny Cash, Michael Caine, Jude Law, Nicole Kidman, Paul Newman, Robert Redford, Kenneth Branagh, Naomi Watts, George Clooney, Matt Damon, Catherine Deneuve, Clint Eastwood, Harvey Weinstein, Julian Schnabel, Rod Stewart, Sir John Mills, Sir Ian McKellen, John Updike, Leonardo DiCaprio, Bill Nighy, David Hare, Geoffrey Rush, Cate Blanchett, The Duchess of Devonshire and five Australian Prime Ministers. He rarely answers his phone. *www.hughstewart.com*

THANK YOU

THIS BOOK IS DEDICATED TO THE LATE, GREAT INGRID SISCHY FOR BELIEVING IN ME, and on one incredible evening around a table in Montauk, encouraging me to sit down and write it.

Also to my dearest and long-departed friend George Hayim, for being the one magical person in my life who believed frogs could have feathers and who lived for every moment he could show his own off to perfection.

I would like to thank my beautiful contributors and hope that you will all continue to speak to me after you have received your own copy! With special thanks to the trustees of the late Martin Sharp Estate.

I also would like to thank my indomitable team for making this possible: Tracy Lines, Designer; Kate Pollard, Publisher; Wendy Hobson, Editor. Your patience and belief in me was my 'blanky' of security for the duration. An extended thank you to my friend Juno Gemes, who was never more than a FaceTime away ... through tears and laughter, she was my brick!

The Maverick Soul by Miv Watts
First published in 2017 by Hardie Grant Books, an imprinting of Hardie Grant Publishing

Hardie Grant Books (UK)
52-54 Southwark Street, London SE1 1UN

Hardie Grant Books (Australia)
Ground Floor, Building 1, 658 Church Street
Melbourne, VIC 3121

hardiegrantbooks.com

The moral rights of Miv Watts to be identified as the author of this work have been asserted by her in accordance with the Copyright, Designs and Patents Act 1988.

Text © Miv Watts 2017
Photography © Hugh Stewart 2017

'To My Mother' by George Barker reproduced with the kind permission of Rafaella Barker.
'Garden Poem — For Juno' by Robert Adamson reproduced with the kind permission of Robert Adamson.
Quote on page 123 from *The Wind in the Willows* by Kenneth Grahame, first published in 1908.

Photograph on page 238, an evocative image of an Aboriginal family looking out to sea by Juno Gemes, reproduced with her kind permission.

British Library Cataloguing-in-Publication Data. A catalogue record for this book is available from the British Library.

ISBN: 978-1-78488-0-439

Publisher: Kate Pollard
Senior Editor: Kajal Mistry
Publishing Assistant: Eila Purvis
Photographer: Hugh Stewart
Art Direction: Tracy Lines
Copy Editor: Wendy Hobson

Colour Reproduction by p2d
Printed and bound in China by 1010